LEONARDO'S
LOST PRINCESS

LEONARDO'S LOST PRINCESS

One Man's Quest to Authenticate an Unknown Portrait by Leonardo da Vinci

PETER SILVERMAN
with Catherine Whitney

WILEY

John Wiley & Sons, Inc.

Published by John Wiley & Sons, Inc., Hoboken, New Jersey
Published simultaneously in Canada

For general information about our other products and services, please contact our Customer Care Department within the United States at (800) 762-2974, outside the United States at (317) 572-3993 or fax (317) 572-4002.

Wiley also publishes its books in a variety of electronic formats and by print-on-demand. Some content that appears in standard print versions of this book may not be available in other formats. For more information about Wiley products, visit us at www.wiley.com.

Library of Congress Cataloging-in-Publication Data:
Silverman, Peter, date.
 Leonardo's lost princess : one man's quest to authenticate an unknown portrait by Leonardo da Vinci / by Peter Silverman with Catherine Whitney.
 p. cm.
 Includes index.
ISBN 978-0-470-93640-5 (hardback); ISBN 978-1-118-16310-8 (ebk.); ISBN 978-1-118-16311-5 (ebk.); ISBN 978-1-118-16312-2
 1. Leonardo, da Vinci, 1452–1519—Criticism and interpretation.
 2. Drawing—Expertising.
 3. Portraits—Expertising. I. Whitney, Catherine. II. Title.
NC257.L4S55 2012
741.945—dc23
 2011042291

Printed in the United States of America

10 9 8 7 6 5 4 3 2 1

To all the wonderful people who have so generously stood up to defend the honor and reputation of La Bella Principessa—*often at great personal risk. Without you this astounding saga could never have progressed so far so fast. I am humbly in your debt.*

To my patient and perceptive wife, Kathleen, for your invaluable collaboration and forbearance over these past three years.

This book is further dedicated to those who were instrumental in helping to make me who I am: Dr. Irene Duerking and my teachers, Swami Rudrananda (Rudi) and Professor Namkai Norbu Rimpoche.

Contents

Acknowledgments ix

1 Found! 1
2 Who Is She? 15
3 Leonardo's World 23
4 Real or Fake? 35
5 The Magic Box 51
6 A Scholar's View 71
7 Leonardo's Principles 79
8 Beloved Daughter 91
9 The Art of Fingerprints 105
10 The World Reacts 117
11 The $100 Million Blunder? 129
12 The Art World Strikes Back 145
13 What Constitutes Proof? 167
14 Miracle in Warsaw 183
 Epilogue: Life's Fleeting Grace 197

Contents

Appendix: Nicholas Turner's Report on *Portrait of a Young Woman in Profile* 201

Notes 213

Bibliography 239

Index 243

Acknowledgments

I am indebted to the many people who made this book, and the amazing discovery that prompted it, a reality. First and foremost, my wife, Kathy, who shares my passion for art and has been my partner in both life and work, joined me in a search for the truth about the found portrait. My sister, Tina, a consultant on the project, has been a great help as well, particularly with press relations.

Nicholas Turner, the former curator of drawings at the British Museum and a former curator of the J. Paul Getty Museum, was the first person to suggest to me that I might be holding a Leonardo, and he followed up his initial intuition with a full support of the portrait's authenticity.

My dear friend Mina Gregori, an acclaimed doyenne of art history, also saw the hand of Leonardo in my find and supplied excellent advice. She insisted on being the first to actually write down the Leonardo attribution. Giammarco Cappuzzo, an independent art consultant in Paris, supplied me with the right contacts at the right time, including recommending Lumiere Technology and the Swiss laboratory for carbon-14 dating. His input saved many months of futile work.

Pascal Cotte of Lumiere Technology, the visionary inventor of the technology that allows one to view great works of art

"like Superman," took on the task of proving that the portrait was the Master's work. His work and that of his associate, Jean Penicaut, was invaluable. Martin Kemp, a sleuth extraordinaire, one of the world's foremost Leonardo scholars, and an emeritus professor of art history at Oxford, surmised rightly from the start that the portrait represented Bianca Sforza, which led us to the Warsaw revelations. His analysis was exemplary and masterly in its scope and detail. Peter Paul Biro was brought into the analysis, and using his expertise in art forensics and fingerprint science, he concluded that a fingerprint and palm print on the portrait were of high probability Leonardo's.

I am grateful to other experts who have supported the Leonardo attribution. Sir Timothy Clifford, the former director general of the National Galleries of Scotland, was an early enthusiast. Considered by many to be one of the most successful and dynamic museum directors, he is a specialist on Renaissance art and concluded early on that it was Leonardo's hand in the drawing. Alessandro Vezzosi, the director of the Museo Ideale Leonardo da Vinci in Leonardo's birthplace of Vinci, believed it was the work of Leonardo and published his findings in his superb monograph on da Vinci. Carlo Pedretti, the director of the Armand Hammer Foundation, added his belief in the Leonardo attribution. Although Pedretti was suffering from a serious health issue and was in pain, he made the trip to Paris to view Lumiere's findings firsthand. Simon Dickinson, a former director of Christie's and now one of the world's leading Old Master dealers, showed his mettle in coming out early in support of the attribution.

I am also very appreciative of the other specialists who took the time to study the portrait and concurred in the da Vinci attribution. These include Cristina Geddo, a scholar of Leonardo's workshops and the first to actually write a detailed study of the work; Claudio Strinati, the former head of Rome's museums and now in the Italian Ministry of Culture,

who was an enthusiastic supporter from the early stages; and long-term acquaintance Catherine Goguel, a former Louvre drawing specialist, who made a number of interesting observations. For the hairstyle comparison and analysis in its historical context, special thanks to Elisabetta Gnignera. A tribute, too, to D. R. Edward Wright, an emeritus professor of art history at the University of South Florida, Tampa, who discovered clues that could resolve the mystery of provenance (the record of the artwork's history). His insights led us to the Sforziada manuscript in Warsaw.

I also appreciate the work of Simon Hewitt, Oxford trained and a journalist with *Antiques Trade Gazette*, who helped launch the story to the world. Simon is a fine sleuth and scholar in his own right. Other journalists who took the time and made the effort to get the story right include Milton Esterow of *ARTnews*; Julien Pfyffer of *Paris Match*; Jean Folain of the *Times* of London; Stefan Simon of *Der Spiegel*; and Randy Boswell of Canadian broadcasting. I am grateful for the time Simon took to review this manuscript. His insights were always helpful.

Thanks, too, to Mats Ronngard and his team at Excellent Exhibitions, as well as to the officials and city of Gothenburg for their kindness in helping with the first showing of *La Bella Principessa*.

Special thanks to Peter Haas and his team at Moebel Transport for their invaluable help and expertise in storing and shipping *La Bella Principessa*.

I am grateful to my art-savvy legal team—Eric Kaufman in New York and Peter Mosimann in Basel—for advising on this project, as well as Brinsley Dresden in London.

Madame Jeanne Marchig, *La Bella Principessa*'s former owner, gave of her time to explain her and her late husband's involvement and fill in the gaps of the provenance during the past half century. When she consigned the painting to

Christie's for sale, she hoped to be better served by a company with which she had had a fruitful and trusted relationship for decades. It is her fervent hope that she will be made whole in the end.

Producing a book is a collaborative effort, and many people have made this one possible. I am grateful for the fine work of my collaborator, Catherine Whitney, who faithfully recorded my story and views. My literary agent, Jane Dystel, brought her considerable experience and expertise to the project, finding a good home for the book with John Wiley & Sons. My editor, Stephen Power, has been passionate and insightful in his pursuit of a great story.

I beg forgiveness if anyone has been omitted, and I thank all who have helped to make this come to fruition.

Naturally, a thought goes out to the beautiful and tragic subject of this portrait, *La Bella Principessa*, Bianca Sforza, and finally, my profound admiration and respect to the great Master himself, Leonardo da Vinci, who allowed me to enter his world in this small way.

A final note: This book is one man's story about one man's discovery. It is not and does not pretend to be art history, although great pains were taken to ensure that it reflects art history accurately. To this end, it was submitted for review to several prominent scholars. For those wishing to study Leonardo da Vinci, the bibliography contains many fine titles. I had a lot of pleasure telling this rather improbable story of what many consider to be the most important art discovery in generations. If any lesson is to be drawn, it is that in art, as in life, things are not always as they seem.

1

Found!

O! Wretched mortals, open your eyes!

—*Leonardo da Vinci*

My wife, Kathy, and I strode arm in arm along the winter-slicked sidewalks of Fifth Avenue, past the elegant buildings with their shivering doormen blowing whistles to hail taxis. There was nothing beautiful about January in New York, with its ice-encrusted pavements and towers of dirty snow. But the major art auctions at Christie's and Sotheby's were held in January, so that is where we had to be, like it or not. We never missed an auction season; we eagerly traveled from our home in Paris to immerse ourselves in the hunt for the next great find.

Kathy and I are full partners in life and in art, and over the years we had amassed a large collection, mostly works on paper, ranging from the fifteenth to the twentieth century. By

the turn of the twenty-first century, we were already known for a handful of remarkable discoveries, including three miscatalogued paintings by van Dyck and a Raphael that was sold as the work of an anonymous sixteenth-century artist.

The most prominent find was a profoundly subtle and moving wooden crucifix we bought in the early 1990s that has recently been attributed to Michelangelo in a new major monograph on the artist. When we purchased the crucifix through an agent, it was presented as the work of a seventeenth- or eighteenth-century unknown German artist, which I suspected was totally wrong. In 2005, through my contacts in Italy, I heard of a newly found wooden crucifix, attributed to Michelangelo, that was to be exhibited at the Horne Museum in Florence. I immediately saw a resemblance to the crucifix we had, so I sent photos to a specialist in Florence, who confirmed that it seemed to be by the same hand. Subsequently, a number of experts who studied the piece stated that not only was it likely a Michelangelo, it was even more sublime than the crucifix on display at the Horne Museum. In 2009, a London auction house estimated its value at £25 million (more than $39 million).

Kathy and I delighted in these adventures, and in time we learned to turn our differences into assets. And different we were! I was well aware and appreciative of Kathy's balancing influence. As is often true in partnerships, we slipped easily into distinct, complementary roles. Kathy is the practical one with the critical eye, more earthbound and analytical. I am the dreamer and the hunter, with a passion for beauty. Kathy once told me she thought I had the curiosity of a Renaissance man but also that I spread myself too thin. I will say that I've always believed there is only one school, which is quality.

On this January day in 2007, we were headed to an address on 73rd Street, between Fifth and Madison Avenues: the gallery of Kate Ganz, a dealer in Old Master drawings. It was

the custom for major art galleries, mostly clustered around the Upper East Side of Manhattan, to host exhibitions and sales of their own during auction week, and we usually tried to visit those that featured Old Master drawings and works on paper. The weather was so icy we had actually considered skipping the Ganz exhibition, but I was representing a couple of wealthy European collectors on this trip, and I felt obligated to see as much as I could.

As we walked into the enveloping warmth of the gallery, my eyes were instantly drawn to a display to the right of the door. I moved closer. Standing on a small easel in the center of a table was the portrait of a lady I had never forgotten during the last nine years—a portrait I had missed out on at a Christie's auction, which I had always regretted. I froze, staring. Behind me, Kathy gave a small gasp. It was the last thing either of us had expected to encounter that afternoon.

I first laid eyes on the image in 1998, in a Christie's Old Masters catalog.[1] I vividly remember perusing the catalog at our Paris apartment in advance of the New York auction and stopping at the full-page display of the portrait. I still recall being struck by the image and feeling a sense of excitement and recognition that I couldn't quite identify. The quality of the work stood out. Because I have spent many years studying art, my eye was trained to respond instinctively to quality before my rational mind could kick in.

The portrait was a 9-by-13-inch drawing in chalk and pen and ink on vellum, mounted on an oak board. It portrayed a young woman, her face in profile, her carriage erect and still, her features delicate and lovely. Her gaze was steady and expectant, her lips parted ever so slightly. The barest hint of a blush teased her porcelain cheek. Her light brown hair was dramatically braided with ribbons and tightly bound in a ceremonial style, falling in a thick coil down her back. She wore a richly detailed costume: a green dress over a red bodice, with

a beautifully embroidered pattern at the top of the knot work. The setting and formality of the drawing suggested that it was a betrothal portrait.

The portrait was catalogued as "German, early 19th Century." I immediately questioned the annotation. I was not an art historian, but I was a collector of long experience, with a trained eye for period details. I didn't believe it was nineteenth century. I stared at the image for a long time, convinced that I was looking at either an original Renaissance period work or a forgery, but certainly not a nineteenth-century German work. That was plain wrong.

What possible reason could there be for such a blatant misattribution? I thought I understood the logic, flawed as it was. In the early nineteenth century there was a neo-Renaissance movement by a small cadre of German painters, known as Nazarenes, who longed to recapture the nobility, beauty, and spirituality of Renaissance art, which they lamented had been lost by the modern neoclassicists.[2] Modeling themselves after the pious romantics, they lived a pseudomonastic life, dressed in monks' garb, and called themselves the Brotherhood of St. Luke after a medieval painters' guild.

In 1810, four of the cadre moved to Rome, where they set up shop in an abandoned monastery. As their numbers grew, their influence spread. Artists such as Johann Friedrich Overbeck, Franz Pforr, Ludwig Vogel, and Peter von Cornelius created elaborate pieces, often duplicating the work of great Masters such as Raphael and Rubens. For example, Franz Pforr painted a variation of Raphael's *St. George and the Dragon*, and others painted *The Wedding Feast at Cana* and *Madonna and Child*, in the style of the Masters.

Eventually the group disbanded and most of the artists returned to Germany, but they made a mark on the art world that was felt for decades. Still, the Nazarene artists are practically unknown by most people today, and accounts of their era are

sketchy at best—at least in English; there are some written in German. Short of traveling to Germany, there's no way to see the Nazarene paintings. Many critics dismiss the art as plastic and fault the Nazarenes for using art to serve religious purposes, thus diluting its importance and purity. In some respects, their aims were similar to those of the current fundamentalist Christian revival, whose followers read biblical implications into every endeavor, no matter how painfully forced they seem.

Stylistically, most experts have little trouble distinguishing true Renaissance art from the nineteenth-century derivatives.

Having once lived in Munich for several years, visiting museums replete with works of the Nazarene school, I was sufficiently familiar with it to know that this portrait did not belong among its works. It was simply not in the spirit of the Nazarenes. In particular, there was no religious symbolism or pious significance to the work. To me, it was not at all reminiscent of the nineteenth-century German painters. That determination had been made by just one man, François Borne, Christie's resident expert for Old Master drawings, and to this day there has been no explanation from Borne or from Christie's of how this attribution came to be. I would love to sit across a table from Borne and hear his reasoning, but I seriously doubt that this will ever happen.

If the lady in profile was not the work of a nineteenth-century German artist, then by whose hand was it? That was less clear. Although I recognized some characteristic Leonardo touches, the "L-word" didn't even spring to my mind. First, that would have been too far-fetched. The portrait was, after all, catalogued by Christie's, one of the world's leading auction houses, and it was logical to assume that the house had done due diligence. I was ignorant of the provenance (the record of the artwork's history) and the technical examination that had surely occurred. I had a healthy respect for Christie's experts.

By the time I arrived New York for the Old Masters auction in January 1998, I had looked at the catalog image of the portrait many times. The first thing I wanted to do was see the real thing for myself. I headed over to Christie's to take a look. In the showroom, I gave it close scrutiny, and I have to say, somewhat to my surprise, it was everything I might have hoped for. On the spot I decided to place a bid for double the minimum estimate.

I didn't plan to attend the auction itself. I make it a principle not to be seen bidding in an auction room. You never know who might be inclined to bid against you, just for spite—or because they think you may know something they don't. I am more comfortable with anonymity.

Christie's auctions are the ultimate insider's game, but often Christie's makes news in the mainstream press, especially when there is something unique on the block. There is a vicarious thrill to be had by the masses—and anyone can visit the auction house and see remarkable works of art, as well as artifacts, jewelry, clothing, musical instruments, and many other items of value. The auction can spark tremendous media attention, especially when there is something awe-inspiring to be had. In 1994, Bill Gates purchased Leonardo's *Codex Leicester*—a collection of scientific notes and drawings—for more than $30 million, and to this day, when it is not being shown at exhibitions, he keeps it in his personal library at his estate near Seattle. The purchase created a huge stir.

A different 1998 Christie's auction would make big news for the $71.5 million sale of a self-portrait by Vincent van Gogh. But my focus was on the portrait of a young woman that I believed to be misattributed. It wasn't unheard of. Art authenticating is not an exact science but relies on the ability to fit together many connecting pieces. I often found that when my colleagues and I made mistakes, it was usually the result of listening too uncritically to others' opinions, reflected

in auction-catalog entries, expert treatises, and just plain hearsay in the salesrooms. I always tried to abide by the philosophy of a colleague who once advised, "Trust your eyes and not your ears."

I wish I had taken that advice in 1998. At the auction I lost my nerve, or at least my resolve. I was not feeling flush enough to punt—as they call it in the trade—for more than $17,000. The winning bidder, whose identity was unknown to me, paid the hammer price of $19,000; with Christie's commission, the total was $22,850. I lost out, but over the years I would sometimes think about the portrait and wonder if it would ever resurface. I had that gnawing, uncomfortable gut feeling that I'd mucked up big-time. My lovely lady was gone forever. Or so I thought.

Kathy had often remarked on my obsession with the portrait, pressing me to explain what it was about the one that got away that so enraptured me. I could not fully explain my feeling of being captivated, or what it was about the portrait that made it so unforgettable, except to say that it was incredibly lovely, and had immediately presented me with a mystery: when was it really drawn, and by whom? I never abandoned my initial sense that it was perhaps a true Renaissance work.

I had often imagined the exquisite piece permanently exiled to an ordinary living room wall somewhere in North America or Europe or Asia, lost forever to the world at large. Now here it was, close enough that I could reach out and touch it. It was for sale, and most amazing of all, after so many years, the label did not vary much from the original Christie's attribution, reading:

A carefully rendered study, this portrait is based on a number of paintings by Leonardo da Vinci and may have been made by a German artist studying in Italy.

I circled the table nervously, mumbling with agitation. "My God, I don't believe it. There you are, my lost lady," I whispered. "Where have you been all this time? Has Kate been keeping you in a drawer?" I felt my heart thumping in my chest, and certainly the melodrama was warranted, but I tried to slow my breathing and look calm and casual.

If anything, the portrait drew me in more fiercely than it had before. Once again, I noted that it was beyond credibility that a nineteenth-century plagiarist would be capable of such a sensitive, fully realized rendering. The young woman seemed alive and breathing, every feature perfect. Her mouth was serene, her lips gently parted with the subtlest hint of expression, but her eye in profile was radiant with emotion. The formality of the portrait could not mask her blushing youth. She was exquisite. I could easily have stood gazing at the drawing for hours, but I knew the moment required decisive action.

Leaning toward Kathy so I wouldn't be heard, I said quietly, "I missed it the first time—not again."

I glanced over to where Kate Ganz was chatting with a customer. I knew I must not appear to be too excited or she'd guess I was onto something. Finally, I murmured, "Here goes," to Kathy and beckoned the dealer over.

Ganz is an attractive woman in her early sixties, with a dynamic personality and a sharp edge that could sometimes make her seem insensitive and caustic. She is one of half a dozen highly respected dealers of works on paper. She also has an impressive professional pedigree. Her parents, Victor and Sally Ganz, were acclaimed collectors of twentieth-century art, and her father was a vice president and trustee of the Whitney Museum.

I guessed that she must have shown the drawing to some of her contacts, which included top curators and others in the museum world. It's what I would have done. It's what any

collector or dealer would have done. Apparently, none of them gave it a second glance. I thought about it and found it not so surprising. I had often seen a similar dynamic in evaluating art. The eye of the beholder could be clouded by the conventional wisdom about an artist's modus operandi, the norms of an era, and the collective opinions of experts. In this case I suspected their eyes had betrayed them.

Kate came over to where we were standing. "Peter, Kathy," she greeted us coolly, kissing our cheeks. We chatted politely for a few minutes about our lives—Kate had recently remarried and now lived primarily in Los Angeles—and finally I asked, "Kate, how much for this portrait?"

Kate consulted a price list and named a figure nearly identical to what she'd paid at Christie's in 1998.

I frowned deliberately, still contemplating the work. I rocked back and forth on my heels, mimicking indecision. "I don't know," I said carefully. I felt a moment of trepidation, fearing that accepting Kate's price without haggling would make her suspicious. "Can you give me a discount?" I asked, worrying that I was already showing too much interest. Kate might see through me. After all, we'd known each other for nearly thirty years. But she wanted to sell the portrait, and after a bit of discussion, she finally agreed to 10 percent off the listed price, for a total of $19,000.

It was customary to let collectors with long-standing reputations walk away with their purchases before paying, and I fully expected Kate to say, "Take it now and send me the money."

But in spite of having known me for so long, she suddenly became brusquely businesslike. "You know, I can't let you have it until you pay me," she said, surprising me. Maybe that was her way, or maybe she was already hedging, deliberately placing obstacles in my path because something was telling her not to sell.

I felt a small clutch of panic. This was a crucial moment, and so much could go wrong. "Fine," I said to Kate. "I am making the purchase on behalf of a wealthy collector, and I'm sure the arrangements will be no problem." Kate walked away, and I pulled Kathy aside. "We have to have the money wired immediately," I said urgently. "If I don't seal the deal today, anything could happen. Another collector might express interest. Kate might get suspicious and call off the sale. I can't walk out of here without the portrait."

It was agreed that Kathy would leave to make arrangements for the payment while I hung around the gallery, nibbling on bits of cheese, sipping wine, and trying not to look too obvious. I spent a terrifying hour that way, never straying far from the table that held my prize. Every time a visitor paused to look at the portrait, my stomach lurched.

Finally, Kathy returned, having successfully managed the transaction.

By the time we left the gallery with the wrapped portrait, we were feeling giddy from the adventure. "That drawing had your name on it, Peter!" Kathy exclaimed. We laughed excitedly, hardly noticing the cold.

I held the painting to my chest and quickened my pace, searching for a taxi. We were staying with a friend—a former model I'd met during my early years at the Hotel Stella in Paris—only a few blocks away, but I did not want to spend a single unnecessary minute on the street. I felt very nervous and very vulnerable, as though I were holding a treasure.

On the flight back to Europe the following evening, I calculated my next moves. I was a bit agitated, but I kept reminding myself that it was a work of art, not the crown jewels. Mostly I was anticipating the revelations that lay ahead, whatever they might be. I enjoyed this kind of research, for there was always a one-in-a-million chance that something magnificent would be revealed.

• • •

I have always thought that there is more than a little madness in the soul of a collector. Collecting is about passion, money, ego, and being the best. It does not take place solely in the hallowed corridors of galleries and auction houses but also, literally, on the street, and it involves trolling the back alleys— street markets, private dealers, small galleries—as well as the front lines, seeing not only with the eye but also with the heart and the soul. I have tried to understand each work of art from within, without allowing greed to undermine my judgment. This instinct was developed over many years in the field.

However, I also knew that a serious collector must not be afraid to stray from consensus and be independent, original, and hungry for finds. Miracles do happen! One must follow one's own instincts. For me, the hunt was the thing, and I enjoyed taking it off the beaten path. I often rose before dawn on Fridays to attend "dealer's day" at Porte de Clignancourt, the largest and most famous flea market in Paris. Its origins date back two centuries to when poverty-stricken men and women would search Paris refuse at night and sell their small discoveries at market the next day.

In modern times, Porte de Clignancourt had become a huge venue for art sales. On Fridays, hundreds of dealers who had combed country auctions, Paris consignment shops, and private collections brought their findings. For small dealers, turnover is the name of the game, and at Porte de Clignancourt they hoped to quickly buy, sell, and buy again, with a quick and decent profit in between, if possible. There were pitfalls, of course: the fakes, the stolen items, and the works that looked good at first glance but turned out to be third-rate imitations.

The flea market opened at 6 a.m., and it was often still dark when I arrived. I carried a flashlight and tried to concentrate and focus through sleepy eyes. The early hour, the coldness

of my feet, or any other discomfort did not deter me. I was immersed in the hunt, intoxicated by the sheer possibility of it. In the back of every collector's mind is always the hope of stumbling upon a great discovery. Whispered stories filled the early morning air and became elevated to folklore among the collectors digging for buried treasure in the dawn's early light.

There was the tale of the filthy picture, found in rubble, black with soot and years of grime, purchased on a whim for $10,000, which when cleaned was revealed to be a Brueghel worth $1 million; or the equestrian bronze, purchased for $5,000 and thought to be nineteenth century, which was actually by Antico, one of the masters of the Renaissance, and was later sold to an American museum in excess of $5 million. There was the little sketchbook of one hundred drawings brought to a dealer who didn't know what they were; he paid a few thousand dollars, sold them for triple the price, and thought he'd made a great bargain. Then the dealer who subsequently bought the drawings recognized the hand of the great fifteenth-century Venetian painter Vittore Carpaccio, and the sketches were ultimately valued at nearly $10 million. The lesson: never be complacent, never assume, always be on your toes. I lived and breathed hope.

After spending four hours at the flea market, I usually headed off to the Paris auction rooms to view the upcoming sales. Almost every day there were at least a dozen different salesrooms filled with new works, often from private homes where the owners had died, had moved away, or needed quick cash. I understood that searching for treasures in these secondary venues was a long-shot venture.

However, the formal auctions did not normally yield too much, either. Most of the catalog works had been studied and pawed over by countless experts before they ever made it to a show. And even though the experts seldom made mistakes, there was always that one-in-a-million miss—like

the discovery of a Frans Hals portrait, originally estimated at $30,000, purchased by a smart French dealer for more than $500,000 and resold less than two years later at a major London auction house for close to £10 million; or the very large painting of a biblical battle scene, miscatalogued as a relatively minor Roman painter by a London auction house, that was later proved to be a major early work of the great seventeenth-century French Master Nicolas Poussin and was subsequently sold to the Jerusalem Museum for more than £7 million. There was, I knew, always that chance.

2

Who Is She?

The noblest pleasure is the joy of
understanding.

—*Leonardo da Vinci*

Soon after Kathy and I returned to Paris with our prize, we
were fortunate to have a houseguest who could shed some
light on the portrait. At eighty-two, Mina Gregori was con-
sidered the doyenne of art history, the unrivaled expert on
Caravaggio as well as on the Florentine. She had been a pro-
fessor of medieval and modern art history at the University of
Florence for more than fifty years, had written several books,
and counted among her students many of the leading art
historians.

We had become close friends with Mina over the years,
and she frequently stayed with us when she visited Paris. Mina
was a sharp-witted, keen-eyed bundle of energy, and we often

laughed about how she ran circles around us at expos and fairs, never seeming to tire.

In early March, Mina visited us while she was in Paris, accompanied by Catherine Goguel, a mutual friend and a Louvre drawing specialist. The occasion was a birthday fete in Mina's honor. With trepidation, I showed them the portrait and watched closely as they studied it, murmuring softly, their faces showing keen interest but no emotion.

"It's of extraordinary quality," Mina said finally, and Catherine nodded in agreement, adding, "I believe it is fifteenth century."

"You can clear that up by having it carbon-dated, and also by having a good restorer look at it," Mina proposed. "If you like, there are clues to authorship."

"Please go on," I said eagerly.

"It appears to be by a left-handed artist," Catherine said significantly. Mina then pointed out a detail that only a person with her flawless eye and expertise would have noted. "This drawing shows dual influences: Florentine in its delicate beauty and Lombard in the costume and braid, or *coazzone*, which were typical of a court lady of the late fifteenth century," she said. "Of course, the most obvious artist to come to mind is Leonardo, one of the few artists who made the transition from Florentine to Milanese. I would start with his circle."

Inspired by Mina's enthusiasm, I began a lengthy investigation. Always in the back of my mind was the faint hope that I had achieved the dream of every collector: to bring to the world a previously undiscovered Master work. I also had the portrait reviewed by Caroline Corrigan, a highly respected restorer for museums and dealers. After examining the work under a microscope, she concluded it was fifteenth century, noting that it had been very well restored, including recently. "I wouldn't touch it further," she advised.[1]

For a year, I carefully conducted my study, taking little definitive action. The portrait sat in a place of honor in our

living room and gave Kathy and me much pleasure, which of course is what art is supposed to do.

I showed photo transparencies to a number of people I respected, operating on my belief that the portrait was from the fifteenth century, not the nineteenth. The Leonardo influence was unmistakable, and I considered that it might be the work of a student. I began to do serious research on artists, including Leonardo's disciples in Florence and Milan during the late fifteenth century. I also considered that it might be Florentine, perhaps by Domenico Ghirlandaio, who had been in the same workshop as Leonardo.

The great artists of the Renaissance were noted for their workshops of talented apprentices and pupils. Art history is full of speculation about the role of student hands in the signature works of the Masters. Leonardo himself began at the age of fourteen as an apprentice to Verrocchio.

Master or pupil? That is often the question when studying Renaissance works. For example, a centuries-long controversy has raged among art scholars regarding a collection of drawings from a Rembrandt workshop. The question: Are the drawings Rembrandt's own, or are they those of his pupils? To this day, there is no definitive answer, although an impressive show at the J. Paul Getty Museum in February 2010, titled "Drawings by Rembrandt and His Pupils: Telling the Difference," drew convincing conclusions about a small collection by detailing the distinctive elements that might or might not be attributed to Rembrandt himself.

Similarly, there is some debate about whether some of Leonardo's Milanese students authored or contributed to Leonardo-attributed works. However, for the most part, it is clear: the Master has a hand, and very seldom can a student match it—unless, of course, the student has a rare hand of his own, as was the case with Leonardo.

Kathy and I talked about it endlessly. As the months passed, I immersed myself in study. I was in no hurry. It was a reward in itself to study and speculate.

In January 2008, while we were in New York for the auctions, we ran into Kate Ganz at an art opening. "Did you ever find out who did that drawing?" she asked.

"Obviously, Leonardo," I replied, flashing a big smile. We shared a laugh at the absurdity of the notion.

"Dream on," Kate said, waving a dismissive hand. As she walked away, I squeezed Kathy's arm. "Dream on," I repeated. "That's what we're doing." But I suddenly had a more sobering thought: I should be careful about throwing around big names, because a great find could so easily be revealed as a dud.

On a cold afternoon in February, shortly after returning from New York, I found myself standing in the Italian picture gallery of the Louvre, studying a portrait by Boltraffio, who was considered to be Leonardo's most gifted disciple. I was pondering whether this artist, or any other artist in Leonardo's circle, could have executed the mysterious lady on vellum. As I stood there, a voice behind me spoke my name.

"Peter, is that you?"

I turned to see Nicholas Turner lumbering toward me. Turner, portly, distinguished, and serious, was the former curator of drawings at the British Museum and a world-renowned expert on Italian Old Master drawings. Turner's encyclopedic knowledge and expert eye gained him wide respect in the incestuous little world of Old Master drawings.

After exchanging greetings and chatting for a bit, we stood companionably, looking at the painting. Boltraffio's skill was undeniable. Finally, with a bit of hesitation in my voice, I said, "I have something that I believe is more important than Boltraffio."

Turner looked at me curiously. "Oh?"

I pulled out my digital camera, scrolled to a photo of the portrait, and handed it to Turner. I was astonished when he immediately said, "I saw a transparency of this not long ago, but I didn't realize that you were now the keeper of the remarkable work." I hadn't expected that reaction! He explained that he had missed the 1998 sale in New York but had been contacted in the autumn of 2007 by a London dealer. "He showed me a good color transparency and asked my opinion. He was working on behalf of a colleague who had an interested purchaser."

"I have been trying to determine if it is the work of one of Leonardo's disciples," I said, gesturing to the Boltraffio portrait.

"No, it is not a student's work," Turner said with conviction.

"Oh," I said, deflated. "But how do you know?"

"Well," he said carefully, "apart from the work's very high quality, what immediately struck me—even from the transparency—was the extensive left-handed parallel hatching. See here." He pointed, and I strained to see what he meant on the small transparency. "It is most conspicuous in the background, behind the girl's profile." He looked up from the photo and smiled at me. "As you know, the most famous left-handed Renaissance artist was Leonardo da Vinci," he said. "And none of his students were left-handed."

I suddenly remembered Mina and Catherine's remarks, which hadn't fully struck me at the time. However, the left-handed shading was a critical point. Experts agree that whereas it is possible to copy some aspects of a Master's style, it is not possible to duplicate left-handedness. Although the three greatest artists of the Italian Renaissance—Leonardo, Michelangelo, and Raphael—were all left-handed (a remarkable fact!), extensive research has failed to locate a single left-handed Leonardo follower.

"What are you saying?" I was stunned.

"I am not a Leonardo specialist," Turner said, "but I think you can't rule out the possibility of Leonardo's authorship."

He smiled wryly. "That's what I told my London colleague when I first saw it, but he did not believe me, and he never pursued it. More the pity." He suggested that I show it to as many Leonardo specialists as possible and also undertake a thorough technical examination.

That night, I went home to our apartment, which overlooks that most Parisian of monuments, the Eiffel Tower. I poured two glasses of wine, and handing Kathy one, I said, "I ran into Nicholas Turner at the Louvre today. It turns out that someone sent him a transparency of the portrait without our knowing it."

"What did he think?" Kathy asked.

I paused, relishing the moment. Then, taking the glass from Kathy's hand—for fear she'd drop it—I said, "He thinks it may be by Leonardo himself."

Some months after our meeting in the Louvre, I invited Turner to see the portrait for himself. He was enthralled. "It fully lives up to my expectations," he said enthusiastically, adding that he was struck by its great beauty and refinement. He promised to give me an official report soon.

Mina was visiting Paris at that time. I asked her to look at the portrait again, telling her, "Mina, people are saying it could be a Leonardo. Please sit and study it carefully and give me your honest opinion."

She sat down at a table and took the portrait in her hands. Her examination followed the traditional approach of the connoisseur. She believed that the best way to approach the study of a new work was to set aside technology in favor of the trained eye. Technology could come later. This was her favorite part of the process, when she could empty her mind and immerse herself fully in a work, which might turn out to be by the hand of a major artist.

Mina would subsequently describe her method in a published article.[2] She wrote, "My examination was exclusively visual, and was carried out by carefully scrutinizing the work's surface, following the traditional approach of the connoisseur—an approach that is today too readily disregarded, especially by universities, or at best not adequately appreciated by them. For centuries connoisseurship has enabled an expert to formulate opinions, sometimes very rapidly. These opinions, which are the consequence of visual and mental associations, are sometimes confused [with] intuition, which they are not, since opinions are based solely on previous experience[,] and this important point should be remembered."

As Mina studied the portrait, the first question that came to mind concerned its date of execution and the age of the vellum. "The subtle darkening of the support and its natural wear over time led me to believe that it was indeed late fifteenth century," she explained in her article. "I could therefore go a step further, but in the full knowledge that the authenticity alone of the vellum support was not in itself a guarantee that the portrait drawn on its surface would be genuine, since we all know that the wiliest of fakers have successfully used old supports, or ones that have been cleverly aged by artificial means."

As Mina gazed at the face of the sitter, she felt a strong sensation of being in the presence of a living person. She took note of many instances of a high level of execution. These were convincing details, but it was the advanced level of artistry that really compelled her:

As always happens, I first devoted my attention to the face: from this I gained the feeling of being in front of a living being whose beauty suggested an Antique profile. This ancient classical portrait type was the source of inspiration for this head, which was a form that was so successfully revived by the painters and sculptors of the Florentine Quattrocento.

A dating of the portrait to the last decade of the fifteenth century is confirmed by the young woman's ornate costume and her coiffure, with her hair gathered together behind her head in a thick plait, called a "coazzone," an unusual and locally specific fashion which places the portrait's production in Lombardy at a time when Leonardo was in the service of Ludovico il Moro. In both date and cultural context, it therefore differs markedly from portraits by Leonardo's Lombard followers. Indeed, in my view, exact parallels in the brightness and transparency of the girl's eye are only to be found in other examples in the drawings of Leonardo.

After having directed my attention to the linear development of the portrait, I took note of the execution of the fine hair at the top of the girl's head, which is the best preserved area of her elaborate tresses. Of the same high level of execution is the subtle colouring in the un-retouched areas of the cheek, where the tonal gradations are almost imperceptible. This inimitable delicacy made me think of this same famous characteristic found in the face of the *Mona Lisa*.

Mina remained bent over the portrait for a very long time. Finally, she called me to her side. "Yes," she said. "It is Leonardo. Allow me to be the first to say so formally." I handed her a black-and-white photo, and she wrote the attribution on the back. I still have it.

She concluded in her article that "what most readily evokes this portrait is the utter simplicity of its structure, and yet at the same time the young woman's imperious air. But the whole work is also enriched by the artist's unshakeable intention to be governed solely by natural appearances, an ambitious motivation that can only be realized by a great master. And that master is Leonardo."

3

Leonardo's World

We, by our arts, may be called the
grandsons of God.

—*Leonardo da Vinci*

Five hundred years after his death, Leonardo da Vinci continues to intrigue us. He is the most famous and revered artist of all time. Leonardo was a prolific artist, yet he left fewer than twenty paintings—the most famous being *The Last Supper* and *Mona Lisa*. He was the ultimate Renaissance man: an artist, a scientist, a designer, and an inventor whose imagination and scientific prowess were centuries ahead of his time. Artists, designers, and engineers still study the meticulous drawings in Leonardo's notebooks for their innovative technique and anatomical precision.

As I contemplated the possibility that I was holding in my hands the product of Leonardo's work, my thoughts were

consumed with images of the artist's remarkable journey. Thanks to the Renaissance biographer Giorgio Vasari, we have some insight into Leonardo's life. From a very young age, he was something special.

Physically, Leonardo was a beautiful child, tall and sturdy, with curling hair that made him seem angelic. He had been born out of wedlock to his father Ser Piero's mistress, Caterina, who soon left the picture. However, being a motherless child did not seem to hold Leonardo back. This was largely because of the great love and admiration of Ser Piero, and also because of Leonardo's unearthly genius. He was gifted in a way that produced both pride and worry in his father, who wondered what would become of him.

This dreamy, brilliant, sunny boy could not seem to settle down to any single pursuit. He picked up an interest—mathematics, the flute, clay modeling—only to put it down and start on another. The detritus of partly completed projects was scattered around the property. Beneath the whimsy of Leonardo's varied exploits, Ser Piero could see that his son's talent for drawing and modeling was quite exceptional, especially given his age of fourteen. But he needed a guiding hand, and although his father, a notary, could provide him with a stable home, he could not help him on that journey.

One day, while gazing at the lovely artistry of a series of Leonardo's drawings, Ser Piero decided to seek the opinion of his close friend Andrea del Verrocchio, an artist and a sculptor who oversaw the best workshop in Florence. Membership in it was greatly coveted. Handing Andrea Leonardo's drawings, Ser Piero asked him, "Do you think if he gave himself entirely to drawing he would succeed?"

Andrea studied the drawings with a growing sense of astonishment. A mere child of fourteen had mastered form and face with a maturity and skill that Andrea had never seen. Who was this boy? On the question of his future, Andrea

had no doubt. He agreed to make a place for Leonardo in his workshop.

Leonardo's father was ebullient and relieved. He felt sure his boy's talent would be safely nurtured under Andrea's tutelage. Leonardo was also quite eager to go. He was glad to be immersed in art and design at every level.

Leonardo thrived in Andrea's workshop, and he would ultimately spend ten years in its comfortable creative embrace. He was not in a hurry to strike out on his own, and his father did not pressure him. In spite of his son's clear genius, Ser Piero believed that his distracted manner and instability made him a poor candidate for independent work.

There were plenty of opportunities to be had in the workshop, however. The first significant one was a painting of the baptism of Christ by St. John. Andrea gave Leonardo the task of painting one of two angels holding Christ's robe. Although Leonardo was quite young, he managed it so well that his angel was better than Andrea's figures. When Andrea saw Leonardo's angel, he could not contain his feelings of anger. How could this mere apprentice outshine him? It was reported that he petulantly vowed to never touch a brush again after being outshone by his pupil. (*The Baptism of Christ* is currently in the Uffizi Gallery in Florence. Leonardo's angel is the one on the left.)

Leonardo was something of a loner among his peers. He would later write:

The painter or draughtsman must remain solitary, and particularly when intent on those studies and reflections which will constantly rise up before his eye, giving materials to be well stored in the memory. While you are alone you are entirely your own [master] and if you have one companion you are but half your own, and the less so in proportion to the indiscretion of his

behavior. And if you have many companions you will fall deeper into the same trouble. If you should say: "I will go my own way and withdraw apart, the better to study the forms of natural objects," I tell you, you will not be able to help often listening to their chatter. And so, since one cannot serve two masters, you will badly fill the part of a companion, and carry out your studies of art even worse. And if you say: "I will withdraw so far that their words cannot reach me and they cannot disturb me," I can tell you that you will be thought mad. But, you see, you will at any rate be alone. And if you must have companionship, find it in your studio. This may assist you to have the advantages, which arise from various speculations. All other company may be highly mischievous.[1]

According to Vasari, while Leonardo was at work one day, his father brought him a round piece of wood. He had been asked by a friend in the country to have something painted on it, perhaps to be used as a shield, and Ser Piero thought Leonardo might take on the task. Leonardo, finding the wood crooked and rough, straightened it by means of fire and then smoothed its rough surface. Having prepared it for painting this way, he began to think what he could paint on it.

He wanted to create the most dramatic and frightening image, so he considered the effect of a Medusa-like head. For models for the image, he brought into his private room lizards, grasshoppers, serpents, butterflies, locusts, bats, and other strange animals, and from them he produced a great animal image so horrible and fearful that it seemed to poison the air with its fiery breath. He portrayed it coming out of some dark broken rocks, with venom issuing from its open jaws, fire from its eyes, and smoke from its nostrils—a monstrous and horrible thing, indeed. He was so engrossed in his work that

he didn't even notice the terrible smell emanating from the rotting carcasses of his animal models.

Finally he was finished, and he sent word to his father that he could come and get it. Ser Piero arrived early one morning at Leonardo's room; when he knocked, Leonardo told him to wait a moment, and he staged the scene—placing the picture in the light and darkening the window around it to create an ominous effect. Ser Piero stepped into the room, saw the image, and turned to run, not realizing that the terrible creature was painted and not real. Leonardo called after his father and brought him back, saying, "That was exactly the effect I was trying to create."[2] He was quite pleased with himself that the painting was realistic enough to scare his father.

The thing seemed marvelous to Ser Piero, and he praised Leonardo's whimsical idea, but he didn't want to give it to his friend, so he secretly bought another circular piece of wood, already painted with a heart pierced with a dart, and gave it to the friend in the country, who remained grateful to him as long as he lived. Ser Piero sold Leonardo's work to some merchants in Florence for a hundred ducats, and it soon came into the hands of the Duke of Milan, who bought it from the merchants for three hundred ducats—both considerable sums at that time.

Even when Leonardo was a young man, his genius was well understood—and it didn't hurt that he was also quite charming and agreeable. Many fell under his spell, only to learn that his work ethic was as ethereal as the wind. It was said that he was a procrastinator, but it was probably more true that he was a perfectionist and a generalist, easily distracted by his many different interests. For the young Leonardo, daydreams were not wasteful drifts, they were exercises for the imagination and interior building blocks for his work. One of his patrons once grumbled that he spent more time thinking than doing, and when he finally got going, the road to completion was a virtual obstacle course.

Leonardo soon gained a reputation for leaving work unfinished. (As Vasari lamented in a rare criticism, "In erudition and letters he would have distinguished himself, if he had not been variable and unstable. For he set himself to learn many things, and when he had begun them gave them up."[3] A lesser talent would have been ruined by the flightiness, but to this day Leonardo's unfinished works are counted as some of his greatest.

One of these, *Adoration of the Magi*, was a commission in 1481 by the Augustinian monks of San Donato a Scopeto in Florence, which he received thanks to his father's influence.[4] The job was to create a large altarpiece, measuring 9 by 8 feet, depicting the adoration of baby Jesus by the three magi. Leonardo was given thirty months to complete the complex task, and he spent nearly a year sketching out the plans. Even in the sketches it was plain to see that Leonardo's vision was very different from that of others who had portrayed the scene. His view was more humanistic, emotional, and egalitarian, with many figures whose expressions were vivid and dramatic. Instead of narrowing his focus to the magi or the Holy Family, he explored all of the action going on around them.

While Leonardo was working on *Adoration of the Magi*, he was sidetracked by a request from Lorenzo de' Medici, the ruler of Florence, that he go on a diplomatic mission to the court of the Duke of Milan, Ludovico il Moro Sforza. It seems that Leonardo had learned to play the lyre as a child, and in early adulthood he had created a marvelous silver lyre, shaped like a horse's head, that had a beautiful resonance when played. When de' Medici saw the lyre, probably through Leonardo's father, whom he knew, he decided that it would make the perfect gift for the duke—especially if Leonardo would play it for him.

So Leonardo left for Milan, and his performance so far surpassed the performances of the Milanese court musicians

that the duke was charmed and intrigued. His eye turned with great interest on the fascinating young man with so many talents in plain evidence. Leonardo obviously felt similarly intrigued, for shortly after this event he sent Ludovico il Moro Sforza the following letter—arguably the most famous job application in history:

> Most Illustrious Lord: Having now sufficiently seen and considered the proofs of all those who count themselves masters and inventors in the instruments of war, and finding that their invention and use does not differ in any respect from those in common practice, I am emboldened . . . to put myself in communication with your Excellency, in order to acquaint you with my secrets. I can construct bridges which are very light and strong and very portable with which to pursue and defeat an enemy. . . . I can also make a kind of cannon, which is light and easy of transport, with which to hurl small stones like hail. . . . I can noiselessly construct to any prescribed point subterranean passages— either straight or winding—passing if necessary under trenches or a river. . . . I can make armored wagons carrying artillery, which can break through the most serried ranks of the enemy. In time of peace, I believe I can give you as complete satisfaction as anyone else in the construction of buildings, both public and private, and in conducting water from one place to another. I can execute sculpture in bronze, marble, or clay. Also, in painting, I can do as much as anyone, whoever he may be. If any of the aforesaid things should seem impossible or impractical to anyone, I offer myself as ready to make a trial of them in your park or in whatever place shall please your Excellency, to whom I commend myself with all possible humility.[5]

How to explain Leonardo's interest in being on hire to the court? A man of his extreme talent could have had as many independent commissions as he chose. Perhaps he was aware of his own failings, his tendency to lose heart in the midst of a job, his need for structure and discipline. Perhaps, too, he required the regular reinforcement and support of his superiors, for he struggled with self-esteem and often questioned his own abilities. On a practical level, he was constantly worrying about money, and the Court of Milan probably seemed like a guarantee of job security.

His letter was obviously an effective résumé, for the duke brought Leonardo to his court, where he remained for seventeen years. He was a young man of thirty when he accepted the position of painter and engineer of the duke.

It was a wonderful era in Milan, a golden age of art and science. The duke, a benevolent dictator with a love of the arts and a fascination with urban modernization, was happy to attract the great master painters, poets, and engineers to his city.

Sforza's court, at the massive Castello Sforzesco, was renowned for its spectacular pageants and festivities celebrating marriages and births; court poets recorded flowery verses, and Leonardo himself was involved in executing elaborate stage designs for theatrical productions at the court. Pomp, circumstance, and glitter reigned at the court, evidenced by the elaborate gold embroidery on the gowns of the highest court ladies. One cannot emphasize enough the beauty and splendor of the court during Ludovico's reign. The company that gathered in the Castello of Milan seemed, according to the chronicles of the writer Baldassare Castiglione, "the flower of the human race."[6]

The enormous prosperity was reflected in the lifestyle of Milan's citizens, who lived chiefly by trade and manufacturing,

and all benefited from the fertility of the soil. Two main industries formed the basis of Milan's success as a manufacturing center: Milanese armor and the woolen industry (which included silk weaving, embroidery, and gold and silver cloth). This created a merchant class, which bought up all the wares and then sold them to the consumer. Trade generated great wealth for the top echelons of society, and they lived in noble houses—if they were not quite royalty, they were the closest thing to it. The aristocracy of Milan was based on wealth, not birth.

It was a rich intellectual culture for Leonardo. The Court of Milan became a sort of academy, which united writers, poets, mathematicians, scientists, and philosophers. Illustrious scholars from throughout Italy gathered there.

Visitors to Milan were impressed by the splendor of the ladies' dresses, often made entirely of cloth of gold, adorned with rich embroidery and laden with jewels. Technically, there were laws governing rank, which determined manner of dress, but it seems that these prohibitions were rarely enforced, because to have done so would have destroyed an important Milanese trade. Luxury was encouraged in the interest of a strong trading community.

Outside the court, the citizenry lived a frugal existence, but for the privileged class, luxury was on the increase throughout the Sforza period. Note, for example, the splendor that marked the birth of Duchess Beatrice d'Este's firstborn child in 1493: a gilded cradle, a rich brocaded quilt, and a grand show of gifts.

Society modeled itself on the court, because the two were tightly connected. Unlike the city of Florence, which at this time had experienced a religious revival, Milan tended to emphasize the material side of life through outward magnificence and commercial interest. Piety manifested itself less in devotional fervor than in such practical works as building

hospitals and founding schools. And always there were the lavish pageants, which drew visitors from across the country.

This was the universe Leonardo stepped into when he arrived in Milan to offer his skills as a painter, an inventor, an engineer, and a sculptor to the duke. Leonardo adapted well to the Milanese court. It was there that he was able to let his imagination and skills fully develop. It was there too that he developed his full appreciation of art—things observed—and of the artist as the greatest communicator. "If you, historians, or poets, or mathematicians, had not seen things with your eyes, you could not report of them in writing," he wrote sensibly, continuing:

> If you, O poet, tell a story with your pen, the painter with his brush can tell it more easily, with simpler completeness and less tedious to be understood. And if you call painting dumb poetry, the painter may call poetry blind painting. Now which is the worse defect? To be blind or dumb? Though the poet is as free as the painter in the invention of his fictions, they are not so satisfactory to men as paintings; for, though poetry is able to describe forms, actions, and places in words, the painter deals with the actual similitude of the forms, in order to represent them.[7]

Leonardo's contribution to the court was eclectic and exciting. His schemes for civic engineering were far ahead of his time, and so were his plans for war machines. He designed sets and costumes for many festivals and plays. Among his most ambitious projects was the creation of a massive equestrian monument in honor of Francesco Sforza, the founding father of the Sforza dynasty.[8] Over a period of ten years he constructed the model in clay, but, sad to say, before it could be cast in bronze, the French invaded Milan and destroyed it.

Occasionally, at the request of his benefactor the duke, Leonardo set aside his drawings and his building and spent his afternoons with a favored court lady, bringing life to her features with his pens, paints, and chalks. Although other artists could have handled the task quite competently, Sforza had confided that he trusted only Leonardo to capture the countenances of his beloved ones. Sometimes Sforza would stand in the doorway, smiling his encouragement to the young lady, for whom the sitting required great poise. Indeed, in the finished works, sitters seemed to be turning their gazes upon another person, and the result was a softening of their features so unlike the expressions in the stiff formal portraits that were common at the time. This, then, was Leonardo's signature—the animating quality that would allow these special ladies to stand apart even centuries later.

4

Real or Fake?

The truth of things is the chief nutriment
of superior intellects.

—*Leonardo da Vinci*

Before my fateful encounter with Nicholas Turner at the Louvre, I had been reluctant to pursue the possibility that I held the work of a Master—indeed, *the* Master. I knew how tongues would wag. Every so often someone popped up with a claim of holding a lost Leonardo, a lost Michelangelo, or a lost Pollock, but these claims were invariably disproved. It was almost unheard of for a new work to appear out of nowhere, especially a work by one of the Renaissance Masters. Despite the common myth that these treasures were out there in abundance, buried in people's attics waiting to be discovered, it was more a romantic notion than a reality.

In his 1996 book, *False Impressions: The Hunt for Big-Time Art Fakes*, Thomas Hoving, a former director of the Metropolitan Museum of Art (and recently deceased at the age of seventy-eight), wrote that we live in a time when there are so many art fakes that he almost believed that there are "as many bogus works as genuine ones." I'm not sure I'd go that far. Hoving also pointed out, "Art forgery is as old as mankind."[1] And the art forger, by nature, must be as passionate about art and often as gifted as the genuine artist.

According to Hoving, every art historian abides by some basic tenets when determining if a work is a forgery:

- The forger will always betray himself by some silly personal mannerism of style.
- A fake will always lack freedom of execution and originality.
- The phony is always lower in quality than the original.
- Where gut reaction and intense scrutiny by the naked eye fails to detect a fake, "science"—the computer, the laser—will always unmask the bogus.
- Fakes eventually reveal the taste of the time in which they are created and never stand up more than a generation or so before they crash.[2]

This seems to be a rather narrowly constructed list—optimistic even about the historian's ability to scout out the inferiority of a forgery. History shows that fakes do not always reveal themselves so plainly. But I also find Hoving's tenets interesting in light of his assertions (described later) that our portrait is not the real thing.

Hans van Meegeren is the most notorious forger of the last century, and his case is a cautionary tale for all who place their trust in the arbiters of artistic greatness. Van Meegeren's brilliant forgeries were at the center of a notorious 1940s scandal

that rocked the art establishment. Van Meegeren was an artist and a picture restorer who considered himself an unheralded genius and who took advantage of the fact that Jan Vermeer, a real genius of intimist interiors in seventeenth-century Holland, was reemerging three centuries after his death as one of the greatest Masters of the Golden Age of Dutch Painting.

Vermeer's style was still a subject of speculation, with attributions not yet totally cemented, since almost none of his paintings were signed. Van Meegeren created a few pictures in what he considered Vermeer's style and technique, mixing his colors and using some pigments that existed in the seventeenth century. One of his forgeries, *Christ and His Disciples at Emmaus*, was bought in 1937 by the Dutch Rembrandt Society for about $4.7 million in today's dollars and donated to the Museum Boijmans Van Beuningen in Rotterdam. The painting was loudly acclaimed by the scholarly powers of the time as a long-lost painting by Vermeer, whose known production did not exceed thirty-five works. The excitement generated by this new "discovery" among members of the art establishment was so great that the director of the State Museum himself contributed personal money to purchase it for his institution.

There the story took a shocking turn. After World War II it was learned that the Rotterdam painting was not by Vermeer but by the forger van Meegeren. In a dramatic twist, the revelation was made by the forger himself under some obvious duress, because he was about to be indicted by the Dutch government for collaborating with the Nazis during the war. The charge: he had sold Dutch patrimony—*Christ and His Disciples at Emmaus*, the alleged Vermeer—to the notorious Nazi art lover Hermann Goering. Revealing the secret of the forgery was the only way to exonerate himself! So, before the tribunal and to the incredulity of scholars and the world press, van Meegeren showed how he painted his "Vermeers,"

including *Christ and His Disciples at Emmaus.* Van Meegeren was sentenced to a year in prison but died six weeks after he was sentenced. He is still cited as an enduring reminder of how art connoisseurship can sometimes go dreadfully wrong.

How did van Meegeren succeed in fooling so many learned and competent individuals? The painting had even passed the test of the museum restorer's examination. Van Meegeren had developed an ingenious technique for aging the canvas, including damaging parts of it and then restoring those areas in order to give the picture an aged appearance. He was even adept in creating a network of fine cracks in the painting surface (*craquelure*) so that to the naked eye the picture would appear to meet one of the criteria one looks for in a seventeenth-century work. The eye of the beholder, alas, was completely fooled by the overall effect created by an artist who chose to use his uncanny talent for hoodwinking the powers that be.

I must say, however, that standing in front of that picture, and benefiting from today's vastly greater understanding of Vermeer's style as well as having viewed nearly every painting he ever painted, I thought the van Meegeren creation wasn't that convincing from an aesthetic viewpoint. The facial types and the lighting effect do not correspond to what we know about Vermeer today. Today's connoisseur would no doubt dismiss it outright, and a scientific examination would further confirm that it was a forgery. In fairness to the experts of that time, it is necessary to acknowledge that today we have so much more scholarly knowledge about artists and their techniques at our disposal, and a lot of this information is the result of scientific technology that has exploded in the last few decades.

Another fascinating story about the potential for forgery involves none other than the *Mona Lisa* itself.[3] On August 21, 1911, the *Mona Lisa* was stolen from the Louvre early in the

morning. Rather bizarre is that when the guards noticed that the painting was missing, they assumed it had been taken to be photographed, and an entire day passed before the theft came to light. The *Mona Lisa* would remain at large for more than two years. In the process of a worldwide investigation, hundreds of people were questioned, including Pablo Picasso. Picasso was wrongly implicated because he had once purchased two stone sculptures that were later found to be stolen from the Louvre, and he had returned them.

For twenty-seven months, the investigators scoured the world looking for the lost treasure, only to learn that the *Mona Lisa* had been in Paris and Florence all along. Vincenzo Peruggia, an Italian carpenter who had once worked at the Louvre and had helped to build the glass case for the *Mona Lisa*, was found to be the culprit. Peruggia was discovered trying to sell the painting to the Uffizi Gallery in Florence for 500,000 lira (about $100,000). When the museum reported him to the police, he was caught in the act.

In spite of seeking a large sum of money, Peruggia claimed his motivation was purely patriotic. "I am an Italian patriot [who] was seized by the desire to return to my Italy one of the treasures that Napoleon stole from her," he said.[4] The recovered painting went on display in Italy for a month before being returned to the Louvre in January 1914. Peruggia was sentenced to a little more than a year in prison, but his sentence was later reduced to seven months and nine days. Once released, he went on to lead an uneventful life. However, the *Mona Lisa*'s adventure did not end there.

In 1931, a reporter named Karl Decker came forth with some startling information. Decker said that at the time the *Mona Lisa* was found and returned to the Louvre, he had interviewed a man named Eduardo de Valfierno, who told a different story about the theft. Sworn to secrecy until Valfierno's death, Decker was only now coming forward. Valfierno had

been in the business of selling forged Spanish Master paintings with his partner, a conservator and skilled forger named Yves Chaudron.

In 1910, the pair moved to Paris, and according to Valfierno's account, they hatched a plan to produce forged copies of the *Mona Lisa*. Valfierno convinced Peruggia to steal the painting so that its whereabouts would be in question. Chaudron would make several copies, which he would sell as the original to private foreign collectors, who might each be persuaded that his or her copy was the missing painting. He reasoned that if the *Mona Lisa* were ever recovered, he would simply tell his investors that the one in the Louvre was a fake and only they had the real thing.

When the alleged plot was revealed, people immediately became concerned about the authenticity of the lady at the Louvre. However, none of the supposed fakes ever emerged, and the Louvre has authenticated its treasure to the satisfaction of the art community. Even so, every once in a while there is a whisper: Is she for real?

Nicholas Turner himself had been something of a sleuth while curator at the J. Paul Getty Museum in Los Angeles in the 1990s, and he was at the center of arguably the greatest controversy of the museum's history. Shortly after starting in his position in 1994, Turner made the astounding declaration that six major drawings attributed to Renaissance Masters were forgeries. They included a pen-and-ink drawing of a woman attributed to Raphael, a portrait of an infant attributed to Fra Bartolommeo, and several other pieces, some attributed and some not. Turner was appalled by the apparent clumsiness in the works, which to his trained eye screamed forgery. One example was a Desiderio da Settignano, which the Getty had just bought for $349,000. A figure on the bottom of the Desiderio turned

out to be identical to the figure on the left edge—but in reverse. Mixing and matching elements from different compositions by the same artist is one typical forger's ploy.

Indeed, a supposed Fra Bartolommeo drawing, a black-chalk study of an infant's head, had caught Turner's eye as being the near replica-in-reverse of a study in a German museum—same child, same artist. The baby used to face right; now the baby faced left.

After Turner raised the alarm, Ari Wallert, an associate scientist at the Getty Conservation Institute, examined a supposed Raphael with X-ray fluorescence spectroscopy and found that it contained titanium oxide, which was not in existence at the time. Turner believed that this was proof of fakery. But just as Turner was about to pursue the matter, Getty shut him down. What ensued was a very messy and bitter affair that culminated in Turner's dismissal. As part of his severance, he was paid a substantial amount of money to waive any disputes with the museum, including his assertion that his predecessor had purchased forgeries. He was not content, however, to walk away, and he sued again. To allow known forgeries to stand was an insult to the conscience of a curator.

In a lengthy article about the claims in the *New York Times Magazine* in 2001, Peter Landesman hit the nail on the head when he wrote,

> We want to walk into a museum and know that what we find there is real. "Museums act as a guarantee of the authenticity of what's on display, but the sources of authenticity are decreasing," [Mark] Jones [head curator of the British Museum's "Fake?" exhibition] says. "People are more geographically mobile than their parents were. The past is some sort of fiction. The loss of certainty about what is and what is not real, and the increasing fictionalization of the past, means that

museums have found themselves acting as psychic anchors. . . . But the knowledge that we don't always know what is real—and neither, always, do museums— infects us with doubts that corrupt all of our other dealings with the culturally sacred. Experts are fallible. We have to take responsibility for what we look at. "If a museum contains things which are inauthentic," Jones says, "then what it is saying becomes a lie."[5]

In subsequent years, Turner did not give up on his quest. His primary suspect was a man named Eric Hebborn, a brilliant forger of Old Masters who actually revealed all in the 1980s. Hebborn never admitted to the Getty forgeries, but he did brazenly acknowledge his role as a forger in general in 2004 in a book—*The Art Forger's Handbook*—in which he boasted of his methods and philosophy. He had a particularly bold explanation for his actions:

There is nothing criminal in making a drawing in any style one wishes, nor is there anything criminal about asking an expert what he thinks of it. "But what about gaining pecuniary advantages by deception?" My answer to this is that I can see no reason why I should give my work away. Furthermore, I can truly claim never to have asked or received sums of money for my Old Masters in excess of what an artist of my reputation can command for his own work.

The pecuniary advantages were gained by the dealers, and for this reason I object to being considered a criminal. However much some people may confess to a sneaking regard for rogues, I do not happen to belong to the fraternity—let them save their sneaking regard for the dealers. Moreover, if Christie's, Colnaghi's, Sotheby's and other important merchants who

have handled my work really think that I am a crook, why do they not press charges?

The answer which comes first to mind is of course that they do not want to rock the boat, and no doubt this is true, for as London art dealer and specialist in nineteenth-century paintings David Gould said about the Keating affair: "There's an awful lot more that hasn't come out and won't come out. You don't want to rock the market. Faith in the market is a very delicate thing."[6]

Turner's disappointing experience trying to bring forgeries to the attention of his museum's directors would support Hebborn's suspicion that it was not always in the market's best interest to know the truth. In my experience, however, there is more than an excess of caution when it comes to attributions. I have never known a connoisseur who would tolerate error for the sake of the market. When I began to consider the possibility that I was holding a Leonardo, I knew that only the most rigorous examination would do. Indeed, one would have to be a fool not to be wary of a Leonardo attribution. There's bound to be controversy. The last time a serious claim was made, it took nearly a century to sort it out.

In the early years of the twentieth century, Kansas City, Missouri, was the last place one might expect to find a painting by Leonardo da Vinci, especially since there was not another Leonardo to be found in the entire United States. Yet that was the claim being made.

In 1920, Harry Hahn, a car salesman, married a Frenchwoman named Andrée Lardoux, whose godmother gave the couple a very special wedding gift: a picture that had been authenticated as a Leonardo by Georges Sortais, a French expert who specialized in the Italian Renaissance. The picture happened to be

nearly identical to a work of Leonardo's housed in the Louvre, called *La Belle Ferronnière*. That portrait was believed to be of Lucrezia Crivelli, a mistress of Ludovico il Moro Sforza's in the 1490s. (*Ferronnière*, which means "ironmonger," refers to the fact that the subject of the portrait wears a thin gold chain with a gemstone across her forehead.)

The young couple didn't have much interest in art but did appreciate the economic advantage of owning a Leonardo. The Hahns contacted J. Conrad Hug, a local art dealer, who arranged to sell the painting to the Kansas City Art Institute for $250,000, a princely sum at the time, especially since the new museum normally had an annual procurement budget of $60,000 to $80,000. One can only imagine how important a Leonardo might have been to the museum.

Sir Joseph Duveen, thought by many to be the greatest art dealer in the world, had never seen the Hahns' painting or even a photo of it, but when he learned of the sale he immediately declared it a copy. "The painting in Kansas City is a measly copy of which there have been hundreds made of this and other subjects by Leonardo da Vinci and offered to the world as genuine," he said. "Leonardo never made replicas of his works, and the real original *La Belle Ferronnière* is in the Louvre."[7]

Persuaded by Duveen's certainty, the museum canceled the purchase, and the Hahns were left holding a portrait whose value was suddenly in question. They were horrified that their dreams had been so casually dashed by a man they had never met and who had never "met" their Leonardo. Andrée Hahn sued Duveen for $500,000.

In his responses to the lawsuit, Duveen listed eleven elite European and American experts who agreed with him, and he continued his assault on the Hahns' portrait, writing, "The head does not show the consummate skill of the human structure that is fundamental and inherent in the works of

Leonardo. The head is attached to the shoulders in a poor fashion, the plaits of flesh below the chin are not natural; the neck itself is a dummy cylinder of flesh, and the left hand profile of the neck is out of design: the moulding of the shoulders and neck is primitive."[8]

A trial by jury was held in the Supreme Court of New York, before Justice William Harman Black. It commenced on February 5, 1929, and lasted twenty-eight days. The trial was a populist tour de force, including dramatic and controversial testimony by Duveen and his experts. Among them was a man named Bernard Berenson, who was a world-renowned authority on the Renaissance and a connoisseur of the Masters. Hahn referred to him as "the majordomo of the picture guessers."[9] In a curious incident, Berenson had previously gone on record as saying he doubted that the Louvre version was authentic; now he appeared at the trial prepared to testify otherwise. Harry Hahn cynically judged Berenson's change of heart as the result of the generous payment Duveen was giving him.

Berenson's description of his qualifications as an expert included this lofty statement: "You get a sense, if you have had sufficiently long training—this is not for beginners. It takes a very long time before you get a sort of sixth sense that comes from accumulated experience. When you get that, you get a sense of what the master is up to, what he is likely to do, able to do, and what he is not likely to be able to do."[10]

Nonsense, responded Harry Hahn—doublespeak. He later wrote that he was not alone in challenging the hoity-toity mentality of connoisseurs, whose pretentions relied on such questionable attributes as Berenson's sixth sense: "Some groups in the art world have at last commenced to breathe and bestir. They are demanding something more than a neatly worded attribution from a Mr. Berenson or his like as a guarantee of authenticity. They have seen some highly questionable old

masters cluttering up our public museums."[11] That was probably wishful thinking on Hahn's part, for no such revolt ever occurred.

When Duveen took the stand, he insisted that the Hahns' painting was a fake, even though he seemed to contradict his own connoisseurship with this testimony in this exchange with the Hahns' lawyer, S. Lawrence Miller:

> Miller: What is your method of expertizing paintings?
> Duveen: First I look to see whether it is an original or a copy.
> Miller: Oh, then you have to see it in order to pronounce on it?
> Duveen: I have bought paintings by looking at a photograph.
> Miller: Then it is necessary to see either the painting itself or a photograph of it?
> Duveen: Yes.
> Miller: In this case, however, you saw neither when you passed judgment on the painting?
> Duveen: In this case I saw neither.[12]

Time magazine wrote colorfully of the trial, describing Duveen on the stand:

> For four days Sir Joseph had been a harried witness. He had flayed the Hahn picture, testily calling its left eye "dead," "very dead," and "beadlike." On the fifth day he covered the whole damozel with one more coating of scorn. "She is a fat person!" he gibed. "A peasant type." Then he joyously pointed to a reproduction of the Louvre *Belle*. "This is a great lady of the period." Reverting to the Hahn painting he described the shoulders as flabby, the arms as puffy, the breast as lacking modeling,

the embroidery as untrue to Leonardo's period. "The hair!" he exclaimed, "That's not hair—that is mud! . . . If an artist paints wood it must be wood, not steel. If he paints hair it must be hair, not mud."[13]

The Hahns had their supporters, including Georges Sortais, who had made the initial attribution, and J. Conrad Hug, the elderly art dealer who had represented the work in the museum sale. Evidence was also presented that a number of experts had judged the Louvre portrait as being by Leonardo's school but not by the Master himself.

At the end of the day, the task of sorting out the expert opinions was left to the jury. In his instructions, Judge Black cautioned the jurors in a manner that might have been a not-so-subtle dig at Duveen. "You will be wary in accepting the conclusion of experts," he said. "Because a man says he is an expert does not make him one. An expert is no better than his knowledge, and it is for you to determine how much an expert a witness is."[14] The jurors deliberated for fifteen hours before announcing to Black that they could not reach a verdict. He dismissed them, and the process started all over again. The Hahns pushed for a second trial, and one was scheduled for April 15, 1930. However, Duveen had become ill and did not think he could withstand another trial. He reached a $60,000 out-of-court settlement with Andrée Hahn, which left the question of the portrait's authenticity in limbo.

Duveen had always contended that the Hahns' painting was an eighteenth-century copy of the one in the Louvre. In 1933, after spending several years studying the chemistry of paint, Harry Hahn came forward with new pigment evidence, which he said proved just the opposite was true: the Louvre painting was the copy.

In particular, he made two chemical comparisons: the shadow color and the lip color. In the Hahns' portrait, the

lady's shadows were painted with lapis lazuli, the expensive mineral used during the Renaissance, including by Leonardo, but which was not available in the eighteenth century. The Louvre version's shadows were created with lampblack, a product from the soot of oil lamps, which *was* used in the eighteenth century.

The Hahn version's lip color was a red dye from the so-called kermes berry, which is not a berry at all but a red insect that was dried and ground for pigment. The Louvre version's lips were also stained with the color of a cochineal insect, which arrived in Europe from the Americas only with Cortés in 1523, years after Leonardo's death.

Hahn also showed that their portrait was done with a mix of water-based tempura and oil, which was more typical of Leonardo at the time, whereas the Louvre painting was entirely oil. "The full oil technique is definitely not the technique of Leonardo nor any of his pupils, and did not come into use until the time of Titian and Correggio," the budding expert Hahn observed.[15]

Still no one would listen. The Hahns held on to the painting, believing that someday their claim would be vindicated. During World War II, they kept it in a bank vault.

As the years passed, Harry Hahn's bitterness over what he called the Old Masters racket only grew. He believed that museum curators—especially those at the Louvre—were craven overlords who could not bear the idea that they held a copy while the real thing was in the hands of a lowly American. After the war, he collaborated with the painter Thomas Hart Benton in writing a book titled *The Rape of La Belle*.

In the introduction, Benton wrote scathingly of the art community. "I have long been profoundly suspicious of America's Old Masters mania. I have been suspicious of the institutions which encouraged it, and of the secretive and often oblique characters there reigning who make of art and

the history of art a perfumed carcass. . . . The professional critic is a frustrate who is always cockeyed in his view."[16]

In the main text, Hahn released his frustration, writing, "Anyone who knows what has been going on in the art world since the turn of the century recognizes that the business of the art expert is largely fraudulent. It is a well established fact that the dubious and counterfeit works of art hanging in honored niches in some of our best public museums and private collections vastly outnumber the genuine works. And it is clear that venal art experts are responsible for this condition."[17]

Hahn also complained of the naiveté and greed of wealthy art collectors who longed to possess rare paintings, writing, "Any man not yet in his dotage, not completely ga-ga, who willingly parts with several hundred thousands of dollars for three square feet of painted canvas simply on the glittering say-so of a polished gentleman with continental mannerisms, striped pants and gray spats, is a patient for a psychiatrist if there ever was one."[18]

The controversy went on for decades, and the Hahns never did find satisfaction. Only recently has the painting, titled *Portrait of a Woman Called La Bella Ferronnière*, been subjected to a modern level of forensic analysis and been judged to be a copy—in the style of Leonardo but not by his hand, probably painted in the eighteenth century. The Hahns would certainly dispute these findings. For example, one piece of evidence is the backing, which is canvas, tested as eighteenth century. However, on the back of the Hahns' canvas is an inscription: "Removed from wood and transferred to canvas by Hacquin in Paris 1777"—which would explain the dating of the surface.

In 2010, Sotheby's put the Hahns' portrait up for auction and published this in a press release: "In 1993, *La Belle Ferronnière* was examined by a leading Leonardo expert, who concluded that while the painting was not by Leonardo, it did

in fact have age, and suggested that it dated to the first half of the 17th Century. Recent scientific analysis of the pigments used confirms that conjecture and suggests the work was painted by a French artist, or someone using French materials, before 1750." Ironically, even though it was judged a copy, the controversy surrounding the portrait increased its value. It fetched $1.5 million at Sotheby's in 2010.[19]

For many people, the case still isn't closed. The obstinate consensus of the art world, based on so little, reminds me of the same wall of denial that I have experienced. John Brewer, who wrote about Hahn's painting in his 2009 book, *The American Leonardo*, found the experience sobering. He said, "Working on this book I was often astonished at the cavalier (and, as far as I could see, largely groundless) judgments made by members of the art world, comments based more on fitting in with a consensus or on hearsay than any careful deliberation or consideration of evidence."[20]

I hasten to add that for me the case *was* closed as soon as I saw the work. I found it to be a very nice copy, and I probably would have barely given it a nod had it come up for sale in a Paris auction room. I don't think it's worth a tenth of what it made at the auction. My verdict is that the hope of a Leonardo da Vinci miracle created worth where there was none.

I am aware that history is filled with disputes about provenance and authenticity, with the eye of the connoisseur the only evidence. But what of opposing connoisseurs? We long for surety but often have to make do with trust. Now we are entering a new era, when science can deliver a verdict with a level of proof we are unaccustomed to. A collaboration between connoisseurship and science seems in order. The connoisseur can shuffle the cards, but we must leave it to science to cut the deck.

I was about to enter just such an arrangement.

5

The Magic Box

Nature never breaks her own laws.
—*Leonardo da Vinci*

After Nicholas Turner and Mina Gregori both expressed the view that my portrait might be a Leonardo, I could hardly contain my excitement. Could it be? On one level I was stunned by the possibility of it. On another, I was able to bring the critical eye of a collector to my find. Was she or wasn't she?

Was there perhaps another way to find the truth? I contacted my old friend Giammarco Cappuzzo, an independent art consultant in Paris. I'd known him for more than twenty-five years, and he had all the right contacts. "Where do I begin the authentication process?" I asked him.

His response was immediate. "Take it to Pascal Cotte at Lumiere Technology," he said. "He and his partner, Jean Penicaut, have quite an operation."

"Never heard of him," I replied. "Are you sure he will help this thing along?"

"So sure," Giammarco replied, "that I'll bet you a dinner at La Tour d'Argent."

"That's a bit pricey. How about lunch?" I offered.

He agreed. I didn't want to lose the high-priced bet, but at the same time I was hoping I would find answers from Pascal Cotte.

As a young boy growing up in Paris, Pascal Cotte was obsessed with the *Mona Lisa*. He recalled his mother telling him it was the most beautiful painting ever made, and at the tender age of eleven he took the metro to the Louvre to see for himself. He stood before the painting and had been studying it for two hours when a curious guard approached him. "Young man," the guard said with a smile, "would you like a chair?" Cotte nodded, and he was soon seated in comfort. Tourists who wandered into the hall assumed that the precocious young man was there in some official capacity, and they began asking him questions. He answered enthusiastically, emphasizing what he saw inside and behind the painting.

He found the experience thrilling. He was hooked.

Cotte returned again and again throughout his youth, spending hours gazing at the face, curious about the secrets inherent in Leonardo's most famous portrait. The *Mona Lisa* had long been characterized by variations of the word *secretive*. As Oscar Wilde proclaimed, "The picture becomes more wonderful to us than she really is, and reveals to us a secret of which, in truth, it knows nothing"[1] More recently, the writer Umberto Eco weighed in, saying,

I don't think that in painting the *Mona Lisa* Leonardo just thought of himself as painting a portrait of a lady. I believe that he knew very well that he was creating

something that would spark people's curiosity for centuries to come. He must have known that generations of people would busy themselves trying to unravel a great mystery—a mystery which may or may not exist. Leonardo was a great clown, and he knew better than anyone how to play with people's imaginations in order to create an impression of mystery.[2]

It can be fairly stated that entire libraries could be filled with the speculations about this lovely lady and her mysterious smile. Young Pascal Cotte was merely joining a rather large fan club.

Later, Cotte's career ambitions led him to focus on engineering and invention rather than art criticism. He wanted to see beyond—to take the art apart and look inside. His cheerful round face, jaunty attire, and absentminded-professor air masked the dead-on seriousness of a scientist, the ability to meander in highly technical arenas. A brilliant engineer and scientist, Cotte had long been intrigued by the possibilities of bringing new photo technology to the business of art examination.

He and his partner, Jean Penicaut, established Lumiere Technology in 1989—*lumière* means "light"—with the goal of illuminating the previously hidden secrets of the world's great art.[3] The centerpiece of his company was a very special camera that allowed a process called multispectral digital imaging, which electronically uncovered each layer of a painting, enabling one to see, in Cotte's words, "like Superman."[4]

This revolutionary camera allowed a work to be digitalized at a resolution of 1,570 pixels per millimeter.[5] To put that in perspective, a conventional professional camera achieves a resolution of 100 pixels per millimeter. It was as though one could see into the soul of a painting, to study each stroke and shading, and to do it digitally without in any way harming the original.

The technique was also revolutionary because it resolved a problem that had plagued the discipline for more than a century: accurate, or true, color. The technology allowed each pixel to be given an exact scientific measure. In traditional photography, color data was restricted by two factors: (1) the conventional RGB (red-green-blue) system of primary colors, and (2) the light source used. That is, a photographer in New York did not have the same light as a photographer in Paris or Madrid, so their photographs could not be scientifically comparable.

In April 2000, the European-financed CRISATEL project endorsed the use of Lumiere Technology's multispectral camera and its lighting system for the archiving and digitalization of museum works. In 2004, armed with this endorsement, Cotte went to the Louvre with a bold request. He explained that his camera allowed him to photograph any painting, and he wanted permission to use the process on the *Mona Lisa*. The museum agreed!

This was a particularly exciting venture for art historians, who had agonized over the question of how to properly separate the original from the protective varnish that had been applied in later restorations. Thanks to Cotte, there was a way to accomplish digitally what had been perilous physically.

The session was scheduled to take place after hours. A nervous group of curators and security personnel gathered to supervise the delicate removal of the painting from its bulletproof case. With a full contingent of guards surrounding it, the *Mona Lisa* was carried to the photograph room in the basement of the Louvre while technicians constantly monitored the temperature, which was required to be 20 degrees Celsius (68 degrees Fahrenheit), with 50 percent humidity.

Standing by as the frame and the glass were removed, Cotte felt his heart flutter. "I am not an artist or a curator," he said later, his voice filled with awe. "But when you see *Mona Lisa*

like that, naked, unadorned, you understand why the whole world says, 'Wow!'"[6] He had no doubt that he was gazing on the object of a lifetime's love. It was proof, he thought, that any dream can come true.

Once the *Mona Lisa* was ready, Cotte set up his camera. It was large and ungainly, and the technology was entirely new.

Here's how it worked: The camera projected a ray of white light across the surface of the painting. The ray passed over the surface thirteen times before re-creating a computerized version of the image that was, in Cotte's view, closer to the original than one could imagine possible. The thirteen photos resulting from the scan accurately split the light spectrum from ultraviolet to infrared at the limit of the optical laws—into 240 million pixels (as opposed to 20 million by the highest performance commercial camera), generating 22 gigabytes of data. The result ran the spectrum from objects visible to the human eye to those that were invisible.

Cotte began with a digital photograph of *Mona Lisa*. By digitally "removing" layers of varnish, he was able to construct a virtual image of the picture, unveiling its true colors—before time and restorers had altered them. The light actually went inside the painting, in a manner that seemed almost magical, superimposing all thirteen images on top of one another to form an accurate whole.

Eighteen hours after entering the Louvre, Cotte emerged, ebullient, quipping, "I spent the night with *Mona Lisa*."[7] He had reason to be thrilled.

For the first time in centuries, the true colors of the painting could be viewed. Most copies of the *Mona Lisa* are very dark, but the original colors, Cotte found, were quite vivid. For example, the sky was revealed as brilliant blue, painted with lapis lazuli, a very expensive pigment. Cotte also detected a fur-lined coat resting on the woman's knee that is invisible

to the naked eye, which helped to explain the odd position of her hand.

Cotte was able to give special attention to the woman's luminous face by enlarging portions with his powerful camera to more than 4,000 pixels per square millimeter. In the process, he solved the mystery of the missing eyebrows and eyelashes. This was something that had always disturbed and fascinated him. He could not imagine that an artist such as Leonardo, who worked with impeccable anatomical accuracy, would forget to give his subject eyebrows and eyelashes.

He was not alone in this fascination. Art scholars have long debated the barren brow, trying to make sense of it. Most peculiar was the evidence that eyebrows and lashes once existed in the painting. Giorgio Vasari, who wrote the book *The Lives of the Artists* in 1550 (considered the first art history book, in the modern sense), describes the *Mona Lisa* thus: "The eyes are bright and moist, and around them are those pale red and slightly livid circles seen in life, while the lashes and eyebrows are represented with the closest exactitude— with separate hair drawn as they issue from the skin."[8]

Although it is uncertain that Vasari ever saw the portrait in person, he did know the Giocondo family so it is possible he might have viewed it. Vasari was also a great admirer of Leonardo's writing at one point, "Occasionally heaven sends us someone who is not only human but divine, so that through his mind and the excellence of his intellect we may reach to heaven."[9]

Evelyn Welsh, a professor of Renaissance studies at Queen's College in London, wrote extensively about women's styles and fashions of the period. She declared, "I would absolutely stake my life on it that *Lisa* had eyebrows. She had eyelashes."[10]

Was she right? Using his magical technology, Cotte was able to discover a single strong brushstroke in the eyebrow area. Thank God—the Master did not leave his subject

without! They had merely been lost to time and restoration. (It is unlikely, however, that the real eyebrows will ever be restored, except in digital form. Physically touching the painting would be a task fraught with danger. I know of no one who would be willing to take it on, now that the painting has achieved such iconic status.)

Buoyed by his success with the *Mona Lisa*, Cotte now had a new ambition: to digitalize all of Leonardo's paintings and create a database. His next stop was the Czartoryski Museum in Kraków, Poland, where Leonardo's *Lady with an Ermine* was on display. This was one of Leonardo's most famous works, a portrait of Cecilia Gallerani, who was a mistress of Duke Ludovico il Moro Sforza's at the Court of Milan during the period when Leonardo was working there in the 1490s.

Invited by Prince Czartoryski and his foundation to digitalize the portrait, Cotte set to work. Studying his digital impressions of *Lady with an Ermine*, he found that Leonardo's brilliance was masked, to some extent, by overly rigorous restorations and overpaintings.

"Although the painting's overall condition is excellent, it is covered with innumerable tiny repaints," he reported. "Those have been suppressed by computer, thus freshening up the tones in the Lady's lovely face, her décolleté, the embroidered ribbon around it, the pearl necklace, her right hand, the black ribbon of the sleeves, the blue mantle and the red velvet of the gown, etc. The ermine had been retouched in the past equally. Thanks to the computer restorers its white fur, meticulously depicted by Leonardo, can be viewed again."[11]

He also discovered, to his horror, that restoration work had resulted in the partial removal of Cecilia's eyebrows and eyelashes, and he wondered if the same fate had befallen the *Mona Lisa*.

Cotte's multispectral imaging camera opened up a new arena of art exploration and authentication. Leonardo's

blending method—called *sfumato*—was delicate and integrated. Prior to the existence of the digital process, there was no way to remove restoration touches or varnish without jeopardizing the integrity of the art itself. Indeed, one expert in the Leonardo technique once fretted that to touch the face in the *Mona Lisa* would be to potentially erase the famous smile. But now Cotte had found a way to do the job without jeopardizing the painting.

In time, Lumiere Technology began to emerge as a vital player in the expertise and study of art history with a process that modified the traditional methods of investigation used by experts and museum labs to achieve high-definition digitization in one operation. Cotte and Penicaut were quick to assert that they were not replacing conventional expertise. Explaining and defending their process, they wrote the following:

> We get no other pride than to remain ourselves, innovative, listening to art historians, experts, collectors and players of museum life whose knowledge we seek only to enrich by providing them new evidence, scientifically proven for more certification. We are not art historians. We are experts in scientific imagery for fine arts. Like it or not, these scientific measurements of multispectral paintings open a new area of investigation, in the same way that medical imaging has enabled practitioners to work better. These images should be commented on, analyzed, compared and shared. Deny to Lumiere Technology, inventor of such process, the right to exist and to comment on the images under the pretext that we are not art historians is nonsense. Like radiologists, we provide a checkup, a first observation, and then refine it for other professionals. The only requirement for expertise and study is the use of more

efficient tools to search for the truth. The multispectral analysis, as a scientific measurement of the substance of the artwork, seems to be one of the most sophisticated, if not the most successful. It is never too late to recognize a breakthrough and to use it.[12]

On a spring day in 2008, I rode up to the front entrance of Lumiere Technology on the back of Cappuzzo's Vespa scooter, clutching the portrait in my arms. (Kathy nearly fainted when she learned about my cavalier means of transporting our priceless lady. I don't know what I was thinking—perhaps it was a reckless yearning to spit in the face of propriety. Fortunately, we arrived safely!) I carefully dismounted and carried my precious package into the building, where I was greeted by a beaming Pascal Cotte. I liked him immediately. He was vibrating with warmth and enthusiasm. I turned over my treasure, telling him only that it had been attributed to an unknown nineteenth-century artist.

He asked me to be seated while he took a quick preliminary look, and he disappeared with the package. He was back within half an hour, his face flushed and his eyes gleaming. He bounced excitedly on the balls of his feet. "Do you know what you have?" he asked.

I feigned ignorance, not wishing to let him know I knew. I wanted him to form a totally independent opinion.

"On a hunch, I ran a digital scan of your drawing through my database and came up with many similarities that intrigued me," Cotte said. "I believe this may be a portrait by Leonardo."

I grinned and admitted my suspicions. "I didn't want to influence you," I explained.

Cotte was trying to contain his enthusiasm and view the matter objectively. This was a different challenge than investigating a painting like *Mona Lisa*, which had a proven authorship. Could he also use his technology to *detect* authorship?

With Cappuzzo's help making arrangements, we sent a tiny sliver of the vellum to be carbon-dated at the Swiss Federal Institute of Technology in Zurich. This was a crucial part of the authentication. If it were determined that the parchment was of a later era, all bets were off. And so the process began.

Carbon-14 dating is a chemical examination based on the way natural elements age, and it can be used to test a material or substance that has a biological origin—such as vellum, cloth, or wood. Carbon is breathed in by animals and plants through the carbon dioxide in the atmosphere. Carbon-14, one of three carbon isotopes, is radioactive and subject to decay over a very long period. Its half-life is 5,730 years, which means that in that period, half of the carbon-14 isotopes will have decayed. By measuring the percentage of carbon-14 that remains in a test sample, it is possible to determine its age to within two hundred years.

The most famous and controversial case of carbon-14 testing involved the Shroud of Turin, the cloth that is alleged to have been the burial shroud of Jesus. In 1988, carbon testing revealed that the age of the cloth was medieval, which means it could not have belonged to Jesus. That might have settled the matter once and for all, but there was so much interest in the Shroud of Turin, and so much passion among true believers about proving its authenticity, that speculation raged about possible explanations for the "false" result.

In 2005, Raymond N. Rogers, a highly respected chemist and a fellow of the Los Alamos National Laboratory, revealed in a scientific journal that the entire cloth was much older than the test sample—at least twice as old, and possibly two

thousand years old. The explanation: the corner that was tested had been subject to mending and thus contained newer material. Rogers's discovery did not stop the controversy, and studies of the Shroud of Turin continue.[13]

We knew that carbon-14 testing could not authoritatively establish that our portrait had been created in the fifteenth century, much less in Leonardo's lifetime. But it *could* contradict the Christie's attribution of the nineteenth century, and that's what we were after. The carbon dating of the vellum showed that the drawing had with great probability been done between 1440 and 1650, which was within the perimeters of a fifteenth-century authentication. It was important evidence, although carbon dating alone wasn't proof. Art forgers were known to use materials from a desired era. For example, Hans van Meegeren, who created phony Vermeers, used canvas from the seventeenth century. Nevertheless, the carbon dating was a first positive result in a long checklist, and Cotte and his technicians began their study in earnest.

Cotte's scientific method did not ignore the processes of art anthropology; it just made it easier to view the evidence. Much of Cotte's investigation involved the details of style, fashion, and era as well as a comparative analysis with Leonardo's other signature works. Science does not replace aesthetic sense, historical study, or any of the other expert means of authenticating works of art. It merely adds another layer of proof.

Cotte began by digitizing the portrait at a resolution of 1,570 pixels per millimeter, an extraordinary level of definition. At this resolution, the slightest nuances and tiniest details—the *craquelure* (network of fine cracks on the surface), the grainy surface texture of chalk or graphite, and even fingerprints—were perfectly visible.

In a single scanning session, which lasted only one hour, the work was measured and captured in thirteen spectral bands, and the multispectral camera recorded and generated

approximately 24 gigabytes of digital data. Cotte's goal was to produce an image that contained additional information: what could be seen beneath the various paint layers, since many pigments that are opaque to ordinary visible light are transparent to infrared. Cotte explained:

> The study or analysis of images of such ultra high resolution and high definition gives the researcher a considerable weapon—a trump card, if you will. A few hours spent before a large computer screen, armed with images produced by a multispectral camera, can be invaluable, complementing the evidence obtained in a traditional conservation studio. The high degree of sophistication and extreme precision of multispectral images enable an in-depth study of the object's physical characteristics, reducing the need for further direct contact, since the work is handled only once in the initial scanning session.[14]

The results:

- Perfectly clear, ultra-high-resolution images
- Normalized (standardized) colors with a unique level of accuracy
- A broad spectral range, with infrared and raking light infrared images extended to 1,050 nanometers (instead of the 850 nanometers possible from film)
- Information that is more pertinent and discriminating

With this new method of investigation, the colorimetric print was born. Works of art can now be compared on an accurate scientific basis. With digital reconstruction, multiple combinations of data can be explored from different points of view and for different purposes.

Recalling his initial impressions of our portrait, Cotte wrote,

> When the portrait was first presented to us, it was described as a watercolor, a colored drawing, or, alternatively, as a drawing in wax crayons, chalk or pastels. No one was exactly sure of its technique. That the technique had not previously been accurately described is almost certainly due to the later restorations, which masked the media of the original drawing . . . the portrait is drawn on the smooth hair side of the vellum rather than the rough side. This provides an important clue, for some techniques can only be carried out on the flesh side, which results in an entirely different appearance.
>
> The multispectral images enabled us to identify accurately the media of the portrait. It is executed in the technique generally termed *à trois crayons*, that is to say, with finely sharpened pieces of natural black, red and white chalks. This mixture was combined with pen and ink, especially in the areas of hatching. Pen and ink was a favorite technique of Leonardo's, as was red chalk (of which he may have been an early pioneer). Although generally associated with later periods (especially the 18th century), the *trois crayons* technique has been used for portrait drawings since the Renaissance. To be completely effective, it requires a toned or colored support to set off the white highlights. In early periods, artists often exploited the natural flesh colour of vellum or parchment, mixing red and white chalks on top of it to reproduce the sitter's complexion.[15]

Aided by his illuminating camera, Cotte was able to present a clear view of the media used in the portrait. He found

that the basic contours and shadows were executed in black chalk, strengthened in pen and dark brown ink—once again, a typical technique of Leonardo's. A detail at the junction of the subject's bodice and neckline showed traces of strokes of all three chalks against the flesh-colored midtone of the vellum. The way in which the artist exploited the support is particularly clear in another detail: the eye, where the untouched golden tone of the vellum conveys the amber color of the subject's iris.

Cotte and his digital detectives carefully studied the innovative media technique, analyzing the chalks used (black, red, and white) and their mixture with pen and ink; examining the stylistic parallels with known Leonardo works; and cataloguing the period details of style and dress. They found that the interlace ornament in the costume corresponded to patterns that Leonardo explored in other works. They easily determined that there were noteworthy similarities between our portrait and Leonardo's *Lady with an Ermine*. These included the modeling of flesh tones using the palm of the hand, the intricacy of the patterns of the knot-work ornament, and the treatment of the contours.

Each of these pieces of evidence was significant in the slow building of a case. But another test of authenticity when studying Leonardo is whether there is mathematical precision in the anatomy. Leonardo's rules of anatomy are well known and described in his notebooks and teachings. Most famous is the drawing *Vitruvian Man*, which depicts a male figure in ideal proportions. Cotte's digital equipment allowed the level of high resolution that made this examination possible.

It was Leonardo who first called the eye "the window of the soul," and his fascination with the eye's anatomy and transcendent function is obvious in all of his portrait works. For this reason, Cotte paid special attention to the eye of the lady in profile. "Some of this might seem obvious or universal," he

explained, "but the way each artist handles these features is more individualized than one might imagine, and their combination is unique. Leonardo, for example, consistently made the bottom of the eye's iris coincide exactly with the edge of the lower eyelid, and it is surprising how few portrait artists took the time to render the delicate lower eyelashes of their sitter."[16]

Once again, Cotte was aided in his comparison by an earlier digitalization of *Lady with an Ermine*, Leonardo's rendering of Cecilia Gallerani. Scrutiny of the two pieces showed a thrillingly identical treatment of each detail, including the outer corner of the eyelid, the fold of the upper eyelid, the contour of the iris, the lower eyelashes, the upper eyelashes, and the juxtaposition of the edge of the lower eyelid with the bottom edge of the iris.

Recall that in her evaluation of the drawing (see chapter 2), Mina Gregori had also noted the eye, stating, "In my view, exact parallels in the brightness and transparency of the girl's eye are only to be found in other examples in the drawings of Leonardo."

The anatomical details offered further proof through the unique Leonardo attention to measurement in the construction of his subject. Cotte found that the proportions of the head and face reflected the strict rules that Leonardo outlined in his notebooks. Yet even though these measurements added to the body of proof, there was much work still to be done. This magnificent process would open up the discussion between old school and new school. Old school uses connoisseurship; new school brings in technology as well. New school methods merely confirm or disprove; they don't change the art or replace the eye. The eye still comes first.

One of the most innovative aspects of Cotte's camera technique was its ability to track restorations, separating them

from the original and from one another. In the course of its existence, the portrait had undergone extensive restoration—not uncommon for works of this age. Cotte observed, "Because Leonardo was so innovative and adventurous in his exploration of new techniques, many of his works have suffered more than those of his contemporaries. (One thinks of the wall painting of *The Last Supper* or the lost *Battle of Anghiari*.) Even the portrait of Cecilia Gallerani reveals condition issues."[17]

With the aid of the standardized multispectral images and a cross-comparison of the false-color ultraviolet, and infrared, Cotte was able to construct a map of restorations, allowing a clear distinction between the original media and the pigments added later. He found that "in this case, the restorations— the retouching and reinforcement of the original lines and hatching—are, by comparison with Leonardo's own handling, heavy and overemphatic; in a few areas, they compromise the reading of the work."[18]

Among Cotte's findings was that a thin layer of pink pigment had been applied by brush to much of the cheek area and forehead, using a system of hatching. "The restorer obviously aspired to be consistent with Leonardo's handling, but, alas, no restorer could achieve the same degree of subtlety."[19]

Reinforcements in pen and ink carried out during restoration were easy to recognize, and Cotte was able to identify the ink used by the original artist (purportedly Leonardo) and the restorers. In the knot patterns on the shoulder, the restorer's efforts to reinforce contour lines, details, and hatchings were likewise easily distinguished. Cotte saw that occasionally, the transparency of the ink in the redrawn areas allowed the original black chalk strokes underneath to show through, again highlighting the distinction between the artist and his restorers.

"The restorer's stroke is hesitant, sometimes wavers, and is irregular in its thickness," he noted. "It is not always easy to read. The contrast between the labored, less coherent, and less logical hatching of the later intervention and the lively, correct, refined, and harmonious hatching of Leonardo, in which each stroke seems to have a precise role or significance, is abundantly clear from the multispectral images."[20]

Cotte also discovered that the later restorations were the work of a right-handed person. "The movement of the strokes, in contrast to those of Leonardo, starts with a rather timid—even hesitant—placement of the drawing instrument (brush or pen), then continues with a thicker line, with its several nervous wobbles, only to taper off again," Cotte observed.[21]

As part of his investigation, Cotte studied the ink. Although he acknowledged that ink cannot be scientifically dated in the same way as vellum, since the same recipes continued to be in use for centuries, he was able to determine that the ink was compatible with a fifteenth-century date.

In the end, Cotte attempted to establish a firm distinction between the original and the restoration, creating a virtual reconstruction of the original based on a number of educated assumptions:

- The vellum, naturally soiled by the wear and tear of five centuries, would have been brighter.
- The colors throughout were probably less dirty, less grayish.
- The green was made from a piece of ampelite (a black substance like coal) on a yellow background.
- The red of the bodice was achieved with pigment from hematite on a yellow background.
- The entire bodice would have been rendered with the same red.

Cotte also noted a tantalizing clue as to the portrait's original usage. The remains of three needle holes along the left edge of the vellum showed that it originally came from a book or a manuscript. The piece of vellum was evidently cut from its codex with a knife. Small cut marks were visible a few millimeters in from the lower left edge. He judged that they could not have been made with a pair of scissors and that they were situated exactly at the fold of the gathering of the codex, below the lowest needle hole. It was one more piece of the mystery we were destined to pursue: What was the purpose of the portrait, and where had it originally been displayed?

We sadly realized that the portrait could no longer hang on our wall for our private enjoyment. "This is scary," Kathy worried. "It's an enormous responsibility, and I don't want it. Isn't the purpose of a work of art to enjoy it? Art is made to be displayed, not to put away. But the whole thing makes me very nervous."

As we were deciding what to do, a friend told a story about Bill Gates and his *Codex* (a collection of scientific writings by Leonardo that Gates acquired at an auction in 1994). There was to be a show in France, and someone involved in the show described the security as intense, saying the *Codex* was always accompanied by a team of former Special Forces heavies. Furthermore, Gates's home, outside Seattle, Washington, was a fortress with advanced electronic security systems. Each guest entering the property carried a microchip, which identified him or her throughout the house.

When Kathy heard of these extreme security measures, she looked at me meaningfully and said, "Peter, the *Codex* is highly significant, but so is our portrait, in its own way."

At the urging of Kathy and others, I placed the drawing in a secure vault in Zurich, protected by armed guards and alarm

systems. Until I knew for sure whose work it was, I wasn't going to take any chances.

In any case, Cotte no longer needed the original. He had all of the digital information required. Multispectral imaging had digitally stripped away the "noise" built up through centuries of aging and restorations. So many of the critical pieces fit together to form a high probability that it was the work of Leonardo. But high probability was not enough.

Sitting at his computer, lovingly reviewing the photo enhancements of the portrait, Cotte's curiosity grew. He needed to look into questions of style and period that were beyond the range of his camera. He could make the details visible, but he could not know all of the meaning. For that he needed another eye. It was time to bring in a big gun, a Leonardo expert of unquestionable authority. We discussed names and were inevitably led to Martin Kemp.

6

A Scholar's View

It had long since come to my attention
that people of accomplishment rarely sat
back and let things happen to them. They
went out and happened to things.

—*Leonardo da Vinci*

Martin Kemp, emeritus professor of art history at Oxford University, was a leading Leonardo scholar. Slender, soft-spoken, and youthful in his sixties, he lived in something of a Renaissance cocoon: a historic eighteenth-century house near Oxford. It was there that he burrowed in to do the laborious work of examining the numerous pieces of art and photographs of art that were sent his way.

Kemp was a star in the art history arena, and he had written extensively on imagery from art and science in the Renaissance. He had recently published, in 2004, *Leonardo*, in

which he probed the real meaning behind Leonardo's greatest masterpieces.

Kemp's passion was the relationship between art and science, and he had an unusual background for an art historian. He was trained in natural sciences and art history at Cambridge University and at the Courtauld Institute of Art at the University of London. In his career he has curated many exhibitions and has been the favored consultant for those exploring the intricacies of Renaissance style.

Kemp's explorations have also taken him in intriguing directions. Always fascinated by Leonardo's scientific sketches, in early 2000 he was visited by daredevil skydiver Adrian Nicholas, who wanted to consult him on the construction of a parachute according to the specifications of Leonardo's drawings, using authentic period materials. In 1485, Leonardo had scribbled a simple sketch of a four-sided pyramid covered in linen. Alongside it he had written, "If a man is provided with a length of gummed linen cloth with a length of 12 yards on each side and 12 yards high, he can jump from any great height whatsoever without injury."[1] Nicholas wanted to test the concept, and he figured the best person to help him was a bona fide Leonardo scholar.

Kemp agreed to serve as a consultant, and in June 2000 the contraption was ready. The chosen destination was South Africa, where Nicholas launched himself from a hot-air balloon 10,000 feet high. He parachuted for five minutes as a black box recorder measured his descent, then he cut himself free of the contraption and released his Leonardo-inspired parachute. He made a slow, graceful, uneventful descent.

Leonardo's parachute design had worked flawlessly.[2] Nicholas and Kemp were elated. "It took one of the greatest minds who ever lived to design it, but it took 500 years to find a man with a brain small enough to actually go and fly it," Nicholas told the media, adding that "all the experts agreed it

wouldn't work—it would tip over or fall apart or spin around and make you sick—but Leonardo was right all along. It's just that no one else has ever bothered trying to build it before."[3]

It was an exhilarating adventure for Kemp, who would grieve deeply for Nicholas when he died in a skydiving accident only five years later.

Kemp's fascination with the intuitive integration of art and science made him the perfect choice to weigh in on the authorship of our portrait. But getting his ear was no easy task.

"Since the publication of *The Da Vinci Code*, I was getting e-mails from people saying they owned the next Leonardo," Kemp told me. "I call them the 'Leonardo Loonies.' Leonardo attracted lunatics more than any other figure—Shakespeare, Dante, Newton."[4]

Kemp liked to recount some of the wilder stories, including the theory that Leonardo had faked the Shroud of Turin and that the image was not Jesus Christ but Leonardo himself. But Dan Brown's huge bestseller *The Da Vinci Code*, and the fantasizing it encouraged, drove him around the bend. In Kemp's experience, especially in the modern media–saturated environment, if there was a conspiracy theory or a secret society, Leonardo was bound to make an appearance.

So Kemp was naturally skeptical of all claims. When I first e-mailed him about a possible Leonardo find, he later told me, he thought, "Oh, dear, another bout of painful correspondence." But after the digital file came through, he saw that it warranted a closer look.

Kemp's first task was to view the original, which was locked away in Zurich. He told us that the viewing would have to wait several months, when he planned to be in Zurich to make a television program. He would not go beforehand; it was his policy to accept no money, even travel expenses, for giving an attribution. He believed unequivocally that once one accepted money of any kind, one's opinion could be bought.

True to his word, some months later Kemp sat in a large viewing room at the bank where the portrait was being kept and waited for the two security guards (whom he humorously described as having big shoulders and no necks) to retrieve the portrait from storage. They laid it on the table in front of him and retreated to a corner of the room to wait in respectful silence.

There is a mythology about art experts like Kemp that they have an unerring instinct, like an energy vibration, that tells them they are in the presence of a Master. Would Kemp have that moment of recognition? He himself had once described a similar sensation when viewing the real thing. "It was what struck you—that first jump of recognition," he said reverently. "If you didn't get that interior feeling that grabbed you, perhaps you would not pursue the matter. But the process was also more organic—involving other criteria and contextual support to ask, 'Does this belong, does it tell us about Leonardo?'"[5]

When he viewed the portrait, he admitted to having a sense that there was something to it. "I immediately saw it was in a different league than others," he said. "But I was still very, very cautious. I didn't want to jump at it, because once you start believing, you can summon all the evidence you need."[6]

Kemp's method was from the "doubting Thomas" school. He kept pulling back and saying to himself, "Let's see what's wrong with it. What tells me it's not a Leonardo?" Because he was trained in scientific methodology, Kemp's road to attribution was heavily paved with skepticism. Over the next few hours he became lost in the portrait, studying it from every angle.

He left the vault feeling very positive. His initial interest had been fully corroborated in the presence of the real thing. The next steps involved further technical and historical analysis to see whether, on the whole, the portrait was consistent with Leonardo and to determine whether the subject could

be identified. His process was organic, pulling in every imaginable piece to a giant jigsaw. And like a jigsaw, if a single piece didn't fit, the entire puzzle would be ruined.

He compared the process of review to a well-designed piece of furniture, like a cabinet, which through the construction process gradually becomes a functional whole. In the end, everything fits together. The drawers don't stick, the legs don't wobble. It is sturdy.

Kemp decided to pursue the matter, and he is the one who dubbed the portrait *La Bella Principessa* ("The Beautiful Princess"), a title that stuck. The name, he explained to us, referred to a princess not in the royal sense but in the generic sense. "She is wearing a court costume with the colors of the court, and her long pigtail is the badge of court ladies of the time." So *La Bella Principessa* she was! (When Kathy and I had initially discussed naming the portrait, we had considered using the more accurate *La Bella Milanese*—denoting the portrait of a beautiful Milanese woman. We were dissuaded, however, by the fact that *milanese* is also the Italian term for veal cutlet.)

As he immersed himself in his investigation, Kemp noted a series of incontrovertible facts about the work. These were key in preparing for an ultimate determination of period and hand. They included the following:

- The vellum and the pigments had undergone the kinds of damage, abrasion, and restoration that were to be expected of an object dating from the late fifteenth century.
- The shaded areas were first laid in with extensive parallel hatching in Leonardo's distinctive left-handed manner—that is, inclining from upper left to lower right, often at or close to a forty-five-degree angle.
- The opaque areas of pigment on the forehead, cheek, and neck resulted from an old campaign of restoration,

to cover areas of damage and losses to the original chalk surface.

- The darker ink reinforcements added with the brush, most evident in the headdress, hair, and costume, also resulted from restoration, undertaken piously to "improve" the image in a way that differs from modern procedures. Kemp determined that the retouchings had been made by a right-handed artist.
- A left fingerprint was evident close to the left margin at the level of the woman's hairline.
- There were clear signs that some part of the artist's hand, probably the outside of the palm of the right hand, had been pressed into the pigment layer in the subject's neck.
- The contours of the facial profile, neck, and shoulder revealed some maneuvering to establish the right outline; there were also signs that the rear contour of the subject's braid was first laid in further to the right of its present location. These are known as *pentimenti*—underlying images from a draft or an early version that show through—and were common to Leonardo.
- The upper, right, and lower edges of the sheet were consistent in appearance and could be original.
- The relatively regular distribution of tightly spaced follicles suggested that the vellum was from the skin of a calf.

Now Kemp turned his attention to the investigation of elements. The first question was about the material itself, the vellum. Vellum is parchment made from the skin of a calf or a kid. There was no record of Leonardo's ever having used vellum. For some, this would have been evidence enough that it was not his work. But Kemp found it intriguing, and he thought that the vellum surface militated against a forger. What forger would have placed such an enormous obstacle

in his path? Kemp dug deeper, discovering a telling passage in Leonardo's "Ligny Memorandum" in which he referred to an interest in using chalk on vellum:

> Get from Jean de Paris the method of dry colouring and the method of white salt, and how to make coated sheets; single and many doubles; and his box of colours; learn the tempera of flesh tones, learn to dissolve gum lake.[7]

Jean de Paris was Jean Perréal, the French portrait painter, illuminator, designer, intellectual, and poet, who happened to be in Italy in 1494 with Charles VIII and again in 1499 with Louis XII—and possibly at other times as well. Leonardo seems to have consulted with him on his unique method of using dry colors on vellum, and he was particularly interested in how to achieve flesh tones and how to handle lake pigments—those manufactured by mixing dye with certain insoluble binders, in this case gum arabic. Gum arabic is extracted from the acacia tree and can be used as a binder for pigments or even as a fixative for the whole sheet.

Leonardo is indicating that he was planning to ask the French Master about ways of preparing the drawing surface. He was interested in obtaining single and double sheets, which refers to the cutting of rectangular pages from the irregular, stretched skin of a kid or a calf. The technical examination of *La Bella Principessa* was consistent with the use of a gum fixative over the original medium. In short, Leonardo recorded his intention to inquire about the very techniques that were necessary to create the *La Bella Principessa*! These are different from the standard procedures of manuscript illumination, which were well known in Milan.

A specialist studying the vellum question (who asked to remain anonymous) would later come upon a meaningful

example of the technique: a magnificent, large illuminated portrait on vellum (37 by 27 centimeters, or 14.4 by 10.5 inches) of Lorenzo de' Medici as a boy, which appeared in a deluxe edition of the complete works of Homer. It was printed on vellum in 1489 and now belongs to the Biblioteca Nazionale in Naples. The beautiful *Portrait of Piero* is by the illuminator and painter Gherardo di Giovanni del Fora, who had a workshop in Florence between 1445 and 1497. He knew Leonardo, and it is possible that they discussed the topic of portraits on vellum.

Kemp continued his investigation, slowly fitting together each piece of the complex puzzle. His next area of study was the proportions of the face. This area was absolutely critical when reviewing a Leonardo work, because the Master devoted so much space in his notebooks to the series of harmonic proportions that he believed characterized the internal relationships of the human body. For example:

> The space from the mouth to below the chin will be a quarter part of the face, and similar to the width of the mouth. The space between the chin and below the base of the nose will be a third part of the face, and similar to the nose and the forehead.
>
> The space between the midpoint of the nose and below the chin will be half the face.
>
> The space between the upper origin of the nose, where the eyebrows arise, to below the chin will be two-thirds of the face. [8]

This proportional system was also found in Leonardo's *Lady with an Ermine, La Belle Ferronière,* and *Mona Lisa. La Bella Principessa* complied exquisitely.

Kemp worked on with a growing sense of appreciation, verging on awe. Could it be that this was the real thing?

7

Leonardo's Principles

Men and words are ready-made, and you,
O Painter, if you do not know how to
make your figures move, are like an orator
who knows not how to use his words.

—Leonardo da Vinci

While Pascal and Martin—we were all on a first-name basis by now—labored over their analysis of *La Bella Principessa*, the project began to attract the attention of scholars who brought their connoisseurs' eyes to the project. In particular, they were attentive to Leonardo's ideals of beauty and the human face, which he wrote of in great detail in his notebooks. He urged artists to choose beauty over the grotesque, writing,

It seems to me to be no small charm in a painter when he gives his figures a pleasing air, and this grace, if he

have it not by nature, he may acquire by incidental study in this way: Look about you and take the best parts of many beautiful faces, of which the beauty is confirmed rather by public fame than by your own judgment; for you might be mistaken and choose faces which have some resemblance to your own. For it would seem that such resemblances often please us; and if you should be ugly, you would select faces that were not beautiful and you would then make ugly faces, as many painters do. For often a master's work resembles himself. So select beauties as I tell you, and fix them in your mind.[1]

For Leonardo, anatomical rules and the ideal of beauty might have been one and the same. The animating principle of his work was to paint a living thing—and therefore always know what that living thing is doing and thinking. He wrote:

A picture or representation of human figures ought to be done in such a way as that the spectator may easily recognize, by means of their attitudes, the purpose in their minds. Thus, if you have to represent a man of noble character in the act of speaking, let his gestures be such as naturally accompany good words; and, in the same way, if you wish to depict a man of a brutal nature, give him fierce movements; as with his arms flung out towards the listener, and his head and breast thrust forward beyond his feet, as if following the speaker's hands. Thus it is with a deaf and dumb person who, when he sees two men in conversation—although he is deprived of hearing—can nevertheless understand, from the attitudes and gestures of the speakers, the nature of their discussion. I once saw in Florence a man who had become deaf who, when you spoke very loud did not understand you, but if you spoke gently and without

making any sound, understood merely from the movement of the lips.[2]

Leonardo believed that the only way to paint an image authentically was to understand and accommodate what was going on underneath. Thus he did not just paint a man with a jacket over bare skin; rather, he made accommodations for an undergarment, even if it remained unseen. His studies of the human organs were quite advanced. Dr. Sherwin Nuland, who in addition to being a medical doctor and a renowned author (of *How We Die*, among other books) is also a recognized expert on Leonardo's anatomical studies. Dr. Nuland said:

He was the first person, for example, to realize that the heartbeat and the pulse were synchronous. This is something clearly everybody thinks is automatically understood, but it wasn't at that time. And the way he did it was simply to watch farmers who were slaughtering pigs. They would put a large tube right through the chest wall into the pig's heart to let the blood go out. And, of course, there would be twenty, thirty beats before all of the blood was gone. And he would watch the heartbeat. He would feel the animal's pulse at the same time, and he would synchronize the two of them, plus the sound of the heart thumping against the chest wall. So he was able to identify the fact that the heart functioned like a muscle, that it leaped forward each time it beat, and that it, in fact, caused the pulse.[3]

It is apparent that such studies were made in the interest of authentically portraying a living person in his painting.

What makes Leonardo's work so captivating is the intense human feeling coming from his subjects. With their postures and expressions they beckon us to know them and to know,

as Leonardo put it, their *purpose*. As the scholars began to examine *La Bella Principessa*, they were in agreement that the portrait met not only Leonardo's rules of anatomy but also his rules of artistic motivation.

The first outsider to study *La Bella Principessa* at the lab was Cristina Geddo, a noted scholar of Leonardo's workshops. An attractive, dynamic powerhouse in her late thirties, Geddo was passionate about Leonardo's Lombard period. Showing impressive initiative, Geddo presented herself at Pascal's laboratory, stating her interest in looking at his digital renderings. Pascal agreed. After reviewing the work and Lumiere's spectral images, Geddo wrote a lengthy article about her findings, which was published in *Artes*, the scholarly journal of the University of Pavia.

> The *Portrait of a Young Woman in Profile to the Left*, which recently surfaced in a private collection, impresses itself from the very first encounter as a work beyond the ordinary, not only for the remarkable high quality of its conception but also because of the distinctiveness of the technical means by which it has been realized. It is with a mixture of surprise, caution and embarrassment that the name Leonardo comes readily to mind and, indeed, takes root with time, removing any possible alternative, beginning with the names of his pupils—not one of whom was capable of attaining this level of accomplishment nor mimicking so accurately and to so high a degree the art of his master.[4]

Geddo based her strong conviction on four fundamental arguments: the unequivocal character of the style and of the physiognomy, the unrivaled quality of the execution, the irrefutable evidence of the recurring left-handed shading, and

the experimental technique with which the portrait itself was realized. Of the subject, she wrote,

> The portrait represents a young woman, blonde and angel-like, the most seductive that ever came out of Leonardo's hands, but at the same possessed with a true and vibrant intimacy, reserved in how she offers herself, and inert in her proud firmness of posture. The crystalline eye, offset from the axis of the profile, is slightly tilted and rotates towards us, yet cannot cross our gaze. From this barely perceptible infringement of the rule—that of the absolute profile—comes the "motion of the mind" of our protagonist, an internalized, ineffable look that captures the attention of the beholder with magnetic force.

Reading Geddo's analysis, Kathy remarked, "I can almost feel the sitter come to life in her eyes." I can, too. And we were itching to find out the identity of this beautiful and mysterious young woman.

Meanwhile, Giammarco Cappuzzo, our friend and independent art consultant, was urging me to arrange for Alessandro Vezzosi to see digital images. Vezzosi, the director of the Museo Ideale Leonardo da Vinci in Leonardo's birthplace of Vinci, was arguably one of Leonardo's most passionate fans. A charming man and a serious scholar, Vezzosi had nearly single-handedly built the museum into a stunning tribute to Leonardo. The museum is a marvel, with large-scale models of Leonardo's great inventions, such as flying machines, war machines, and a helicopter built to the specs of his writings and drawings.

In 2005, Vezzosi had spearheaded a "trial" in Vinci of Dan Brown's bestseller *The Da Vinci Code*, summoning art experts and historians to weigh in on the accuracy or, as Vezzosi saw

it, the scandalous belittlement of the great Master by Brown's popular prose. Vezzosi found it an affront that so many readers of the pulp novel actually believed some of its claims—in particular, that Leonardo had belonged to a secret society, the Priory of Sion, which knew the secret of the Holy Grail, and that he'd buried the code in his art. The book had sold eighteen million copies worldwide and was being made into a film. It was a grand moneymaking machine for countless business ventures that wanted to cash in on its popularity— everything from tours to a weight-loss diet. In the process it infuriated, among others, art scholars, citizens of Vinci, the Vatican, and traditional Catholics.

Although Brown and his representatives were not present, Vezzosi's mock trial was attended by hundreds of Vinci residents and other interested parties. Vezzosi made the case for the prosecution, using more than a hundred slides in defense of Leonardo. For instance, Brown's assertion that Leonardo was homosexual was "pure invention," he said, along with his claim that the artist designed instruments of torture. Leonardo did include a drawing of a scythed chariot that sliced people into pieces in one of his works, but he did not *invent* it. In any case, Leonardo's interest was in protecting oneself from the onrush of the deadly chariot, not in using it to harm others.

A high point of the trial was testimony by two members of Opus Dei, who were there to defend the organization from Brown's characterization. The central villain in the book was an evil albino Opus Dei member named Silas, whose mission it was to eradicate the four people in the world who knew the secret of the Holy Grail, because if the truth were known it would spell the destruction of the Catholic Church. Silas was all the more intriguing, or perhaps grotesque, because he wore a sharp instrument of self-flagellation, which was supposedly part of the Opus Dei rubric.

"I've come to tell you what Opus Dei really is," announced Massimo Marianeschi to the breathless audience. "It is not a sect; it's not black, criminal, or catastrophic. I do not flog myself or mortify my flesh. It's a lay organization with no monks. It's not Machiavellian, we don't assassinate people, we don't sanction any negative acts." He received applause from the audience, but there was also a hint of skepticism.

Martin Kemp also testified at the trial, suggesting that the choice of Leonardo by Brown was publicity driven. "The 'Michelangelo Code' would not have had the same impact," he said. Later, in an interview with *ArtNet* magazine, Martin expanded on the idea. "I often ask myself whether the book would have been as popular if it had been *The Michelangelo Code* or *The Shakespeare Code*," he mused. "Would it have had the same sales? And I think the answer probably is no. There is an element of strangeness and something almost magical about Leonardo, both in terms of his work and personality. He served Dan Brown's needs incredibly well."

The interviewer wondered if *The Da Vinci Code* had harmed Leonardo in some way by diminishing his work and his persona. Martin only laughed. "I am not too worried about that. The book is irresponsible in places because it's not just saying, 'I am a novel,' but it is setting itself out as having a certain factual basis, which is not honest. I am on the other hand happy that people are engaging with the historical character and I am keen to build on that interest. Leonardo is not damaged by that. If you do a crappy production of Shakespeare . . . it will not harm Shakespeare. He is still there and Leonardo is still there despite whatever misleading ideas people might have. I would rather people have some engagement than no engagement at all."[5]

The trial garnered a lot of publicity, and in Vezzosi's mind it vindicated Leonardo, although he could do nothing to stop Dan Brown's steady rise to fame and fortune. (Brown became

one of the wealthiest authors on the planet in the process.) Now Vezzosi was in the process of completing an important monograph, titled *Leonardo Infinito*, with an introduction by Carlo Pedretti, the world's most senior Leonardo specialist and director of the Armand Hammer Foundation.[6] Cappuzzo suggested that Vezzosi might be willing to include *La Bella Principessa*.

Vezzosi was interested in seeing the portrait, but he warned that his monograph was literally on the verge of going to press. I asked whether there was any window of opportunity. Just the tiniest, he replied, because he was unwilling to lose the chance completely.

We arranged for Vezzosi to see digital images and the Lumiere lab work, and he was immediately struck with a strong sense that it was the real thing. It just so happened that when I learned that Vezzosi was contemplating including *La Bella Principessa* in his monograph, Mina Gregori was at our home writing her own opinion.

"Call him," I insisted, "and share your thoughts. The strength of your reputation and opinion will carry a great deal of weight."

Mina put down her pen and made the call. Afterward, Vezzosi stopped the presses and added a piece on the portrait, giving it full attribution. He wrote: "There now emerges a singular novelty: a splendid portrait of a young woman in profile, carried out in pen and ink and tempera on parchment and measuring 33 × 23.9 cm [12.9 by 9.3 inches]. Dealing with an unpublished work as important as it is unexpected calls for caution. However, the refined intensity and aura of mystery that distinguish its quality and purity are such as to make the recognition of Leonardo's authorship the logical conclusion of a series of simple and clear investigations."[7]

Vezzosi went on to highlight several key points, in supportive confirmation of the observations of Mina Gregori and

Nicholas Turner, as well as the work of Pascal and Martin. These include the left-handed shading, which he called "unequivocal and impressive in its fluidity, certainty, and precision," and the interplay of light and shadow, which he says can be found in "the Madrid Codex and the anatomical sketches in Windsor from the early Milanese period."

Vezzosi noted, as Mina had remarked from the outset, that the "technique is masterly, Tuscan in style, but undoubtedly the work was finished in a Milanese context." Vezzosi also confirmed the findings and the educated speculation about the subject and the purpose of the portrait. He suggested that perhaps the portrait was not a wedding picture but was made for the purpose of a long-distance proposal. Like others, Vezzosi was drawn to the exquisite detail of the subject's eye in profile and the perfection of her face.

The support of experts and specialists was beginning to come in force. Although the technical investigations were far from complete, I felt deeply moved by the rapid enthusiasm being expressed by some of the great names in art. By the fall of 2008, Turner had prepared an official statement documenting his reasons for supporting the Leonardo attribution. He pointed to these specific factors:

1. The extremely high quality of the mixed-media portrait.
2. The carbon-14 tests, which did not exclude a fifteenth-century date.
3. The extent of the left-handed shading, especially in the face, neck, and background along the subject's profile, which was Leonardo's signature feature. "Similar dense crosshatching is to be found throughout the artist's drawings. Especially good examples of the type, also in pen, are found among Leonardo's studies of anatomical subjects. . . . The hatching strokes in the

new portrait taper from lower right to upper left, just like the strokes defining the left background in the skull studies."

4. Obedience to Leonardo's theories of illumination. In his *Notebooks*, Leonardo writes extensively on the methods of illuminating a subject with proper shadowing to convey night, day, distance, closeness, angle, and so on. "Leonardo talks specifically about the need for the background to make the subject stand out and detach itself sufficiently, contrasting light with dark and dark with light." This was artfully done with *La Bella Principessa*.

5. The presence of pentiments, signs of earlier erasures and redrawing, which are a signature process of Leonardo's.

6. The intense concentration on detail, "from the minutiae of facial features and the pattern of the woman's dress to each knot of her caul. Such an obsessive quest to record even-handedly the appearance of everything within the artist's view, seemingly down to the last particle, is a characteristic of Leonardo's creativity."

7. The stylistic parallels with Leonardo's profile portraits. "Such a delicate, subtly modulated outline is encountered in other examples of Leonardo's head studies . . . [which] satisfy [Leonardo's] precept . . . that 'you must not mark any muscles with hardness of line, but let the soft light glide upon them, and terminate imperceptibly in delightful shadows; from this will arise grace and beauty to the face.'"

8. The drawing of the woman's hair: "among the most beautiful and spontaneous of all the details in the Portrait, as well as the most complex in its colouration. Here Leonardo was not ashamed to mix his media in what for him seems to have been the most unusual

combination of brown ink and brown-red wash over black, red, and white chalk. Nevertheless, the range of textures and colours suggested by the different media enabled him to convey the velvety sheen of hair, and to distinguish subtly between those parts that are relatively loose and in the light, at the top of the head, and others in shadow, at the back, with some of the hair held in place by the mesh of the caul and the rest bound tightly together in the plait."

9. The vellum surface, which Turner believed was a fine example of Leonardo's status as a technical innovator. "The artist has successfully exploited the pitted texture of the material in his rendering of the figure's flesh and clothes." Like Martin and others, Turner acknowledges that although Leonardo was not known to use vellum, he was always poised to pioneer the latest technique and to experiment with media.

10. The style—hair, costume, setting—was consistent with Milanese court portraits of the period but also shows the Florentine influences of Leonardo's training. "From the point of view of style, the legacy of Florence is clearly to be seen in her facial type, with its echoes of heads by Andrea del Verrocchio, Lorenzo di Credi (who trained together with Leonardo in Verrocchio's workshop), and others."

Turner concluded, "Not only does this remarkable drawing by Leonardo fit in stylistically to his oeuvre as a painter and draughtsman, it also conforms to his theories of figurative representation, as set out in his *Treatise*."[8]

In the fall, I got in touch with Sir Timothy Clifford, the former director general of the National Galleries in Scotland, and

asked him to come to Lumiere for a viewing. Clifford, whom I had met on several occasions, was well known and highly regarded. A few years earlier he had discovered a drawing by Michelangelo in the Cooper Hewitt Museum in New York. When asked how he initially knew what he was looking at, Clifford responded, "Cannot I recognize my own wife over the breakfast table?"[9] Of course, he then went on to do a diligent study, but it was his contention that when one is in the presence of a Master, there was almost a knee-jerk reaction of instant recognition. I was curious to see if Clifford would have such a reaction to our portrait.

Clifford told me he was planning to be in Paris in November, and we arranged to go to Lumiere Technology together. He would write, "To my mind, the masterly appearance of the drawing not only proves that Leonardo did work on parchment but it is the finest sheet discovered for very many years by this remarkable genius of the Renaissance. It is an iconic image of haunting beauty."[10]

The forensic and historical analysis was very elaborate, and far too complex for my feeble brain. I did not deal in the world of pixels, but in the world of stories, and I was deeply engaged in the question of what story this portrait was telling the world. I believed that without knowledge of, or at least a strong theory about, the lady's identity, the most compelling evidence in the world would fail to convince. Martin agreed that determining the lady's identity represented an exciting challenge. As a historian, he was particularly drawn to the question of identity. It was not essential that the portrait's subject be identified beyond doubt, but it was critical to the integrity of the work that it be set in a plausible time and place, that it have a function in Leonardo's world. And so the question that had once captivated the masses with the *Mona Lisa* was being asked again: Who is she?

8

Beloved Daughter

Simplicity is the ultimate sophistication.

—*Leonardo da Vinci*

We can imagine Leonardo seated, holding a wooden board to which parchment was affixed, his pen caressing the lines of the young woman's lovely face as it took form on the surface.[1] She was most likely posed across from him, utterly still, her lips slightly parted. She did not smile or frown. She did not fidget with boredom. Her brow was smooth, her posture erect, her gaze steady, her air calm. She would have known that for her father to commission a formal portrait was a supreme act of devotion, and she would have wanted to do it justice. Leonardo was a busy man who had paused in his many court obligations to produce this portrait.

In spite of those obligations, which must have weighed on the artist, his concentration was complete, as though he were attempting to channel the spirit of his subject. He strove, as always, for an eternal portrait, an ode to the young woman and to her father, the duke.

That he could bring such intensity to a simple portrait was a marvel, especially considering the major commissions that were not yet completed. One of these was a grand piece for the friars of St. Dominic at Milan's Santa Maria delle Grazie: a large-scale painting that would become his portrayal of the Last Supper, which he had been working on for quite some time. According to the biographer Giorgio Vasari, the effort required long stretches of meditation because he was intent on portraying not only the group of men around the divine Christ but also their emotions at the point when Christ announced, "One of you will betray me." What were the thoughts of the innocents—love, fear, indignation, and sorrow—and could one read guilt in the expression of Judas?

Like others who had commissioned Leonardo, the prior of the monastery was anxious to see the work completed, and he could not understand what was taking so long. Vasari recounts that the prior would see Leonardo standing around lost in thought, "wasting time" when he could have been working, and it annoyed him greatly. Finally, he complained to the duke, and Ludovico il Moro sent for Leonardo. "The Prior doesn't understand," Leonardo told Ludovico. "Great artists may be working their hardest when they appear to be doing the least—forming those perfect ideas which afterwards they express with their hands."[2]

He added that he had only two heads left to do—that of Christ, whose beauty and divinity his imagination was inadequate to fully portray, and that of Judas. "I feel incapable of imagining a form to express the face of him who after receiving so many benefits had a soul so evil that he would resolve

to betray his Lord," he said, adding that he had been looking for a model of such a face. "If I can find no better, there is always the head of the Prior," he joked, causing Ludovico to roar with laughter.[3]

"You are dead right," the duke told Leonardo, and he promised that the prior would give him no more trouble.[4]

Leonardo's second major project, which had already been years in the making, was an equestrian monument to Francesco Sforza. It was clearly a standout and generated much excitement among those who saw the massive clay horse developing before their very eyes. People said they had never seen anything so beautiful or more superb, but it was a long way from completion.

Yet in spite of these large obligations, Leonardo's concentration on the girl and the portrait was absolute. With every stroke, he sought to illuminate her soul.

The woman in *La Bella Principessa* is young, and the portrait itself is quite formal. It does not have the intimate, "come hither" aura of *Mona Lisa*. Stylistically, the profile implies distance. But who is she, and when was she drawn?

Martin and Pascal, with their historical sensibility veering into the poetic, imagined her thus:

A young lady, or a girl on the cusp of maturity, is costumed for a formal portrait. Her fashionable accoutrements are those of a Milanese court lady in the 1490s. She wears a green dress, under which is a red bodice. The shoulder of the dress is "slashed" to reveal a triangle of red. Green, red, and white were favored by the Sforza family, rulers of Milan. Around the aperture runs a continuous knot design in raised thread. The central flourish at the top of the knotwork is punctuated

by embroidered points. Her light brown hair, glowing and tightly bound, is elaborately dressed with a caul of knotted ribbons, edged by a smaller interlace design. It is held in place by a thin band located at precisely the right angle on her forehead. Extruding from the net, her pigtail—the Milanese *coazzone*—is bound into a neat cylinder by a tightly circled thread. Below this binding, a flat ribbon disposed in two spirals constrains the long tresses of her hair, only a little less strictly.

The details are beautifully observed. Her ear plays a subtle game of hide-and-seek below the gentle waves of her hair. The band pulls the rear profile of the caul into a slight concavity. Below each band of the spiraling ribbon, her hair swells slightly before it is constricted again by the next loop.[5]

Can we sense a tension between the fresh innocence of the young lady and the formal courtly duties that her costume signals as her destiny—before she has become a mature woman ready for the fixed responsibilities of aristocratic marriage and the hazards of childbearing? She is, we may be reasonably certain, fated to become a young bride, betrothed early to cement a social alliance. It is not difficult to be romantic about such an image. It is almost too perfect in its refined poise.

It was irresistible to contemplate what Leonardo himself might say about the drawing and the setting. Martin and others were certain that details of the dress and style pointed to the 1490s, when Leonardo was at the Milanese court.

During that time, he did several portraits for Ludovico il Moro, including the famous *Lady with an Ermine*—which was, coincidentally, the second Leonardo work digitalized by Pascal on a visit to Kraków. The beautiful, serene portrait depicts the duke's mistress Cecilia Gallerani holding a white ermine (a symbol of purity and also a Sforza symbol) to her breast.

She was no more than sixteen or seventeen at the time, and, unusual for a young woman of the period, she was extremely well educated and an amateur poet and philosopher.

Cecilia was not a concubine in the conventional sense but a courtesan whose intellect, style, and sensuality put her on a pedestal in the court during the ten years of her involvement with the duke. She bore him one child, and then went on to marry and have four other children. The portrait itself was a new style for the artists of the period. Typically, portraits were cool and emotionless, with little hint of the subject's personality or thoughts—especially when the subject was a woman. Leonardo infused Cecilia's portrait with life. One can gaze at her countenance and see her deportment, her intelligence, and her selfhood shining through. This, the observer can see, was a woman of substance.

Many years later, Leonardo would take his humanizing approach quite a bit further with the portrait of the wife of Francesco del Giocondo: the *Mona Lisa*. That smile! It just wasn't done. Yet Leonardo apparently evoked it deliberately, perhaps by arranging entertainment for Lisa while she was sitting, and captured her amusement with his brush.

Martin had often contemplated Leonardo's special "eye for the ladies." Indeed, there is only one known male portrait in existence: the unfinished *Musician* in the Pinacoteca Ambrosiana in Milan. Martin observed:

> Leonardo da Vinci was employed by some very powerful men, including members of the Medici family, Ludovico Sforza, the Duke of Milan, and two French kings, Louis XII and Francis I. He was an innovative and masterly portraitist. It is remarkable, therefore, that we have no record of his undertaking portraits of any of his major male patrons. Instead, we have an early portrait of a woman in the Medici circle, two surviving portraits

of the Duke's mistresses, a splendid chalk drawing of Isabella d'Este, the redoubtable Marchioness of Mantua, and the famous portrait of Lisa, the wife of Francesco del Giocondo, a Florentine silk merchant who was acquainted with Leonardo's father. . . . To add to the list of 'Leonardo's Ladies,' we now have the remarkable portrait of the young woman in profile, which I have christened *La Bella Principessa*.[6]

Martin speculated that Leonardo might have been considered something of a specialist in portraying women. As Isabella d'Este, the Marchesa of Mantua, once wrote, he deployed "that air of sweetness and suavity" in which his art peculiarly excels. Who could deny that Leonardo's sensitive, even sensual, portrayals of women—from *Mona Lisa* to the new *La Bella Principessa*—have a stirring quality that seems to reach into the ladies' souls?

Vasari would surely agree, judging by his description of Leonardo's *Mona Lisa*:

The mouth, with its opening, and with its ends united by the red of the lips to the flesh-tints of the face, seemed, in truth, to be not colours but flesh. In the pit of the throat, if one gazed upon it intently, could be seen the beating of the pulse. And, indeed, it may be said that it was painted in such a manner as to make every valiant craftsman, be he who he may, tremble and lose heart. He made use, also, of this device: Mona Lisa being very beautiful, he always employed, while he was painting her portrait, persons to play or sing, and jesters, who might make her remain merry, in order to take away that melancholy which painters are often wont to give to the portraits that they paint. And in this work of Leonardo's there was a smile so pleasing, that it was

a thing more divine than human to behold; and it was held to be something marvelous, since the reality was not more alive.[7]

Martin did not believe, as many did, that Leonardo was homosexual. He could find no reflection of sexual orientation or preference in the artist's portrayals of men and women. Leonardo's reverence for beauty in all its natural forms was more profound than sexual fantasy.

Perhaps, Martin surmised, other court artists were sufficient to the task of portraying male figures—on horses, on shields, at war, stamped on coins—with their stark formality, whereas only Leonardo had an eye for bringing life to the faces of beloved females. He also rendered them with an intimacy that was suitable for private settings, not formal portraits. In each case, the subject appears to be responding to a person or an activity outside the picture. She is alive and fully human.

Although the portrait of Cecilia Gallerani was probably produced several years before *La Bella Principessa*, there are enough stylistic similarities to place the latter comfortably in the period of the Sforza court. Martin advised that there were five women in Sforza's court who might have sat for such a portrait. However, three of them—Ludovico's wife, Beatrice; Isabella of Aragon, the wife of Ludovico's nephew Gian Galeazzo; and Ludovico's niece Beatrice—could be ruled out, since existing portraits showed what they looked like. There remained two possibilities: Ludovico's niece Anna and his illegitimate daughter Bianca. Kemp found himself focusing on the young woman Bianca for a number of reasons, including her extreme youth (Anna was six years older).

Bianca, the illegitimate daughter of Ludovico's mistress Bernardina de Corradis, was the apple of the duke's eye. In

the secularized Milan of the period, the distinction between wife and mistress was not so morally loaded. Because Bianca was so highly favored, Ludovico took steps to legitimize her in 1489, before betrothing her to Galeazzo Sanseverino, the highly regarded commander of his armies. Since Bianca was a mere eight or nine years old at the time, the wedding date was set for 1496, when she would be at least thirteen.

Bianca's future husband was a major figure at the court, a dear friend of the duke's and a patron of Leonardo's. Leonardo would often visit Galeazzo's stables to measure his horses and sketch the anatomical drawings that would become so highly prized. One might imagine that the two men also discussed weaponry, which was a topic of great fascination to Leonardo.

Evidence of Bianca's favor with her father is the fact that he commissioned the creation of a sonnet by the court poet, Bernardo Bellincioni, on the occasion of her betrothal.

> One can recognize and see the person,
> With a great mind in their early years;
> Today Bianca will be for the world a phoenix,
> Because good fruit stems from its roots,
> And she is the heir of her father's mind.
> Heaven accords her a groom
> Who will make them both happy.
> What an unerring choice, both proper and wonderful,
> Was made by my patron Ludovico,
> Because nothing is missing in this couple.
> This star [Bianca] was lacking for Galeazzo,
> And Galeazzo, friend of virtue, was lacking only Bianca.[8]

It was common during the Renaissance for portraits to be commissioned around major events in a subject's life, and the Sforza court, with its love of pageantry, followed this tradition.

The portraits were often bound into tribute books, often garish and elaborate, that sang the praises of the subject. Indeed, Leonardo's portrait of Cecilia Gallerani was accompanied by such a poem, which began:

> Nature, what provokes you, who arouses your envy?
> It is Vinci, who has painted one of your stars![9]

Knowing of Bianca's place in Sforza's heart and of her betrothal to Galeazzo, we can quite plausibly say that she was the subject of *a* portrait. There is also evidence that this portrait was bound into a book, possibly of poems, which was the tradition. Impressions on the grooves of the vellum of our portrait suggest that it was removed from a book. This may help explain why the portrait disappeared from view for such a lengthy period.

All of the beauty and promise evident in the portrait was short-lived. In November 1496, only four months after her marriage, Bianca died as the result of a fatal *passione de stomach*. The cause is not known, although one speculation is that she may have had an ectopic pregnancy. At the time, there were also whispers of the possibility of poisoning, but they led nowhere.

Niccolò da Correggio, the court poet who replaced Bellincioni after his death, wrote the bittersweet tribute:

> Bianca, the daughter of the Duke,
> having achieved two lustri
> Plus a little more than one half of the third,
> Was delighting with Galeazzo in the pleasures of marriage.
> When conjoined in passion within their encampment,
> In the midst of a such a sweet game,

She departed her body
And went amongst the elected souls,
Her beauty and grace buried first in human breasts,
Not content with being only in one place.
Why do you reside in such different graves?
The stones have the bones,
While the world preserves her name,
Since her virtues can be preserved in prose and poetry.
Above all others, Galeazzo, for whom the harvest
Was reaped while still green,
His fruits becoming lost,
Can say that Death was unripe for him.[10]

Incidentally, a *lustro* is a span of five years, so the poem would indicate that Bianca was thirteen or fourteen at the time of her death. Studying *La Bella Principessa*, Martin had a new thought. Noting her lack of celebratory jewelry and the restraint of her costume, he had initially been puzzled. He especially found the absence of pearls interesting. The Sforza court delighted in pearls, and the duke had something of a fetish for them. Martin now wondered if the portrait might have been commissioned as a memorial at the time of Bianca's death and not as a celebratory matrimonial portrait. "If so," he wrote, "Leonardo has evoked the sitter's living presence with an uncanny sense of vitality."[11]

Martin and others who viewed the portrait from a historical perspective could not fail to conclude that everything about the style and fashion of the subject was consistent with the Milanese court of the late fifteenth century.

The long braid she wears in her portrait is called a *coaz-zone*—it was typical for the fashion-conscious ladies of the court to wear extremely long and elaborately bound pigtails

in the 1490s in Milan; the mistresses could be portrayed in less conventional poses, but their daughters, the princesses, warranted the formal profile.

While he was studying the portrait, Martin was contacted by a young Italian costume historian named Elisabetta Gnignera. She was in the process of writing a study of hairdressing in the fifteenth century, and she wanted to include *La Bella Principessa*, since in her opinion "the portrayed Lady wears a beautiful example of a late fifteenth century/early sixteenth century *coazzone* hair dressing—the so-called *acconciatura alla spagnuola* [Spanish hairdressing], which was in fashion in Italy no later than the first years of the sixteenth century."[12]

As Gnignera studied the portrait, she elaborated on the following points to Martin:

- The hairstyle in *La Bella Principessa* was in fashion in Italy from 1491 to 1499—and "absolutely not beyond 1500." This would fit the period of Bianca's marriage, as well as Leonardo's presence at the court.
- In 1491, when Beatrice d'Este entered the Sforza court as the wife of the duke, she established herself as a trendsetter by putting into fashion a particular style of *coazzone*, which she made unique with subtle differences from the Spanish style. This is the *coazzone* worn by the subject of *La Bella Principessa*.
- By the final years of the fifteenth century, a new hairstyle—the *foggia alla Francese* (French style)—replaced the *coazzone*. An example of the new style can be found in the drawing of Isabelle d'Este attributed to Leonardo, with long hair wrapped in a subtle hairnet.

Gnignera's input confirmed what Martin's studies had showed him regarding the high fashionability of the *coazzone* in the Sforza court during the 1490s. To achieve the required

length on these elaborately bound pigtails, a hairpiece was generally added and colored to match the lady's hair.

Martin was also drawn to the intricate knot pattern in the fabric. Leonardo had been fascinated by knots since at least 1480 and had earlier used them as a motif in his portrait of Cecilia Gallerani. Martin would later write down his view that the two examples "show not only an identical way of fashioning the loops, but the same skill and intelligence in rendering the perspective as the ornament follows curves and recedes into the distance. This element is very important, for it confirms that we are in the presence of two works realized with the same creative spirit, the same sense of perfection, and an identical manner of treating details, however tiny they might be."[13]

Vezzosi was also very taken with evidence found in the patterns, commenting, "The 'Leonardesque knot' on the shoulder is obviously a paradigm of the artist and not only a decorative feature. It constitutes here an original assemblage, in a unique arabesque, in the form of geometrical matrices with two knots, alluding to symbols of infinity, like those drawn at the end of 1473 and which can be seen elaborated in the clothing of both *Lady with an Ermine* and the *Mona Lisa*. The border reinforces it, also with simplified knots, which run around the edge of the sleeve in a reticulated pattern, which is, in its turn, created by the most refined interlacing. The hairdo, called in Milan a 'coazzone,' is also characteristic of the period and was fashionable at the Sforza court."[14]

Cristina Geddo concurred, writing,

This was a fashion of Spanish origin, imported by Milan upon the marriage of the daughter of the King of Naples, Isabella of Aragon, to Gian Galeazzo Sforza (1489), but refined and imposed by Beatrice d'Este, daughter of Eleonora of Aragon and younger sister of

Isabella, who married Ludovico il Moro in 1491 and was already dead in 1497. The hairstyle, a *"coazzone,"* is also worn by the *Belle Ferronière* (*Lucrezia Crivelli*) in the Louvre, datable to about 1496–99 and thus chronologically close to our portrait. This look quickly dwindled at the turn of the century with the arrival of the French and the abrupt end of the era of Ludovico il Moro, and was replaced by the loose, layered cut inspired by Transalpine fashion, already adopted by Isabella d'Este in the Leonardo cartoon, datable to early 1500. . . . This is therefore an important element for securing the *Portrait of a Young Woman in Profile* to Milanese territory, and to a time period before 1499, when the artist left the Lombard capital.[15]

In other words, the Master's hand is distinctive.

"The lady in profile is an important addition to Leonardo's canon," Martin said with certainty. "Within the apparently inflexible format of a profile, it exhibits a graphic refinement and poetic beauty that lies far beyond what anyone in his circle could accomplish. He has characterized the youthful sitter, perhaps the tragic Bianca, with infinite tenderness, decisively surpassing (as he would fervently have wished) the effusions of the court poets."[16]

Based on an accumulation of interlocking evidence, Martin had no doubt of Leonardo's authorship. "After forty years in the Leonardo business, I thought I'd seen it all," he told me emotionally. "But I had not. The delight I had when I first saw it has been reinforced enormously. I'm absolutely convinced." He added, with a slight shaking in his voice, "Above all, it's thrilling to look at. There is an incredible freshness, a delicacy. I have seen *Mona Lisa* out of its frame. I have seen *Lady with an*

Ermine out of its frame. All of Leonardo's works have an inner life. The sitters seem to live. This is a rare gift that no other artist, with the possible exception of Rembrandt, could achieve."

He concluded, "After repeated viewings, scientific analysis, and intensive research, I have not the slightest doubt that the portrait that I am calling *La Bella Principessa* is a masterpiece by Leonardo da Vinci." One of the greatest Leonardo scholars in the world was a believer.

I realized that no matter how many experts praised the work as a Leonardo or signed documents stating their beliefs, there would still be an opposing side that would forever question its authenticity. I found the notion somewhat depressing. If only there was a way to prove Leonardo's authorship beyond doubt!

In that respect we had a potential trump card. Pascal and Martin spoke to me about the fingerprint and palm print that were clearly visible in the pigment—and almost certainly belonged to Leonardo. Martin had a fingerprint expert in mind who might confirm it.

9

The Art of Fingerprints

Anyone who conducts an argument by
appealing to authority is not using his
intelligence; he is just using his memory.

—*Leonardo da Vinci*

Peter Paul Biro grew up surrounded by art. His father, Geza
Biro, was a moderately well-known artist and conservator,
and Biro began working in his father's Montreal gallery and
studio as a boy. Now in his fifties, comfortably settled in
Montreal with his wife, Joanne, a mezzo-soprano, Biro retains
a fixation on art, the legacy of a remarkable history, and occa-
sionally pauses to enjoy his favorite hobby of stargazing or his
marine fish tank filled with live corals and exotic creatures.[1]

Geza Biro, who died in 2008 at the age of eighty-nine,
grew up in Budapest, where he had the ambition to be a
great painter. He studied at the Royal Academy of Fine Arts

in Budapest and developed a signature style. Like Leonardo da Vinci, Geza was left-handed. But during World War II, he was drafted into the Hungarian army and was taken captive by the Russians. While he was being transported to a prison camp, the truck he was in crashed, and Geza's left arm was crushed. He never gained full use of it again.

After the war Geza learned to paint with his right hand, and even though he was accomplished, he would never know whether he could have been great. In the late 1960s, he left Budapest, immigrating to Montreal with his wife and his two sons, Laszlo and Peter Paul. There he set up a gallery and conservation studio.

The story of how Peter Paul Biro came to marry the gritty world of crime analysis with the elite world of art authentication is fascinating. He and his brother began working with paintings at a very young age, learning the ropes at their father's knee. It was an exciting and challenging environment to grow up in, and it provided an early introduction to the difficulties of art authentication.

Biro trained and practiced as a conservator, and he might have spent his life in this work were it not for an incident of fate. As Biro tells it, about twenty years ago, a client walked into his Montreal conservation laboratory with a large canvas that he wanted cleaned and restored. Biro noticed immediately that the painting seemed heavily overpainted, and recently so. He provided an estimate for cleaning that was quite high, and the client balked.

"It's not worth it," he said grumpily. Then he gave Biro a calculating look. "Will you buy it from me?" he asked.

Biro was taken aback. "No," he said dismissively, but then he inquired curiously, "For what?"

The man was clever. "Why don't you clean half of it and then you can hang it as a demonstration of your work—a before and after?" he suggested.

After some haggling, the two men struck a deal, and Biro found himself the reluctant owner of what could only be described as a wreck. The painting sat unattended for several months. Finally, Biro got around to testing a small area, removing the overpainting on a portion of sky to see what happened.

"We were awestruck at the beauty of the original surface coming to light," he later said. Now excited, Biro threw himself into the task, removing ever larger areas of the overpainting that was hiding the original surface. As he worked, the conviction grew inside him that this was the work of a Master. But who?

Biro was a practiced student of art, and he determined that the best candidate was the celebrated British painter J. M. W. Turner. For the next few years, Biro tried and failed to gain recognition and acceptance for his find from the imperious and closed art world. No one would give him a hearing. At best, he was able to get the painting judged as a "good Turneresque work." His frustration bordered on outrage. "*Turneresque*? Why not Turner?" It was impossible to break through the stone wall of art experts.

Biro gave up his quest. It was pointless. But then, quite unexpectedly, he stumbled upon a new road to authenticity. In 1985, during a visit to London's Tate Gallery, he found himself contemplating one of Turner's great works, the *Chichester Canal*. Suddenly he noticed that Turner had used his fingertips to model the scene. It was Biro's eureka moment. He realized that these were Turner's fingerprints, right there in full view. Why not compare them with those in the painting in his possession?

He did, and voilà! He had his proof. With time and media attention, some Turner scholars were persuaded that Biro was onto something. In 1995, *Landscape with a Rainbow* was attributed to Turner—the first painting to be authenticated based on fingerprint evidence—and it was sold at the Philips Auction

House in London for more than $150,000. (It would have sold for more had it not been in poor condition.) For Biro it was a case of determining the painting's "forensic provenance."

Thus began a passion and a career. For twenty years, Biro applied the forensic methods used to solve crimes to the mysteries of art attribution. As part of his database, he conducted an ongoing study of the works of Turner in the Turner Bequest at the Tate Britain gallery, comprising some thirty thousand pages of notes, sketches, and watercolors. He discovered about a thousand fingerprints and hoped to eventually compile up to three thousand. He liked to quip, "The issue is not who committed the crime but who committed the painting or drawing."

What excited Biro most about the science was the way it opened up new possibilities in art authentication. Traditionally, art had been authenticated by the inexact methods of provenance and connoisseurship. Provenance was the art's historical paper trail, which was often sketchy, especially for very old pieces. One hoped for provenance but expected disappointment. Connoisseurship relied on the expert's eye: the ability to compare one work with another and judge whether it was drawn by the same hand. Connoisseurship was by nature subjective. Biro believed that with fingerprint evidence, a work of art could literally be traced back to the artist's hand, and in that respect it could fill in the blanks from history or knowledge.

Biro never tired of talking about the marvelous science of fingerprints. He found that in the early twentieth century, mathematical analyses predicted the possible existence of sixty-four billion fingerprint patterns, considerably more than the present human population of the planet. Every fingerprint was an original; however, the individuality of a fingerprint was not determined by its general shape or pattern but by the configuration of its ridge characteristics: the combination of a number of characteristics in a given finger impression that are specific to a particular print.

There are three basic types of fingerprints: latent finger-prints, stamped impressions, and plastic impressions. A finger may leave a latent print due to the presence of fatty sub-stances produced by the sebaceous glands in the skin. This is the kind of print found on objects such as drinking glasses and windowpanes. It is called latent (invisible) because it requires development with black powder or iodine fuming to make it visible. A latent print cannot survive for long.

A stamped impression is a mark left with whatever material contamination was present on the finger (such as ink or paint). The longevity of the fingerprint is contingent on the longevity of the substance deposited. If that substance were oil paint, the print might, if conditions permit, be preserved indefinitely.

A plastic impression is left when the finger was impressed into soft material, such as partly dried paint, putty, wax, or a similarly pliable substance; in other words, it can be seen in relief. The longevity of the impression again depends entirely on the substance, combined with other environmental factors. Under the right conditions, however, oil paint can preserve a plastic impression indefinitely.

Biro was quick to explain that contrary to popular belief, fingerprint analysis is not an exact science. The final verdict relies on an analysis of points of similarity in the prints, gener-ally ranging from seven to twelve. Identifying fingerprints on works of art is even more delicate and difficult than for crime cases. For one thing, crime labs use methods such as staining and dusting that potentially destroy the object, whereas the art examiner must guard against any destruction and normally relies on images rather than the original. In addition, the art investigator does not look for latent prints—the kind left on a glass or other surface—because they break down quickly and would not be there to find.

Biro was focused on prints that were clearly left by the art-ist during the creation of the work. "Such evidence," he said,

"has temporal ramifications, the print having been sealed in time, creating a veritable time capsule from when the picture was executed."[2] However, he acknowledged that an old painting always suffers from wear and tear, the effects of chemical and physical pollutants, and the rigors of cleaning and restoration. In these cases fingerprints could suffer as well.

The multispectral camera opened up possibilities that didn't exist before of enhancing barely visible prints to the point where comparisons could be made. He observed that the new technology "enables the isolated amplification of the fingerprint information against its background, eliminating other interference such as 'noise' created by the imaging device."[3]

Biro was confident that an investigation of fingerprints in the work of great artists was a valid occupation. "Artists have used their bare hands in the creative process—employing their fingers to evoke a variety of effects—ever since prehistory," he noted. "The potential for fingerprints to be left on the surface of their work, either by accident or by design, is thus hardly negligible. In the Renaissance, for instance, both Raphael and Leonardo relied on their fingertips to stamp fine ridges onto their paintings and create delicate and subtle evocations of shading unattainable with the brush."

Of course, as in any forensic investigation, the primary question in identifying fingerprints is whom did they belong to. The artist? Assistants? A restorer? This is where the database came in handy. Biro had been able to authenticate Turner's prints by comparison with others. Might the same be done with a potential Leonardo?

By the time we decided to send the digital file to Biro for his review, he was already quite well known because of his involvement with the authentication of an alleged Jackson Pollock painting.

The story of the Pollock painting epitomizes a popular fantasy about great art: that it is hiding in plain sight in the attics, flea markets, and yard sales of the world. The story of this painting, which was memorialized in a 2006 documentary, *Who the #$&% Is Jackson Pollock?*, directed by Harry Moses, fits into that mode. It was also the subject of a *60 Minutes* report on May 6, 2007, titled, "The Thrift Shop Jackson Pollock Masterpiece."

Teri Horton was a seventy-three-year-old retired long-haul truck driver from California who came upon a wildly colorful painting in a thrift shop. She bought it for $5, thinking it would be perfect to cheer up a friend who was down in the dumps. She had no inkling that it might be a valuable piece of art. In any case, the 48-by-65-inch painting was too big to fit through the doorway of her friend's trailer, so Horton decided to sell it at a yard sale. There it was noticed by a local art teacher who declared he thought it might be a Pollock, causing Horton to say, famously, "Who the f— is Jackson Pollock?"

In the film, Moses said, "I think that the evidence threatens scholarly expertise. Connoisseurship no longer plays a dominant role in authenticating works of art. The art world thinks it can dismiss Teri because she's a truck driver. My movie is a story about class in America."

It's a fascinating aside—a controversy that pitted an ordinary woman against the snobbiest of the snobs of the art world. If anyone characterized the unappealing elitism of the art community, it was Thomas Hoving, the former director of the Metropolitan Museum of Art. Asked to review the painting, he sniffed at it dismissively and declared, "This painting has no artistic soul." (I had my share of disputes with Hoving. Before he died, he saw a photograph of *La Bella Principessa* and declared it "too sweet" to be a Leonardo, explaining that Leonardo's pictures were "tough as nails." I couldn't begin to fathom what he was talking about.)

Teri Horton clearly enjoyed the spotlight and especially her status as an outlier in the snooty art world. Interviewed by CNN journalist Anderson Cooper on July 16, 2003, she said, "There is no way anybody can get up and look at that painting, or any Pollock for that matter, and be able, by visual examination and wait[ing] for this mystical feeling that they get that comes over them, to decide whether it is or whether it is not authentic." She added snidely, "They call it *connoisseurship*"—stretching it out as if it were a dirty word. Asked by Cooper what *she* would call it, she laughingly replied, "Bulls—."

In the midst of the efforts to authenticate the Pollock painting, Biro was hired. After finding a partial fingerprint on the back of the canvas, he set out to look for a fingerprint impression of Pollock's to which he could compare it. Pollock had never served in the military or been arrested, so his fingerprints were not on file. Biro visited Pollock's studio in East Hampton, New York, where he found a fingerprint on a blue paint can used by Pollock. He concluded that the two fingerprints were a match.

Biro checked his work with André Turcotte, a retired Canadian police sergeant who ran the Quebec Police fingerprint lab for more than a decade. Turcotte agreed that the prints matched. But the International Foundation for Art Research, a nonprofit organization that is the primary authenticator of Pollock's works, balked, saying that Biro's method was not yet universally accepted.

Complicating the question was the complete absence of any known fingerprints by Pollock. There was no possibility of making a real comparison. Biro's only option was to build a case through a preponderance of evidence. He could only make cross-comparisons. Nonetheless, he believed he had one important factor in his favor: fingerprinting had been around for more than a century as a true science. There were

no gray areas. There was no room for error or review. Done properly, fingerprint analysis shows a match or does not show a match. Nevertheless, the Pollock attribution remains in limbo.

After his experience with the Horton "Pollock," Biro threw himself into the work with more fervor than ever. He cofounded a company dedicated to the use of scientific methods to help the art community wrestle with these tricky and often controversial issues. He set up laboratories in London and Montreal. His dream was to be at the forefront of an entirely new field: utilizing DNA as evidence in artwork. The old way and the new way were perhaps on a collision course. But it was exciting to watch.

In his workshop, Biro studied Pascal's digital work on *La Bella Principessa* with great care. Lumiere Technology's multispectral images revealed two specific impressions on the drawing. One was a stamped impression in ink of a finger near the upper left edge of the vellum. The other print was a plastic impression in the subject's neck, which appeared to be from the outer edge of the artist's hand.

There was plenty of evidence to support Leonardo's use of fingers and hands to blend in shade. As Martin noted, during the period in question, "Leonardo was pushing his chalk techniques in a painterly direction . . . confirmed by the handprint visible in the Lady's neck, assuming that it is deliberate and not accidental. His paintings before 1500 show extensive use of the fingers or hand to blend the modeling, particularly in the flesh tones. It generally looks as if the soft, fleshy area of the right edge of his right hand was used for this purpose, while he applied the media with his left hand. While he was not unique in exploiting his fingers and hands in paint or priming layers, he did use the technique in a typically widespread and

varied manner. It is likely that more handprints were visible in the flesh of *La Bella* before the restoration(s)."[4]

Biro also examined a number of images from Lumiere Technology's database, including the *Mona Lisa* and *Lady with an Ermine*. He found that all of the works contained both fingerprints and palm prints that could be used for comparison.

What, specifically, was he looking for? For two fingerprints to be considered a match, they must be compared in accordance with basic principles, such as being reproduced to the same scale and presented in the same orientation. If these conditions exist, one of three levels of correspondence is possible.

Level one involves a comparable flow of ridges, showing a similar pattern of loop, arch, whorl, and delta (which are the identifying fingerprint marks). Level-one comparison narrows the field of contributors while not being entirely conclusive. For example, twins often have very closely matching prints, and a finer level of detail is needed to see the difference.

Level two involves more detailed characteristic ridge patterns and deviations. If two prints correspond in level-one detail, then the examiner proceeds to look for level-two detail, involving the bifurcations, crossovers, ridge endings, and so forth. "Characteristic" patterns are essentially deviations in a ridge's path. When a ridge's path divides into two branches, it is called a bifurcation. When two bifurcations appear on the skin overlaying each other, they are called a trifurcation. If these are found in the comparisons in the same basic position, it's a match.

Level three involves the minutest aspect of ridge impressions, such as the outline of the ridges and the placement of sweat pores.

The number of corresponding features necessary for a match is not uniform from country to country and is generally left to the examiner's discretion and expertise.

For Biro, the work that was the most fruitful was Leonardo's unfinished *St. Jerome in the Wilderness* at the Vatican, which contained more than two dozen fingertip impressions left in the wet pigment, clearly used to shape the underpainting for the background of sky, water, and rocks. *St. Jerome in the Wilderness* was significant because it was painted early in Leonardo's career, before he had apprentices. There was no doubt that he was the only artist to touch the painting at that time.

The digital enlargement of *La Bella Principessa* helped Biro to recover ridge-path detail at a resolution approaching what was necessary for fingerprint examination. It revealed a number of recognizable characteristics that could be compared with those of a digitally enhanced fingerprint on *St. Jerome in the Wilderness.* Biro singled out eight characteristics discernible on both prints. He concluded that the correspondence between the fingerprints on Leonardo's *St. Jerome in the Wilderness* and *La Bella Principessa* provided a highly valuable piece of evidence. Although it might not be sufficient to establish innocence or culpability in a legal case, the coincidence of the eight marked characteristics was strongly supportive of Leonardo's authorship of *La Bella Principessa.*

To further strengthen his findings, Biro gained access to a high-quality photograph of an X-ray of Leonardo's *Ginevra de' Benci,* which was on display at the Washington, D.C., National Gallery of Art. He discovered a fingerprint that was similar to the others.

Biro found the examination of Leonardo's fingerprints thrilling, because their presence revealed so much about the genius of the artist. Leonardo used his fingers and palms as extensions of the brushes—he got literally down into the painting, working it over as if he were sculpting. Leonardo's brilliant and effective use of the ridges on his fingers and hands clearly contributed to the subtle and sublime effects

he created here and in so many of his works. It revealed the imaginative and ever exploring creative mind for which he is so revered.

Martin believed that the fingerprints, though not conclusive on their own, added an important piece to the puzzle. He wrote to me, "This is yet one more component in what is as consistent a body of evidence as I have ever seen. I will be happy to emphasize that we have something as close to an open and shut case as is ever likely with an attribution of a previously unknown work to a major master. As you know, I was hugely skeptical at first, as one needs to be in the Leonardo jungle, but now I do not have the slightest flicker of doubt that we are dealing with a work of great beauty and originality that contributes something special to Leonardo's oeuvre. It deserves to be in the public domain."

The jury is still out on the fingerprint evidence as full proof of a Leonardo attribution. Jean Penicaut is in the process of attempting to obtain permission from Vatican authorities to digitize Leonardo's *St. Jerome* in order to properly compare the fingerprints. This is a scientific study in progress, quite promising, but ongoing nevertheless. Even so, when I read Biro's report, I saw one more piece of a complex puzzle leading to Leonardo.

It was time, at last, to introduce the world to Leonardo's beautiful princess—once lost but now most assuredly found. Little did I know the upheaval that awaited me.

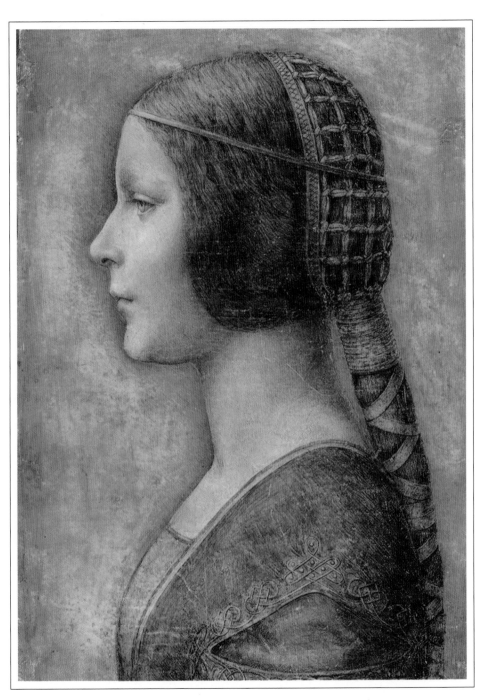

La Bella Principessa. PHOTO BY PERMISSION OF LUMIERE TECHNOLOGY.

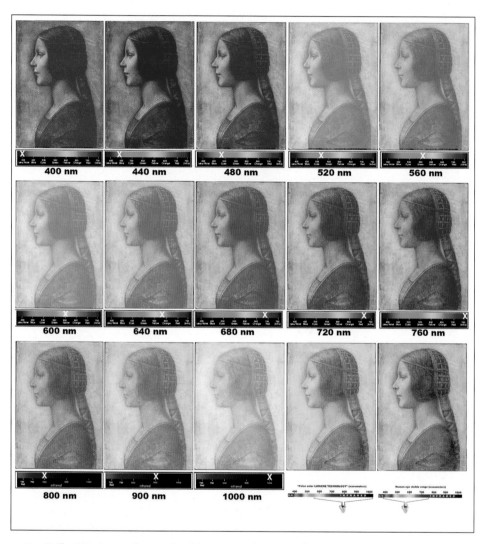

La Bella Principessa shown in thirteen multispectral images, plus reconstructed scans in false color and infrared daylight. PHOTO BY PERMISSION OF LUMIERE TECHNOLOGY.

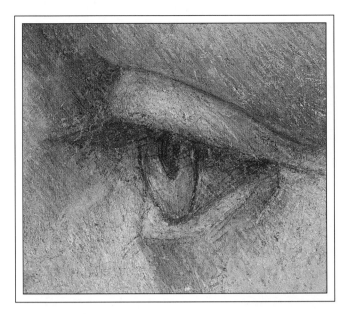

A close-up of the eye, which reveals Leonardo's signature technique. PHOTO BY PERMISSION OF LUMIERE TECHNOLOGY.

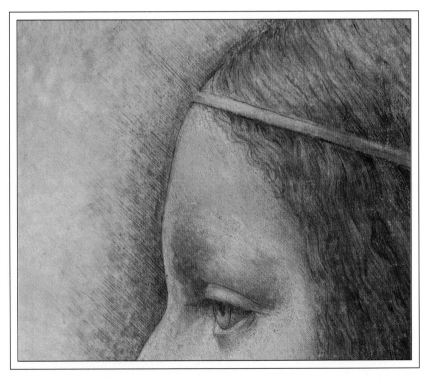

The enlargement allows a clear view of Leonardo's typical left-handed hatching around the profile and in the background. PHOTO BY PERMISSION OF LUMIERE TECHNOLOGY.

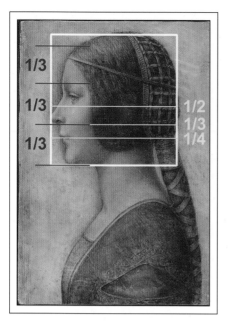

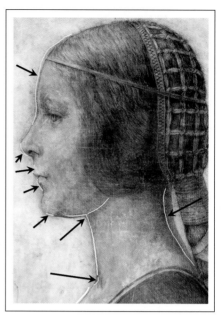

Pascal Cotte's measurement of the head and face shows Leonardo's impeccable specifications. PHOTO BY PERMISSION OF LUMIERE TECHNOLOGY.

Leonardo's typical pentiments are shown in *La Bella Principessa*. PHOTO BY PERMISSION OF LUMIERE TECHNOLOGY.

Leonardo's intricate knot patterns are in evidence on the image of *La Bella Principessa*. PHOTO BY PERMISSION OF LUMIERE TECHNOLOGY.

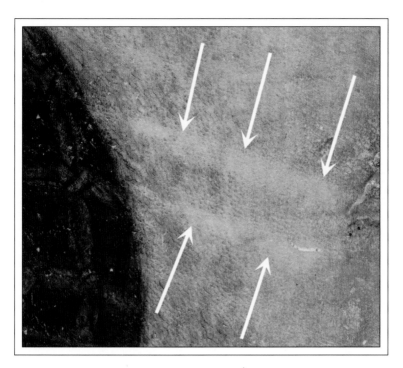

Detail of the pentiments behind the sitter's head, showing areas of the artist's erasures—typical of Leonardo. PHOTO BY PERMISSION OF LUMIERE TECHNOLOGY.

Close-up of a portion of the hair and headdress, showing the intricate detail. PHOTO BY PERMISSION OF LUMIERE TECHNOLOGY.

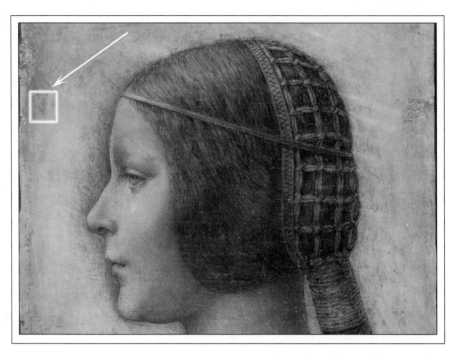

Location of Leonardo's fingerprint. PHOTO BY PERMISSION OF LUMIERE TECHNOLOGY.

Pascal Cotte found numerous comparisons between Leonardo's *Lady with an Ermine* and *La Bella Principessa*. In particular, he noted remarkable similarities in the anatomical structure of the eyes. PHOTO BY PERMISSION OF LUMIERE TECHNOLOGY.

Pascal Cotte (left) prepares to use his revolutionary multispectral imaging camera to photograph the *Mona Lisa* in a private room in the basement of the Louvre. PHOTO BY PERMISSION OF LUMIERE TECHNOLOGY.

Pascal and Martin examine the place in the *Sforziada* showing the missing page and the protruding remnant and find a match for *La Bella Principessa*. PHOTO BY PERMISSION OF LUMIERE TECHNOLOGY AND MARTIN KEMP.

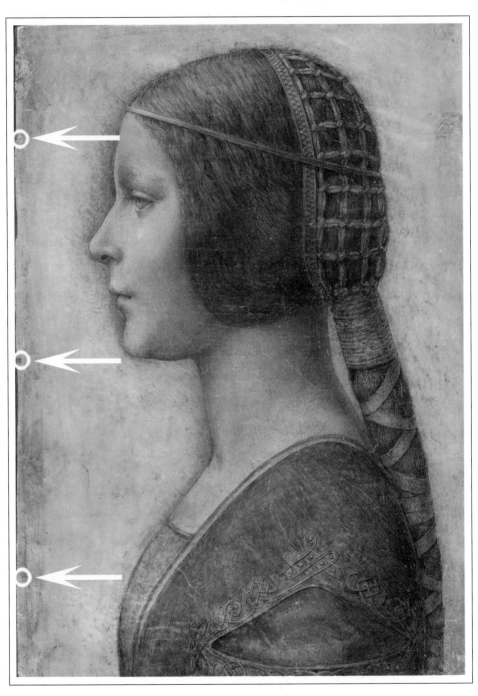

Circles and arrows mark three holes showing that the image was once part of a codex or manuscript. PHOTO BY PERMISSION OF LUMIERE TECHNOLOGY.

10

The World Reacts

The greatest deception men suffer is from
their own opinions.

—*Leonardo da Vinci*

Katsushika Hokusai, one of the world's great artists, who lived between 1760 and 1849, famously exclaimed on his deathbed at eighty-nine years of age, "If only heaven will grant me a few more years, I will become a real painter."[1] To that I can say without false modesty that if heaven grants *me* a few more years, I might just understand a little about art. Certainly, the moment the news of *La Bella Principessa* hit the world, I began my education anew.

It's not as though there had been complete silence about the project. In the summer of 2008, while Biro was still making his fingerprint study, details of Lumiere's findings began

to leak out to the press. Pascal was openly saying he believed the work was by Leonardo, and the buzz began.

The press was interested in tracking down the dealer who had bought the portrait at the Christie's auction in 1998. In the beginning, it wasn't publicly known, and that was mostly my doing. I had decided to be a gentleman and withhold Kate Ganz's name. It was a small deception, made to save Kate the embarrassment. I didn't want to cause her problems by highlighting how she'd kept Leonardo in a drawer for nine years. I thought my motivations were quite honorable. But Kate didn't see it that way.

When the first media coverage appeared about the portrait, Kate herself contacted the *New York Times* and said straight out—and somewhat indignantly—that she was the previous owner.[2] She was clearly incensed by the suggestion that she'd missed a Leonardo, and she wanted to defend herself. However, I found her explanation somewhat disingenuous. She told the *Times* that she had considered a Leonardo attribution when she bought the work but had rejected it after consulting a number of art historians and a conservator at a major American museum.

She didn't name these detractors but boldly declared, "At the end of the day, when you talk about connoisseurship, it comes down to whether something is beautiful enough to be a Leonardo, whether it resonates with all of the qualities that define his handwriting—sublime modeling, exquisite delicacy, an unparalleled understanding of anatomy—and to me this drawing has none of those things."

Oh, really? I found Kate's entire explanation suspect. For one thing, if she had really harbored any suspicions that she was holding a Leonardo, she would have launched a more serious investigation. She never so much as carbon-tested the work to see if the nineteenth-century attribution held. It seemed to me that if there was a possibility that she was

holding a fifteenth-century work, much less a Leonardo, she would have hung onto it and conducted a vigorous investigation.

And who were these experts she had summoned to her side? I wanted names. They certainly could not match the growing list of experts on the side of a Leonardo attribution for *La Bella Principessa*—a large cast of the best and brightest, a group so impressive that it nearly constituted a consensus:

Nicholas Turner
Mina Gregori
Martin Kemp
Timothy Clifford
Alessandro Vezzosi
Carlo Pedretti
Cristina Geddo
Claudio Strinati

I would put this august assembly up against Kate's anonymous experts any day!

Personally, I thought Kate was exaggerating—that she had never considered the portrait a Leonardo. One could not say one day, "This might be a Leonardo," and the next day state, "This is a nineteenth-century German artist." It does not compute. The two are like apples and oranges.

In any case, Kate is perhaps not always the best judge of the Masters. In his book, *Artful Tales: The Unlikely and Implausible Journal of an Art Dealer, 1957–1997*, Richard Day recounts the story of Ganz's miss on a Michelangelo attribution.[3] Much to her embarrassment, Ganz had sought advice from her former art history teacher at Hunter College, and when he dismissed the Michelangelo attribution, she went along with his advice. Perhaps her collection of expert advisers is not all it's cracked up to be.

There wasn't much media attention over the *La Bella Principessa* skirmish, and Kate and her explanations soon faded from view. Biro's report on the fingerprint came, and with that we decided to launch an official investigation.

I had some fantastic news to accompany the announcement. Vezzosi had arranged for *La Bella* to be displayed at an upcoming show for which he was the artistic director. Called "And There Was Light: The Masters of the Renaissance Seen in a New Light," the show, to be held in Gothenburg, Sweden, would be *La Bella Principessa*'s official debut. It was courageous on Vezzosi's part. He wasn't going to wait for the masses to come to the portrait. His conviction was so strong that he was willing to bring it to them.

What do you do when you know for certain that you are holding an authentic portrait by Leonardo da Vinci? How do you tell the world? Suddenly, all I wanted to do was retreat. I fantasized about keeping it secret, avoiding the crush of publicity. I loved the life I had with Kathy, and I knew that once I announced a new Leonardo discovery, the tranquillity we cherished would be lost.

I had an idea of the debate that would ensue over the authenticity of *La Bella Principessa*. In my own heart I had no doubt it was a Leonardo, and Pascal and Martin would back me up, as would others like Mina Gregori and Nicholas Turner. But I also knew that for some media and art critics, the game would instantly be on to show that this was not a Leonardo. I had to be ready for the sheer cynical weight of their skepticism.

I had chosen the man I wanted to write the story. As a point of professional respect, I had decided not to go with the "media circus" crowd like CNN or the *New York Times*. They would surely pick it up, but I wanted the first publication to

be a respectable vehicle within the art world. A serendipitous meeting sealed the choice: a somewhat obscure, high-quality trade publication called the *Antiques Trade Gazette. ATG* was the bible of the art and antiques trade, a London-based weekly newspaper for serious buyers and sellers that had been in business since 1971.

In the summer of 2007, six months after I had acquired *La Bella Principessa*, I was in Brussels, coming from an art fair and waiting for a taxi. Noticing another man also waiting, I offered to give him a lift to his hotel. He turned out to be Simon Hewitt, a well-regarded and influential journalist with *ATG.* I knew and admired his work, and during our twenty-minute ride together, my opinion of Hewitt strengthened. As he shook my hand and prepared to depart, I said, "Give me your card. A year from now I may have an extraordinary story for you."

More than a year had passed, but I was ready. I located Hewitt's card and made the call.

Naturally, he was quite pleased to have an exclusive on what might be the biggest art unveiling of the century. His story, published on October 12, 2009, was titled "Fingerprint Points to $19,000 Portrait Being Revalued as $100m Work by Leonardo da Vinci." Liberally quoting Pascal and Martin, Hewitt described in flawless detail the scientific methods that had been used to determine the authenticity of *La Bella Principessa.* To this day, his article remains the best presented, most thorough account.

With the publication of Hewitt's piece, the great sleeping giant of the international media awoke. Timothy Clifford called me and warned, "Put your seat belt on, Peter. You're about to be swamped."

Five minutes later, I was on the phone with the *New York Times*, and media calls were backing up like jets on a busy runway. In just one week there were fifteen hundred articles and

hundreds of television and radio reports. The press, particularly in the United States, was most captivated by the fingerprint evidence, as though the collective fan base of the crime drama *CSI* had been brought to attention.

In reality, the fingerprint evidence was only a small consideration. The likes of Mina, Martin, and Alessandro Vezzosi had named the portrait a Leonardo before they ever heard of the fingerprint. But people outside the art world, not understanding the issues of connoisseurship and perhaps bored by the technical complexity of multispectral imaging, grabbed onto the fingerprint evidence as the most convincing proof. Despite Biro's cautions to the contrary, most people believed that if there was a fingerprint, that settled the matter. Nearly every media outlet, both print and broadcast, led with the fingerprint. The headlines and quotes screamed. Here are some examples:

> A fingerprint has intensified the debate about the origin of a mysterious drawing sold at auction for $21,850. Experts don't agree whether it's a 19th-century German work or a genuine Leonardo worth $150 million.
> —*ARTNews*

> Fingerprint May Lead to New da Vinci Discovery
> —*USA Today*

> How a New da Vinci Was Discovered
> —*Time*

> First Leonardo Da Vinci Found in 100 Years? Da Vinci Fingerprint Is Clue to Identity of the Painter
> —*Times* (London)

> Is It a Portrait by Leonardo da Vinci? Millions at Stake
> —*New York Times*

Lumiere Technology was swamped with requests and received thousands of hits on its website. Jean Penicaut joked, "I was visiting London, and even my cabbie wanted to talk about the Leonardo."

To no one's surprise, Christie's refused comment, issuing only a tepid statement that set the tone for its future defense: "We are aware of the recent discussions surrounding the possible re-attribution of this work, which rely heavily on cutting-edge scientific techniques which were not available to us at the time of the sale."

I was not accustomed to being in the spotlight, and the phenomenal force of the world's media left me stunned with the magnitude of my find and the enormity of my responsibility. I always thought the purpose of art was enjoyment, but I could not enjoy this work. I could not hang it on my own wall. My guardianship required only that I protect it. It was a burden—a glorious burden, but a burden nonetheless.

And what did the world want to know about *La Bella Principessa*?

How much was it worth? Where was it being kept? Would it be sold? I can't count how many people asked me, "Will you become rich?" I understood the popular fascination with the monetary potential of the discovery, yet I knew I was the keeper of a priceless work, and in that sense I might have answered, "It's worth everything . . . and nothing."

Naturally, everyone was eager to put a price tag on *La Bella Principessa*, but I couldn't help but contemplate—and not for the first time—how whimsical the process of assigning value can be. One might well ask how a painting can be worth $19,000 one day and $100 million the next—the only difference being its attribution. In fact, art has no intrinsic value. It cannot be consumed in a famine or easily traded in

an economic depression. Its worth is always tentative, subject to a fickle marketplace.

I have never pursued art for its monetary value. I believe that people who buy art for speculation are missing the entire point of collecting, which is love. We do not *need* art, but we must love it in order for it to serve its original purpose: to be aesthetic, uplifting, inspirational, and even decorative.

I find myself constantly engaged in a battle with the ideology of the market, where people associate a big price tag with great meaning or beauty. In the case of *La Bella Principessa*, I have watched the cynical process unfold. When the drawing was thought to be a nineteenth-century work, it was deemed "lovely." When it was later surmised that the drawing was fifteenth-century Italian, it was admired as "quite beautiful." Now that the Leonardo attribution has been affixed, the drawing has been heralded as "exquisite . . . extraordinary . . . remarkable" and every other superlative in the book.

Beauty may be in the eye of the beholder, but the prospect of a financial windfall surely improves one's vision. Van Gogh never sold a painting in his lifetime, and many great artists worth millions today hardly survived on their earnings.

The topic of the perception of art and its worth fascinates me. There is absolutely no question that value is a matter of perception. Here's a case in point: This incident took place in a Washington, D.C., metro station on a cold January morning in 2007. A man with a violin played six Bach pieces for about forty-five minutes. During that time, approximately two thousand people went through the station, most of them on their way to work. Only six people stopped and listened for a short while. About twenty gave money but continued to walk at their normal pace. The man collected a grand total of $32.

No one knew this, but the violinist was Joshua Bell, one of the most famous musicians in the world. He serenaded the metro crowd with a violin worth $3.5 million. Two days

earlier he had sold out a theater in Boston where tickets averaged $100 each.

Bell's incognito appearance was part of an experiment dreamed up by the *Washington Post* to determine if passersby would recognize genius when it was disguised in an unfamiliar setting.[4] I am almost certain that if Bell's identity had been known, the metro would have been packed with appreciative listeners.

It would be untrue and hypocritical to say that Kathy and I never thought about the financial aspect of the discovery. We no longer live in a world where it would be considered crass to even suggest a valuation on something as precious as a work by the world's most celebrated artist. However, it was not my primary thought or motivation. We had never been in serious financial straits, and I felt fortunate for that, so I was never in a situation where I had to "turn over"—as the trade would put it—a work of art that gave us both great pleasure and aesthetic satisfaction.

That is why we were able to build up a fine collection of works on paper, within our modest means, in the past quarter of a century. We basically bought with love and connoisseurship, in auction houses and from dealers throughout Europe and the United States. Sometimes we found things that others had missed. Occasionally we paid too much or missed wonderful things that we should have been prepared to pay more for. But we always had fun with the hunt and the idea that a new discovery, albeit more modest than a Leonardo da Vinci, might be around the corner at the next shop or salesroom.

The discovery of *La Bella Principessa* was no more than the same fun and satisfaction—just magnified a thousandfold. I doubted that our lives would radically change if the portrait were one day put on the market and actually sold, although we did enjoy daydreaming about having the money to establish a foundation for Renaissance and classical studies that would rival the workshops and salons of that era.

As for the question "What is she worth?" I had a standard reply for journalists. I asked them to Google the ten most expensive artworks and decide for themselves.[5] If a bronze by Giacometti (one in an edition of twelve) could bring more than $100 million at an auction, a Jackson Pollock a bit more than that, a Picasso $106 million, or a drawing of a head by Raphael more than $50 million, what would be the value of the rarest of rare things: a drawing, more akin to a painting, by Leonardo da Vinci? Less then twenty full autograph paintings survive by the Master, five of which are portraits, and what are the chances of another work of his ever being discovered?

I also noted that there were many major art-loving and wealthy nations—China, Japan, Canada, and Australia, to name a few—that did not have a single Leonardo work within their borders. How would a billionaire in one of these nations value such a piece—and what would be the draw for museums? Leonardo's light reflects on everyone it touches; his presence is capable of transforming the tourism industry of a nation.

Early in the process, when I was first investigating what it would take to display *La Bella Principessa* in museums, the subject of value came up in a most pragmatic context: insurance. How much insurance would we need to protect the work?

Simon Dickenson, the former head of Old Masters at Christie's and considered one of the world's foremost dealers, visited *La Bella Principessa* at its secure vault in Zurich and set the value at £100 million (over $150 million). This is the current insured value.

Sir Clifford had a point to make about the entire matter. He found the publicity quite distasteful. "The press coverage associated with this discovery has been both vulgar and unseemly," he told me. "We should not be focusing so much on a trophy of discovery, which may or may not be worth a great deal of money, but on a glorious and previously

unconsidered masterpiece by one of the greatest artists that has ever lived."

I couldn't disagree.

Shortly after I spoke with Clifford, I traveled to Florence, where I had the privilege of meeting Maurizio Seracini, the director of the Center of Interdisciplinary Science for Art, Architecture, and Anthropology. Seracini is a famous pioneer in the use of scientific diagnosis to study art. His background is in bioengineering and electronic engineering, and he has devoted his career to this pursuit.

In the mid-1970s, he participated in the Leonardo Project, sponsored by the Armand Hammer Foundation, the Kress Foundation, and the Smithsonian Institute, to locate the lost fresco *The Battle of Anghiari*, and this has been his passion ever since. This painting is yet one more Leonardo mystery, albeit one with many clues.[6] In 1504, Leonardo was commissioned by Piero Soderini, head of the government of Florence, to commemorate the republic's military victory in 1440 over the Milanese on the plains of Anghiari with a large wall mural.

His rival (and some say enemy) Michelangelo was assigned an opposite wall but left his portion undone when he returned to Rome to decorate the tomb of Pope Julius II. Leonardo continued Michelangelo's work, and there are many drawings and writings as evidence of his intention to create a glorious, violent battle scene. Unfortunately, due to the materials he used and his technique, the wall began to disintegrate. (A similar deterioration occurred with *The Last Supper.*) It was one of Leonardo's only known failures. In time the project was abandoned, and the wall was whitewashed. Some fifty years later, long after Leonardo's death, none other than Giorgio Vasari was commissioned to paint a new work. It is Seracini's belief that Leonardo's original lies beneath, and he has launched an investigation, using all of the technology at his disposal.

In 2006, Seracini's investigation into *The Battle of Anghiari* was exhibited as part of "The Mind of Leonardo da Vinci" at the Uffizi Gallery in Florence. He believes that Leonardo himself would be enthusiastic about the use of scientific analysis for art understanding because the artist was immersed in the pursuit of engineering innovation. "We do justice to Leonardo," he said. "We are using technology to understand the masterpieces. I think he would have been happy about that."[7]

We talked about the ongoing mysterious aura that follows Leonardo and how many questions remain to be investigated. He promised to make time to view *La Bella Principessa*.

After the initial media craze had died down, I found myself on a crowded flight to New York, squeezed unhappily between two passengers. I had placed a mock-up of the cover of a brochure for the Gothenburg exhibition on my tray table. There was no text on the page, just the portrait of *La Bella Principessa*.

"That's very beautiful," one of my seatmates said conversationally.

I glanced in his direction. "Thank you," I said, intent on my own musings.

"It's a Leonardo, isn't it?" he asked.

Now I stopped and looked at him with more interest. "Why do you say that?"

He shrugged. "I don't know. I'm an art lover, and it looks like Leonardo da Vinci to me."

I gave him a big smile and said that his guess was correct. I didn't elaborate. "I wish the museum world had your eye," I said.

11

The $100 Million Blunder?

Experience does not err. Only your
judgments err by expecting from her what
is not in her power.

—*Leonardo da Vinci*

Madame Jeanne Marchig was eighty-four, but age had
not stilled the passion this Swiss woman felt for animal
rescue. It was her life's work, memorialized in the Marchig
Animal Welfare Trust, which was established in 1989 in mem-
ory of her late husband, the painter Giannino Marchig.
Everything she did was focused on expanding and bettering
the trust.[1]

As I traveled to see Jeanne in early 2010, I reflected on
how strange it was that circumstances would bring the two of

us together. I had always been a fierce animal lover. However, it was art, not animals, that the widow Marchig and I had in common.

When the news about *La Bella Principessa* hit the airwaves, Jeanne was stunned to see a face she was intimately familiar with. After all, the portrait of the young woman had been in her possession for fifty years. It was she who had turned it over to Christie's for evaluation and sale. And it was she who now felt betrayed.

In 1955, when Jeanne married Giannino Marchig, he owned the pen-and-ink drawing with pastel highlights on vellum, and she was quite drawn to it. The profile of a young woman was exquisitely done, and it was one of her favorite works. Although unfortunately her husband never revealed how he had come to possess the painting—thus leaving the provenance uncertain—Giannino, a well-known art restorer with considerable expertise in Renaissance art, told her he was confident that it was a fifteenth-century Master drawing. He believed it to be a work of Domenico Ghirlandaio (a teacher of Michelangelo's), dating from the fifteenth century. Ghirlandaio and Leonardo apprenticed at the same time, both under Andrea del Verrocchio, and certain similarities in style have often been noted. I too had originally guessed it might be a Ghirlandaio, before the left-handed shading was pointed out to me. Ghirlandaio was not left-handed.

Giannino Marchig's story was somewhat remarkable. Before World War II, he had become acquainted with none other than the great Renaissance connoisseur Bernard Berenson (whom you may recall from the tale of the Hahn lawsuit in chapter 4). Berenson lived in a large estate just outside Florence, where he housed a substantial art collection. Giannino visited him there on many occasions, and the two men became friends. (The site is now the Harvard Center for Renaissance Studies, housing Berenson's art collection and library.)

Giannino restored many of Berenson's paintings, but he performed a larger service when the Nazis came into power. Berenson chose to remain in his Tuscan home, 'I Tatti, during the war. Fearing that Berenson's collection would be stolen by the Nazis, Giannino arranged to evacuate his most important pictures and documents.[2] Could *La Bella Principessa* have been one of them? Martin and I extensively searched the Berenson archives at 'I Tatti. Unfortunately, we found no reference to *La Bella Principessa*, so we may never know for certain.

Contemplating these events, I wondered if, *had* he seen *La Bella Principessa*, it was possible that the great Berenson did not recognize the hand of Leonardo in the drawing. Perhaps not, but when one considers how far we have come in understanding Leonardo in the past sixty years, it would not surprise me. *Lady with an Ermine*, *La Belle Ferronnière*, and *Ginevra Benci* were not universally accepted as Leonardo's works in Berenson's day. Furthermore, many works previously attributed to Leonardo were later shown to be not his after all. I myself own a major monograph on Leonardo, published in the 1960s, that includes drawings attributed to Leonardo that are clearly by right-handed artists. So it is conceivable that Berenson might not have recognized the portrait as Leonardo's. Berenson might have passed on a correct attribution for *La Bella Principessa* because, like others after him, he had no point of comparison in another work by Leonardo on vellum. And although he was capable of "feeling art with his whole being"—according to Meryle Secrest, author of *Being Bernard Berenson*—perhaps his intellect got the better of his intuition in this case.[3]

Jeanne Marchig confided to the journalist Simon Hewitt that "it is certainly conceivable that *La Bella Principessa* may at one time have been in the possession of Bernard Berenson"—

because the men were so close and her husband had saved Berenson's art collection during the war.

Giannino lovingly restored the portrait on at least one occasion, using pastels produced by Lefranc of Paris. Jeanne still has the boxes the pastels came in. The restoration was so masterful that the Louvre restorer Catherine Corrigan, the first to examine *La Bella Principessa* under a microscope, stated that she would not recommend further restoration or attempt it herself—a tribute to Giannino's talent and Corrigan's integrity.

Giannino Marchig died in 1983 at the age of eighty-five. Although the portrait had not been on display during his life-time—he had not wanted to expose it to the light—Jeanne took it out after his death and hung it in a dimly lit corner of the house so she could enjoy it.

Many years after her husband's death, looking to raise money for her wildlife trust, Jeanne presented the portrait to Christie's for evaluation and possible auction. She and Giannino had had a long-standing relationship with Christie's, and it didn't occur to her that she would be led astray. Indeed, the Marchigs were regular clients of Christie's and had con-signed many works over the years. After her husband's death, Jeanne continued the relationship, consigning major works from Renaissance Florence, including Piero di Cosimo's 1499 *Jason & Queen Hippolyte with the Women of Lemnos*, sold at Christie's London for £200,000 in July 2007, and a paneled *Portrait of a Young Gentleman* (ca.1505) by Giuliano Bugiardini (who apprenticed under Ghirlandaio); though long attributed to Raphael, it fetched a triple-estimate £700,000 in London in July 2009. Both works were sold to aid the Marchig Trust.

When Jeanne decided to sell the portrait, she told François Borne, Christie's resident expert for Old Master drawings, about her husband's belief that the work was a fifteenth-century piece, perhaps by Ghirlandaio. She was quite surprised

when after examining the picture for a mere fifteen minutes, Borne summarily rejected the Renaissance provenance.

Borne wrote to Jeanne saying that he was fascinated by her "superb German drawing in the taste of the Italian Renaissance." He suggested that it would sell at an auction for between $12,000 and $15,000. He also wrote, "I would be tempted to change the frame in order to make it seem an amateur object of the 19th century and not an Italian pastiche." Although Jeanne did not agree to change the frame, Christie's removed it without her knowledge and sold the portrait unframed. (She never received the original Italian frame back.)

Jeanne was disappointed in Christie's judgment, but she trusted Borne completely. She and Giannino had always been happy working with Christie's, and without her husband by her side, she did not want to rock the boat. Besides, she was extremely vulnerable at the time, suffering from what she calls "a deep depression," and she felt pressured by Borne into accepting his judgment in spite of her reluctance. She was devastated when she learned that major authorities were now calling her portrait a work of Leonardo da Vinci.

I found the changing of the frame particularly curious, so I consulted a friend—a major dealer in Old Masters—about frames and their importance. He suggested that had *La Bella Principessa* been presented at the auction in a Renaissance frame, potential buyers would have viewed the portrait in a different light, as possibly older than nineteenth century. Perhaps Christie's changed the frame to conform with Borne's opinion. My source told me that it is highly irregular for auction houses to change frames on pictures consigned by clients in this way.

As soon as I found out that *La Bella Principessa* was a Leonardo, I decided that Christie's should be informed. I contacted Noël Annesley, international head of Christie's

Old Masters department. I had known him for over thirty years and bought many wonderful paintings and drawings at Christie's, where he was both expert and auctioneer. He was quite courteous and willing to hear me out. I told him, "I believe I have discovered a Leonardo da Vinci that was sold at auction in 1998 as the work of an unknown nineteenth-century artist. It's going to come out, and I'm giving you a heads-up." I added, "Instead of your making a double mistake, I invite you to come to Zurich and view the portrait and then admit you made an error."

To Annesley's credit, he agreed to travel to Zurich, accompanied by the director from Paris. Good for them. Unfortunately, they didn't take my advice and consider how they might turn a bad situation into a positive. Instead, on his return from Zurich, Annesley called Jeanne.

"Mrs. Marchig," he told her, "I'm afraid you're in for a bit of a shock. Please be prepared for the news coming out that the drawing we sold for you is being claimed as a Leonardo. We assure you that we don't believe this is true, but we want you to be prepared."

Jeanne did not take kindly to this news. She immediately contacted Martin and asked if he could see her. Sitting across from Jeanne, Martin was struck by the seriousness of the matter. He recognized her as a savvy art lover, and he was distressed that this had happened to her. He gladly walked her through the evidence, and he watched the expression on her face change from mild concern to alarm.

After her meeting with Martin, Jeanne knew she had to act. She was not willing to just lie down and accept the error. She wanted compensation—not a lot, as she explained to Annesley. She was not greedy. She certainly didn't need the money for herself. She was eighty-four and childless and a wealthy woman. But she thought it was appropriate that Christie's give her something for her animal welfare trust. She

described it as a "gesture." (What that "gesture" meant I can only speculate. Perhaps $3 to $5 million.)

Jeanne told Annesley that she hoped they could resolve the matter amicably, and he concurred that he shared that desire. But time ticked on and there was no action. Eventually, Jeanne received a communication from Sandra Cobden, Christie's senior counsel and head of dispute resolution, who restated the company's confidence that the matter could be resolved amicably—but she ominously added, "One of the things I find most interesting is how many experts have decided to stand on the sidelines." Then, switching gears, Cobden wrote about her family's four rescued cats and burbled about the good work Jeanne's trust performed. Jeanne was not amused. She was expecting action, and she was getting more stalling. She told Hewitt that she thought Christie's might be "playing for time, hoping [she'd] die."

Finally, Jeanne got fed up and called a lawyer. By the time she contacted Richard Altman, a notable art lawyer in New York, she had worked herself into a lather. She was angry at Christie's officious attitude. She believed she'd been wronged. Altman was a lawyer of long experience. When I later met him, I found him to be a mensch as well. He was a perfect choice for Jeanne.

On May 3, 2010, Jeanne's lawsuit was filed in the U.S. District Court, Southern District of New York, for an undetermined amount. The suit alleged, "The drawing sold at a price far below its actual value, solely because of defendant's willful refusal and failure to investigate plaintiffs' believed attribution, to comply with its fiduciary obligations to plaintiffs, its negligence, its breach of warrant to attribute the drawing correctly, and its making of false statements in connection with the auction and sale."[4]

There were several compelling aspects to Jeanne's lawsuit. The first was a claim of breach of fiduciary duty. She

charged that Christie's had failed to investigate whether the drawing could have been attributed to an Italian Renaissance artist. It did not take the most fundamental steps of investigating the age of the drawing using carbon dating or use other routine methods of analysis and connoisseurship. Had Borne taken Jeanne's suggested attribution seriously, it was likely that the drawing would have at least been identified as a fifteenth-century Italian drawing valued far in excess of $22,000, regardless of the artist to whom it was attributed. Submitting the work, as I did at the outset, to a specialist restorer would have most certainly indicated that it was fifteenth century.

Jeanne also had a claim of negligence. Christie's, she contended, failed to exercise due care and act as a reasonably prudent expert. Jeanne also claimed that Christie's fiduciary relationship with her gave rise to a special bond of trust and confidence sufficient to sustain a claim of negligent misrepresentation. That is, Jeanne believed that Christie's knew she required accurate information in order to sell the drawing at the highest possible price and that she intended to rely on Christie's opinion of its attribution.

Would Jeanne's lawsuit have any chance of succeeding? One issue was whether there was a statute of limitations. This was potentially an insurmountable barrier. However, since Jeanne had an ongoing working relationship with Christie's, she could make the argument that the statute of limitations did not apply.

A month after the lawsuit was filed, Jeanne heard from Cobden, who told her that Christie's had reexamined the portrait and "to be blunt . . . the painting simply [did] not appear to [their] eyes to be a work by Leonardo da Vinci." No surprise there. Cobden's reasoning was that there was a heavy layer of what seemed to be shellac on the surface, "which obscures many of the painting's details."

When Hewitt was researching the story for the *Antique Trade Gazette*, he asked Pascal to comment on Cobden's statement about the shellac, since Pascal had already completed his thorough examination of the portrait. Pascal told him that the substance was not shellac but a covering of gum arabic that was laid to protect the painting, and it wasn't accurate to say that it was heavy. Pascal added that even though it may seem to obscure the view if one is looking with the naked eye, the multispectral camera easily saw through the layer.

Cobden also struck a low blow, claiming that the Leonardo attribution was invalidated because "most of the proponents of the new attribution have a significant financial stake in their conclusion: Luminere [*sic*] Technology is struggling to get a firm financial footing for its company and its product; Silverman is seeking to increase his investment in the painting as well as to publish his book on the topic; one of the experts on whom Silverman relies . . . are [*sic*] connected to the book publication project or other publicity projects."

But Cobden's most interesting assertion was that even if the portrait were a Leonardo, Christie's would still be off the hook, because the discovery was based on Lumiere Technology's work. "An auction house is not legally liable for any change in attribution that is based on new technology that was not available at the time the original attribution was made."

After Jeanne's lawsuit was filed, I made a trip to see her. We spent a lovely afternoon together. She showed me her husband's paintings, which were quite good and hung throughout the house. She also spoke passionately about her animal welfare trust, and I was fascinated with the details. In all, I thought she was a youthful, intelligent, and genuine woman.

As we sat drinking tea, Jeanne smiled at me warmly and said, "Peter, you're very rich. Will you give something to my animals?"

I laughed. "Well, I may someday be very rich, but right now I'm not swimming in funds. You know, all of this has cost me a lot of money."

Still, I was interested in hearing what she wanted, because an idea was forming in my mind that perhaps we could make an arrangement. She told me she would be satisfied with 1 percent of a sale, were it to happen.

I told her how Kathy and I had imagined using the money, if it ever came. One of our charitable interests was animal rights, and I was impressed with how well run Jeanne's trust was. "I will give your charity a healthy donation from the proceeds," I told her.

I felt good about my offer because not only was the cause a good one, it also might give Jeanne some small justice. She felt betrayed. She acknowledged what I had suspected: she never would have filed a lawsuit at all had Christie's handled her concerns with more sensitivity. She didn't care about money for money's sake or about some vague calculation of "worth." Her sole interest was for her animals, and she and I saw eye to eye on that.

On November 12, 2010, Jeanne's lawyer, Richard Altman, participated in a panel at the New York University Law Day on "Expert Opinions and Liabilities." The program was attended by about two hundred people, most of whom were appraisers. Altman gave a half-hour presentation, describing Jeanne Marchig's complaint and the legal theories involved. Since the case was ongoing, he chose his words with care, and there were some details he couldn't give. It was a workmanlike performance before professionals. He truthfully stressed that there had been no discovery (pretrial disclosure of pertinent facts or documents by the parties involved) yet in the case, so it was basically only allegations at that point.

But suddenly, just as the program was about to wrap up, a woman in the audience bounded out of her seat and said

loudly that she wanted to make a statement. She identified herself as Sandra Cobden—yes, Christie's senior counsel with the four rescued cats. Altman was taken aback, to say the least. For a Christie's representative to make a statement in this setting was quite surprising. Cobden's demeanor was angry, and she was nearly shaking as she accused Altman of getting the facts completely wrong. She didn't say anything of substance, but she seemed to have a strong personal reaction, as though she herself had been attacked.

When Altman saw Cobden later in the day, she still appeared angry, and he thought the whole thing was peculiar. A number of people came up to him in the course of the day and said that they thought Cobden had embarrassed herself by making a statement on behalf of Christie's in that room. Altman tended to agree, but in describing the incident to me, he added, "It also became clear to me that a room full of appraisers was not really pleased about the case, because it had the potential as a precedent to expose them to liability in the future for making erroneous attributions. But I said that if they wanted to truly be considered professionals, they would have to be as responsible for their actions and opinions as doctors and lawyers."

The case attracted the attention of the legal community as well as that of the art community. Writing for *Art Law*, Judith Bresler, an expert on both specialties, opined,

> The *Marchig v. Christie's* decision could have far-reaching implications in terms of the duties owed by an auction house to a consignor. The ruling will likely touch upon issues such as the length of time a fiduciary relationship between an auction house and consignor might exist, and if parties might alter that relationship by conduct as well as by contract. Does the fact that a consignor continues to consign other works with an

auction house toll the statute of limitations for claims regarding the fiduciary duty owed with respect to the original consigned work? Or, could a call from an auction house official revive a fiduciary relationship with a consignor long after the gavel has fallen? Does a disclaimer in a consignment agreement that an auction house makes no representations or warranties as to the authenticity of an object relieve the auction house from a duty to correctly attribute such object? Stay tuned.[5]

Was there a legal case to be made that Christie's should have known better, or did the subjective quality of art guarantee that different eyes would draw different conclusions? The dilemma reminded me of the classic 1950 film *Rashomon*, in which three people witness a woman's rape and the murder of her husband. When they later recount what happened, they offer three entirely different versions. The great director, Akira Kurosawa, shows in this film how our senses and vision can play tricks on us. We are challenged to ask: What is real? What is the truth?

In art we can have a similar situation. Two people observing the same work might derive completely different signals from it, depending on many factors, including their cultural, educational, emotional, and philosophical conditioning. For example, a non-Buddhist will not understand the image of Buddha in the same way as someone who practices Buddhism. Likewise, a non-Christian would probably not perceive Michelangelo's *Last Judgment*, or the sublime image of Christ on the cross by Bernini, the same way as a Christian would. The believing Christian would see the violent scenes through a prism of faith and feel inspired by the possibility of redemption, whereas the non-Christian might see only violence and terrible suffering.

So the way we look at art is very much determined by context. A true art lover and connoisseur will be aware of these biases and strive to see beyond them and open up a dialogue between the object and the viewer—to see with both the heart and the mind and not allow preconceived notions to cloud judgment.

This brings us to the discovery of *La Bella Principessa*. How is it possible that three—yes, three!—very able and experienced experts at a major auction house got it so wrong, in cataloguing the work as nineteenth-century German over the vehement protests of Jeanne Marchig? It is sad that she was ultimately persuaded by the power of Christie's reputation and expertise to not believe what her own eyes were seeing.

Did Christie's make a $100 million blunder as a result of its own hubris? With a bit of simple due diligence, the auction house might at least have let a competent restorer examine the work to better determine its period—as I did by having the work examined by Caroline Corrigan.

So we must ask how, in this case, did taste and connoisseurship go on holiday, leaving some very experienced specialists behind? One obvious answer is that the experts don't always get it right. It is possible for them to be fooled.

But one thing is undeniable: we have entered an age when science and scholarship walk hand in hand. This was admirably illustrated at a 2010 show at the National Gallery of London, where the usually unknown and unseen aspects of a great museum laboratory were revealed. The public was invited to view the methods employed by the museum to study and analyze a painting's pigments, its surface, and eventually any existing underdrawing—all methods used in determining a picture's authenticity.

The role of science in the art world today is such that a museum curator is in a much stronger position to assess a work of art's authenticity before attempting to acquire it for

his or her institution. This is equally true of the art trade and the auction houses, which no longer have to rely solely on the connoisseurship of their staff or outside expertise when cataloguing works of potentially great value. Technology can exclude works that have traditionally been assigned to an artist as well as include new works that have mistakenly been attributed elsewhere.

The exhibition at the National Gallery made a convincing argument in favor of an intelligent collaboration between scholars who examine works of art with their well-trained naked eye and scientists who examine them extensively with their specialized techniques. The names of these various methods, such as *infrared radiation*, *infrared reflectography*, and *ultraviolet light*, will mean little to the layperson. These methods, intelligently employed and interpreted, can single-handedly tip the balance in favor of a definitive attribution, which makes it even more incomprehensible that any museum curator or scholar would venture to pronounce on the authenticity of a work such as *La Bella Principessa* without subjecting it to stringent museum laboratory examinations. That would simply be missing the boat, and it's what the revered experts at Christie's did.

Nicholas Turner has a more nuanced view of the matter. "Ideally," he told me, "what we need is a hybrid of [the TV crime dramas] *CSI* and *Criminal Minds*, a blueprint for a new kind of connoisseurship where scientific method and traditional connoisseurship interact rather than push each other out. Kemp and Cotte's project just might provide that model; we shall have to see if others follow suit."

On January 31, 2011, Jeanne Marchig's lawsuit against Christie's was dismissed by Judge John Koeltl in a twelve-page ruling, which noted, "The plaintiff's breach of fiduciary duty claim is untimely unless they can demonstrate a basis for tolling the statute of limitations"—which happened to be three years.[6]

Jeanne was outraged at the reliance on the statute of limitations—a technicality—rather than the merits of the case. "I only learned about the Leonardo attribution in 2009," she said. "How could I have exceeded the statute of limitations?" But Judge Koeltl wrote that unless a claim is based on fraud, the statute of limitations clock starts ticking when the event occurs, not when the plaintiff learns of the breach.

A statute of limitations ruling is the most blind form of justice because it has no regard for the validity of the claim, so Jeanne's anger is understandable. She vowed to appeal, and to succeed she might have to prove that fraud occurred—an extremely high bar. But to Jeanne this "crying injustice" would not be allowed to stand without a fight.[7]

12

The Art World Strikes Back

You do ill if you praise, but worse if you
censure, what you do not understand.

—*Leonardo da Vinci*

The detractors of *La Bella Principessa* had been sharpen-
ing their knives ever since the opening of the
Gothenburg show in March 2010. *La Bella Principessa*'s pub-
lic coming-out, as part of the grand exhibition "And There
Was Light," was well thought out and deeply serious. Kathy
and I flew to Sweden for the opening, filled with anticipa-
tion. It was a little more than three years since we had seen
our lady in public, spotting her on an easel at Kate Ganz's
gallery. How far she had come since then! Seeing her aligned

with other Master works, we had an overwhelming sense that she belonged.

The Gothenburg exhibition had impressive credentials, being under the sponsorship of the city of Gothenburg and the patronage of the Vatican and the president of Italy. It was curated by Francesco Buranelli, the director of the Vatican Museums, and Alessando Vezzosi. The exhibition included original pieces by three Italian Renaissance masters: da Vinci, Michelangelo, and Raphael.

As Vezzosi pointed out in his remarks at the opening of the exhibition, these three Masters lived at the same time, knew and influenced one another, and were even rivals. "Leonardo da Vinci, Michelangelo, and Raphael are three of the greatest artists in history," he said. "But they were also people with ideas and visions that reached far beyond the world of art. They were also bitter rivals, competing for both commissions and fame. All three became immortal."

Their appearance together in the grand exhibition hall, Eriksbergshallen, was priceless. The security was as tight as any I'd ever seen.

During the five-month exhibition, more than 150,000 paying visitors saw *La Bella Principessa* for the first time—not bad for a city of fewer than a million inhabitants! Ironically, the masses were eager to view Leonardo's lady, whereas many of her most vociferous critics used every excuse under the sun to *not* see her "in the flesh." In the coming months, as the naysayers lobbed their arrows at the portrait, the one thing that I found most irksome was how many were assuming scholarly airs without exercising scholarly diligence. I have no problem with anyone who studies *La Bella Principessa* closely, views the original and Lumiere Technology's work, and then details his or her arguments against a Leonardo attribution. I do have problems with self-styled experts who declare that it is not a Leonardo without bothering to even view it.

• • •

We were basking in the positive feedback from the Gothenburg exhibition, and the momentum seemed to be in our favor. The March publication of the book *La Bella Principessa: The Story of the New Masterpiece by Leonardo* by Martin and Pascal, with a foreword by Claudio Strinati and a preface by Nicholas Turner, laid out the evidence with a level of expertise, scientific rigor, and detail that I assumed would satisfy the most hardened skeptic. I was being very naive.

The first inkling of trouble came in the form of an article in the London *Daily Telegraph* a month after the book's publication.[1] Written by Richard Dorment, the article was titled "*La Bella Principessa*: A £100m Leonardo or a Copy?" The subhead added, "*La Bella Principessa* has been touted as Leonardo's missing masterpiece, but the experts beg to differ."

From the outset of the article, Dorment attacked my credibility, calling me a "fantasist." He proceeded to also attack Martin's scholarship with a dripping sarcasm that I considered an insult to a man of Martin's stature: "Genuine drawings need to be studied and discussed over time, so that scholars can reach a consensus on their status. I don't doubt that Prof Kemp's belief in Leonardo's authorship is sincere. But he is wrong to think he can prove this by steamrolling the public into accepting his attribution." Steamrolling? In what respect?

Dorment was dismissive of Vezzosi's Gothenburg exhibition; he had viewed a tiny opening snippet on YouTube and therefore felt perfectly qualified to give his opinion. He failed to mention important details about the exhibition, particularly the patronage of the Vatican and the president of Italy.

"As a non-specialist, my opinion of the drawing's status is irrelevant," he wrote, and then proceeded to give his opinion. What troubled me most about Dorment's article was its lack of balance. He presented *La Bella Principessa* as a possible fake

and then went on to find ways to support his view. The "experts" he quoted prominently were from what Martin calls the "New York Gang"—those "connoisseurs" from the Metropolitan Museum and elsewhere who would not deign to give anything a hearing that did not spring from their own initiative. I had long suspected that Ganz had showed the portrait to people at the Met who dismissed it and now had to dig in and defend their opinions for fear of looking bad.

In particular, Dorment mentioned Everett Fahy, the chairman of the Department of European Paintings, and Carmen C. Bambach, the curator of drawings and prints, as two of the heartiest detractors, yet neither of them had ever seen the portrait in person. I had repeatedly urged Bambach to do so, and she also refused an invitation to visit Lumiere Technology when she was in Paris for a colloquium. I could not understand how one could pass judgment on a work of art without at least taking the trouble to view it. I might add that Dorment himself never viewed it, either. Other journalists who have reported on the discovery, notably those from *Der Spiegel* and the *Times* of London, were very serious about their research; they visited Lumiere and learned about the technology so they could report knowledgeably.

It was also noteworthy that Dorment did not interview any of the specialists who had endorsed the Leonardo attribution, which made his article one-sided. In fact, Dorment, who was once married to Ganz, specifically cited people who took issue with the attribution and conveniently excluded the numerous others who defended it, thereby violating one of the first principles of journalism: impartiality. What was equally astounding to me was why a normally serious newspaper such as the *Daily Telegraph* would publish the article and not perceive the manifest conflict of interest. Dorment, as Ganz's ex-husband, should have recused himself. Serious journalist friends of mine, after reading his article, told me that

I was not far off the mark in seeing his ex-wife's sour grapes squeezed between the lines.

Again, I was not surprised by the controversy. In one respect I welcomed it. I was well aware that art frauds occur, and vigilance is advised to prevent them. But I also believed that in the end, the main nemesis of art attribution is not the fraudster but the unbeliever. Inertia, jealousy, ignorance, and envy fill the air of art houses, stifling courage and creativity. The lazy scholar, the blind expert, the forever doubting Thomas—these types plague every institution. Was this the work of those perennial detractors, who anonymously dismiss a work like *La Bella Principessa* before it has been properly viewed?

The main problem is often the museums themselves. To the average citizen, the museum is the bastion of unassailable truth, yet the political reality is a different story. I had to ask myself what was at play here: truth or politics.

One name mentioned in Dorment's article as being on the side of the naysayers was Nicholas Penny, head of the National Gallery of London. Nicholas and I go back more than twenty years. The reason for our first encounter was a portrait I had discovered at a small auction in Paris. It was presented simply as "Italian 16th c." As soon as I saw it, I suspected it might be a late work—albeit rather damaged—of none other than Raphael. Before the auction, I hurried home to check out my library. Lo and behold, in a rare complete catalog of Raphael's work by Leopold Dussler, published in the 1960s, which I was fortunate to own, was the very same portrait.

It was engraved as a Raphael, and purportedly depictied Marcantonio Raimondi, an engraver and a close friend of the artist's The picture was, in fact, engraved already in the seventeenth century; it had been published a number of times and was then lost from view. As it had always been in a French collection, I knew there was no danger of its having been stolen or

exported illegally out of Italy, so I decided to purchase it. There was little interest in the work, and I was able to get it for around $10,000. Naturally, I was thrilled, and because I knew that Nicholas Penny was one of the top experts on Raphael, I contacted him, and he kindly came to our home to view the picture. He hemmed and hawed; he was having trouble seeing the picture for what it was because of its bad condition. The picture was instead published by Pierluigi De Vecchi, the top Italian specialist on Raphael, about five years ago.

Throughout the years Nicholas and I saw each other regularly, either at sumptuous dinner parties given by a mutual friend and top sculpture dealer, Daniel Katz, and his wife, Gree, or at exhibitions or luncheons he attended with his delightful American wife, Mary. We continued to see each other after Nicholas accepted the position as head of sculpture at the National Gallery in Washington, D.C., where my sister, Tina, was living at the time.

Some months after procuring the portrait from Ganz, I was in Washington and decided to stop in at the museum to say hello to Nicholas. I had photos of the portrait in my camera, and I showed them to him. I recall very precisely our conversation at the time.

"Nicholas," I said, "I don't want to seem outlandish, but some people are telling me that this drawing may be by Leonardo. Do you think I am crazy?" He looked carefully at the digital images and replied, "No, not at all. Lovely thing. Please keep me informed of your progress." I was elated. That was a lot coming from a man as cautious as Nicholas Penny.

A year later Nicholas was back in London, now head of the National Gallery, one of Britain's greatest institutions. I had been in contact with him as the evidence continued to mount in favor of a Leonardo attribution, but he had grown distant and unwilling to comment. Nor would he agree to view the original—he'd only seen photographs, at this point. Our regular correspondence was polite, but he seemed to be trying to shake me off. In one e-mail, he wrote: "You bought

it from a very well-known and very well-informed dealer, Kate Ganz, as a nineteenth-century work. It is exceedingly unlikely that Kate did not think of Leonardo when she owned this work, and it would amaze me if she didn't show it to experts in the field of Old Master drawings."

I was totally dumbfounded. Nicholas seemed to be saying that if the likes of Kate Ganz said it was not a Leonardo, so be it. Never mind that Ganz's nineteenth-century attribution was proved wrong, as she publicly admitted. I didn't understand Nicolas's attitude, and I was surprised to find his name among the detractors listed in Dorment's article. It didn't make sense to me that someone of Nicholas's extreme professionalism and expertise would pass judgment so casually, having never seen the portrait.

My frustration was apparent in an e-mail to him after the *Daily Telegraph* article was published. In particular, I invited him to find the time to see *La Bella Principessa* for himself, especially if he was going to comment on its authenticity. I reminded him that many foremost Leonardo scholars had endorsed the attribution. I sincerely believe that Nicholas's scholarship, keen eye, and innate sense of fair play will ulti-mately prevail, and when all the latest facts are presented, he will come around to accepting Leonardo's authorship. But as of this writing, he has not only continued to refuse to view the original, but he also excluded it from his museum's Leonardo show, which opened in November 2011.

I set about crafting a response to the *Daily Telegraph* piece, outlining point by point the evidence in favor of the Leonardo attribution:

1. The work was initially identified as a Leonardo by Professor Mina Gregori, the acknowledged doyenne of Italian art.
2. Support for a Leonardo attribution was first published in September 2008 by Alessandro Vezzosi, the director

of the Museo Ideale Leonardo da Vinci, in a major monograph, with an introduction by Carlo Pedretti, the world's most senior da Vinci expert.

3. Francesco Buranelli, the former head of the Vatican Museums, and Claudio Strinati, the former head of the Museums of Rome and now in the Italian Ministry of Culture, endorsed the attribution. Timothy Clifford, the former director of the National Gallery of Scotland, as well as Simon Dickinson, one of the world's leading art dealers and formerly a Sotheby's senior expert, also endorsed the attribution.

4. Of those whom Dorment cited as rejecting the attribution, not one had actually been to the premises of the research laboratory or had even seen the picture.

5. Those who reported on the discovery, such as journalists from *Der Spiegel* and the *Times* of London, as well as those who ultimately endorsed the attribution, made the effort to visit the premises of Lumiere Technology in Paris—something Dorment did not do.

6. Leonardo's palm print and thumbprint are indeed on the parchment. This was discovered by the Lumiere lab and confirmed by the forensic specialist Peter Paul Biro, assisted by a former director of the Canadian equivalent of Scotland Yard.

7. In denigrating by implication the exhibition hall where *La Bella Principessa* was on view, Dorment failed to mention that the drawing was in the excellent company of works by Raphael, Michelangelo, Filippino Lippi, and others, in a comprehensive survey of the Renaissance, with loans from many major Italian institutions, including the Uffizi Gallery in Florence.

That was just a start. The *Daily Telegraph* was not interested in publishing my rebuttal. I sensed that some minds were

closing. The Germans have an expression, "*Papier ist geduldig*," which means in essence that humans have a tendency to believe what they see in print. This affliction has grabbed hold of many reviewers, who have read the original catalog attribution and can see no further.

In June 2010, Martin gave a lecture on *La Bella Principessa* before a sold-out crowd of five hundred at the National Gallery in London. Nicholas Penny was on hand to introduce the talk. He noted that even though he did not necessarily agree with Martin's conclusions, he respected him anyway. It was quite a backhanded compliment, but Martin, as always, was gracious. A friend who was present at the lecture told me that Martin was brilliant and convincing. He received a standing ovation from the crowd.

The critics weren't through with us yet. Indeed, they had only just begun. In early July, Martin, Pascal, and Jean Penicaut received an e-mail from Peter Paul Biro. Biro's tone had a forced casualness that seemed suspicious. "In the next edition of the *New Yorker* magazine a potentially prejudiced and cherry-picked article is likely to appear about me, my work, and the drawing," he wrote. "I gave the interview because I always want to be seen as transparent and available. The *New Yorker* is owned by Condé Nast, which in turn is owned by Sy Newhouse—a major client of Christie's. Christie's is on the hook for $100 million. So, just to give you a heads up . . .

"I have no skeletons in my closet," he continued, "and I am always ready to answer any questions, as I did with any other interviewer. He [the *New Yorker* reporter, David Grann] spent most of his time digging into my past going back some 20–30 years ago when my family was running a small art gallery and a restoration workshop. . . . I am not worried, and we have good attorneys to handle this if it gets out of hand. But

I wanted you all to know before it hits the newsstands. But again, we have a situation where when they don't know what to do with the information, they attack the person."

Biro's heads-up gave us all reason for concern, and rightly so. The article, published July 12 and titled "The Making of a Masterpiece," was a scathing declamation against Biro that used some of his personal credibility problems to—by extension—call into question the Leonardo attribution for *La Bella Principessa*.[2]

I felt an initial sense of disheartenment. I realized that Biro's background could not, practically speaking, affect his role in analyzing the fingerprints on *La Bella Principessa*. Biro had never touched the original. He had not *discovered* the fingerprints. He had merely studied what was already there and drawn a conclusion, which was then backed up by André, Turcotte, a retired fingerprint specialist from the Royal Canadian Mounted Police. That being said, it was also true that if Biro's reputation was being dragged through the mud, it was definitely not helpful to us.

What especially distressed me was that Biro, with full knowledge that he did indeed have skeletons in his closet—especially involving the Jackson Pollock print controversy—should have been more circumspect. What possessed him to give such an extensive interview to a serious journalist like Grann, knowing that he'd be on the hunt for a juicy story? Still, there was no question that Biro's work on *La Bella Principessa* could withstand scrutiny.

I got a copy of the *New Yorker* and started to read the article. I had to admit that it was a beautifully written piece, full of color and intrigue. In the beginning, Grann wrote in charming detail about Biro's forensic art nest in Montreal—including the smells of his wife Joanne's French cooking coming from the kitchen. But then, many pages into the article, he began scraping away at Biro's reputation. The centerpiece of

Grann's critique of Biro was his questionable actions in the search for authentication of Pollock's fingerprints. Grann also highlighted blemishes in Biro's past business dealings.

The former investigation focused on the Matter controversy. Alex Matter was a filmmaker whose parents had been friends of Pollock's. Matter wanted to know if some paintings he found in his father's Long Island storage compartment were works of Pollock's. He sent Biro a photograph of a fingerprint on one of them, and Biro found six points that matched the fingerprint on the paint can he'd found in Pollock's studio. However, experts weighed in against a Pollock attribution, especially after finding pigments that were not available until after Pollock died. The incident was embarrassing for Biro.

In addition, Grann detailed old family financial problems, dating back several decades. The fact that the Biro family once had issues with creditors seems irrelevant to the question of Biro's scientific credibility.

As I read, I could see the journalistic schemata developing: Biro had made questionable calls in the past; ergo, his reading of our portrait was also questionable. But I believed the article had drawn the wrong conclusion when it came to *La Bella Principessa*, because Biro's ability to read, compare, and analyze fingerprints on works of art was basically sound, and he did have an extensive Leonardo database, which could not be faulted.

I had to admire Grann's skill as a journalist and a writer, but I found many points of dispute. In particular, I was frustrated by the way Grann used "expert" opinions. He quoted Hugo Chapman, an old acquaintance of mine from the days when he worked in the Old Masters department at Christie's; Chapman was now head of the Prints and Drawings Department at the British Museum. "The market is a fairly efficient place," Chapman said. "This would be an amazing miss." I wondered about the characterization. The near meltdowns of the market

in recent years would give pause to anyone inclined to call it "efficient."

As an interesting aside, during my research period after acquiring *La Bella Principessa*, I had been to see Chapman at the British Museum to look through his boxes of Leonardo drawings. At the time, I showed him a photograph of the portrait, and he told me he wanted to remain noncommittal until he'd seen the original. "I am not a Leonardo expert," he said. Yet here he was making a star turn in Grann's article.

The other man quoted in Grann's article was the former Met director Thomas Hoving. Although he had great credentials and was an expert on fakes, Hoving never saw *La Bella Principessa* before pronouncing on its authenticity. (Now that he is deceased, he won't have a chance.)

Grann waxed eloquent about the special nature of art connoisseurs, writing, "Connoisseurship is rife with flaws. It is susceptible to error, arrogance, even corruption. And yet there is something about that 'strange breed of cat,' as Hoving referred to the best connoisseurs, who could truly see with greater depth—who, after decades of training and study and immersion in an artist's work, could experience a picture in a way that most of us can't. Connoisseurship is not merely the ability to discern whether an art work is authentic or fake; it is also the ability to recognize whether a work is a masterpiece."

Yes, yes, yes. I couldn't agree more. That's why it is so inexplicable that Grann did not seek out the most highly regarded connoisseurs of the Renaissance and Leonardo for his article. Where is Mina? Where are Vezzosi and Geddo? Where are Turner and Pedretti?

Grann's article left the impression that Biro discovered the fingerprint, with the implication that he had forged it. I believed that this impression must be corrected, so I wrote a letter to the editor to the *New Yorker*, and it was published in the August 2 issue:

In his piece questioning Biro's methods, Grann describes the process of authenticating a work of art, "La Bella Principessa," that I helped acquire in 2007. Unfortunately, the controversy surrounding Biro distracts from the findings of eminent scholars, none of whom relied upon the fingerprint. The Leonardo was first published by Alessandro Vezzosi, the director of the Museo Ideale Leonardo da Vinci, in 2008, long before the discovery of the fingerprint. Biro's role was minor—he did not discover the fingerprint, nor did he ever have possession of the original. The fingerprint was first identified by Lumiere Technology, which has made all of the technical information freely available on its Web site. Moreover, as Grann states, no claim has been made that the print analysis meets forensic standards. In addition to those named in Grann's piece, scholars who have endorsed the work include the doyenne of art historians, Professor Mina Gregori; Dr. Claudio Strinati, the former head of Rome's museum authority and now with the Italian Ministry of Culture; and Dr. Cristina Geddo, a leading scholar of Leonardo's followers, who published her findings in the scholarly journal ARTES (University of Pavia). "La Bella"'s current exhibition, in Gothenburg, Sweden, is under the patronage of the Italian government.

Biro seemed stunned and demoralized by Grann's article, which he had expected to turn out quite differently. He issued a statement full of personal pain:

I was dismayed by David Grann's article in the *New Yorker* and indignant about the unjust accusations that have been levelled against me. The claims are quite preposterous and the light in which I am cast is a travesty

of my character. I hold to the highest ethical behaviour and categorically deny ever having forged paintings or fingerprints. Moreover, I have always striven for the best possible standards while working actively for the broader acceptance of fingerprint evidence on paintings, now understood and appreciated by many. I believe this highly personal attack is solely designed as a crude attempt to undermine my credibility. Nowhere does the author refer to the numerous clients who regularly attest to my professional integrity.[3]

Later, in June 2011, Biro filed a $2 million lawsuit against Grann in Manhattan federal court, which stated, "Through selective omission, innuendo and malicious sarcasm, the article paints a portrait of the plaintiff which has no basis in reality, and which has been highly damaging to his reputation."[4]

Although I believed that Biro had brought much of this problem on himself, I felt sorry for him. I still believed in his incredible skill and his impressive database. I didn't care about his past problems with creditors.

I accept the fact that there are differences of opinion among experts. I was prepared for the flood of dissent. But even I was surprised by the fury of it. What particularly frustrated me about Grann's article was that the journalistic credibility of the New Yorker gave it extra momentum. Grann's suspicions were republished in dozens of venues and were perfect ammunition for those who were seeking to cast aspersions. I had expected a great deal of opposition to the attribution, because new discoveries by their very nature are rarely received unanimously. But I hadn't expected such hysteria or blatantly biased responses. Ordinary people were writing to me, saying, "Mr. Silverman, thank you for bringing us an unknown Leonardo," but I heard none of that appreciation or awe in the media. I know that sounds peevish, but my feelings were hurt.

To be fair, there were honest critics, and with these I was eager to open a debate. As long as a critic was motivated by a search for the truth, I found it very positive. One such person was Dr. Francis Ames-Lewis, a distinguished art historian, a professor of the history of Renaissance art at Birkbeck College at the University of London, and the vice president of the Leonardo da Vinci Society. I was curious about his opinion on the Leonardo attribution, and I wrote to him detailing some of the criticism that had been directed at Martin since the publication of his book. Dr. Ames-Lewis won my enduring respect for the thoughtfulness of his response to me on August 21, 2010:

> I confess that I have not followed the ebb and flow of discussion about your drawing on a day-by-day basis: I find this sort of backbiting and vituperative polemics distasteful and regrettable. But I am also saddened that you and Martin have both had to withstand any unnecessarily "hysterical" criticism. I quite agree that no honest critic should dismiss the attribution without having seen the drawing; conversely, I do not feel able to accept the attribution without seeing the drawing. But I am well inclined towards putting my name behind it: I find that in his book Martin argues the art-historical case very plausibly, and Pascal's scientific evidence contributes significantly towards strengthening Martin's case. The lecture that Martin and Pascal gave, under the auspices of the Leonardo da Vinci Society, at the Courtauld on 9 May was fascinating and excellent.

He went on to say that he was "intrigued" by the possibility of a Leonardo attribution because of its implications for the history of drawing techniques in late fifteenth-century Italy. "I look forward to someday seeing the original," he wrote, and I hoped that day would not be long in coming.

Once Martin and Pascal published their findings in book form, the reviewers began to respond. My correspondence file was growing fat with the back-and-forth communications with certain reviewers, some of them friends and colleagues, who I believed failed to give *La Bella Principessa* her due. One of these was Professor David Ekserdjian, whose review in *Burlington Magazine* was highly critical. I had known David and his wife, Susan, who worked as a journalist for the *Financial Times*, for many years, and I wrote to him on November 5, 2010:

> If you recall, I offered you, very early on, over two years ago, the opportunity to actually study the drawing in the original, and to view the findings of Lumiere Technology. You never acted on my offer, which is fair enough. But why would you then make statements about the work without even having seen it? Surely this is something you as a scholar would not accept as normal procedure. Martin Kemp absolutely refused to pronounce before *seeing* the *Bella Principessa* in flesh and blood, so to speak, followed by Pedretti, Catherine Goguel, Mina Gregori, Claudio Strinati, Nicholas Turner, Simon Dickinson, Alessandro Vezzosi, Francesco Buranelli, Cristina Geddo and others. If you have any respect for these people, many of whom have devoted their lives to Leonardo studies, and [whom] I would imagine you consider esteemed colleagues, why would you give them the scholarly equivalent of a slap in the face by making such pronouncements?

I reminded him that the portrait was available to anyone who cared to make the effort to view it, and I urged him once again to take me up on my offer to show it to him.

David replied promptly on the same day:

I have just reread my review attentively and cannot understand why you think I have given anyone "the scholarly equivalent of a slap in the face." . . . All I have done is to express a strong suspicion about what it is, absolutely not a certainty. It is true that you encouraged me to see the drawing, but I am an academic and do not have the means to come to Paris. Equally, I have never accepted even expenses to see a work of art, and—perfectly reasonably—you did not bring the mountain to Mohammed, so to speak.

David disputed my strong belief that one could not pass judgment without viewing a work in person:

I do not believe it makes sense to refuse to make an explicitly provisional judgment about a work one has not seen—you may never express an opinion under such circumstances, but I do so all the time, not least when people send me images via e-mail. After all, there are countless works in museums I have never visited or in accessible private collections that I have not seen but need to judge. The same goes for works that have been destroyed, such as the casualties of the Flakturm fire in Berlin. Are we not able to hazard a guess about the authorship of the "Signorelli" Pan and the "Caravaggio" Saint Matthew, or indeed the frescoes in the Eremitani Chapel?

I realise we are unlikely to agree about the *Principessa*, which I regret on a personal level, but not on an academic one. The truth is one's ideas are constantly disputed and rejected, and I am perfectly relaxed about that. I do not need people to agree with my views: I just hope they will attend to my reasoning and make

their own minds up. Moreover, as I tried to say, if you are right (which alas I do not believe), then in the end you are likely to win the argument—the jury does not stay out forever.

I appreciated David's points, and I had a lot of respect for him, but I thought he was being a bit disingenuous—especially regarding his failure to see the portrait. We were, after all, talking about what many scholars were calling the most important art historical discovery in generations. And failing his ability to travel to Paris or Sweden, he might have attended one of two talks given in London at the Courtauld and the National Gallery.

I had little patience for those who would pass judgment on *La Bella Principessa* without viewing her, especially when their judgments could prove so damaging to the cause. Some might even say that David's review was tainted by his former association with Christie's, although I didn't believe that. After all the vicious, and to my mind unfair, shots fired at Martin Kemp, I and others I respect have still failed to see scientific evidence to dispute the science discussed in the book—which actually seems somewhat above the heads of many scholars for its technical arguments. It is hard to believe, but even today there are people who refuse Darwin and accept the biblical creation myth in spite of science. People believe what they want, but the fact is that Lumiere Technology has the absolute scientific evidence proving the attribution.

Charles de Gaulle once asked, "How does one govern a country that makes five hundred cheeses?" In the same spirit, how does one obtain a consensus on an artist like Leonardo when there are scores of self-proclaimed Leonardo experts? One has only to Google "La Bella Principessa" and "Leonardo" to see some of the most far-fetched opinions by these self-styled

experts, who are often anonymous, including: "It can't be by Leonardo because the neck is too long." Or, "It has never been documented in his body of works."

Obviously, there are many who claim expertise and are not competent; this is true in any field. There are also those who are competent but sometimes mistaken; none of us has a perfect score. Everyone is entitled to his or her opinions, but I believe that these should be based on the evidence.

The controversy surrounding this newly discovered work of Leonardo is of titanic proportions, with far-reaching implications and repercussions for the art world. I am thankful that I came into the arena with more than thirty years of solid experience and important contacts among art experts. Had I been a naive, inexperienced collector, I would have either not entered the debate or thrown in the towel early in the process, and *La Bella Principessa* might have remained undiscovered for another five hundred years. Instead, I have been able to follow the long path to the Leonardo attribution, sidestepping most of the pitfalls. I am at heart a man of consensus, not confrontation, but I won't abide laziness, lack of rigor, prejudice, or intellectual turpitude.

It is an intriguing topic: How can opinion and perceptions differ so widely? There is rarely a major discovery that is uncontroversial in the art world. Many people surely wonder how can there be such extremes of opinion about *La Bella Principessa*— from "This is a forgery" to "This is a work of sublime beauty by the greatest artist the world has ever known." In some respects, this was a Herculean battle between, on the one hand, the forces of inertia and reaction (those whose minds are set and closed) and, on the other hand, the forces of openness and curiosity (those who use all of their faculties of connoisseurship, knowledge, emotion, and soul to investigate a work of art).

One Leonardo da Vinci specialist declared to the press, "It does not look like anything I know of the artist." I am still

puzzled by what she meant. Is this a valid line of reasoning? Is it reasoning at all? Ganz's argument against a Leonardo attribution was that the portrait wasn't beautiful enough. So why did she buy it in the first place? Hoving followed with "too sweet." These are subjective comments and should be considered as such.

Furthermore, the experts in favor of a Leonardo attribution saw it differently. Leonardo's greatness was that he followed his own creative genius and was constantly inventing new techniques and methods. He of all people would not have appreciated being placed in such a narrow mold. It raises the question of whether some art experts too slavishly expect artists to conform to a particular style or method; when an artist deviates from the pattern, the close-minded experts do not recognize the artist's work. Yet it is these deviations that reveal an artist's genius.

Those who believe that *La Bella Principessa* is worthy of Leonardo are generous and often wax poetic. Sir Clifford told me plainly, "I really think and still think that the only artist who could have drawn it was Leonardo. In spite of later strengthening, the graphology seems entirely consistent with the master's work, and I can think of no artist in the circle of Leonardo who is capable of producing such a consummate image, which is consistent with his paintings and the most finished of his drawings."

I asked Clifford why he thought the portrait went totally unrecognized both at Christie's and during the nine years Kate Ganz had it. This is the biggest sticking point for the naysayers. They simply cannot believe that so many practiced eyes fell upon the portrait with no reaction.

Clifford admitted that he saw a small image of the drawing when it was offered at Christie's, and he confessed that "lazily [he] dismissed it as something perhaps created by one of the Nazarenes." He is therefore understanding and somewhat

forgiving of the museum colleagues who didn't see Leonardo's hand in the work.

"Few connoisseurs would dare to give it such an illustrious attribution," he said. "Too many people approach the attribution of drawings only with their head and not their heart. I have found that knee-jerk reactions of recognition have been the surest way—for me—of arriving at attributions, and for what it is worth, my immediate reaction, which I still hold to (on the basis of photographs), is that the attribution to Leonardo is convincing."

"So, why," I asked him, "have so many of your museum colleagues now come out so violently against the attribution? Most of them have never seen the portrait in reality."

He responded carefully but thoroughly. "Of course, I have a great regard for my colleagues in museums," he replied. "Those who work in print rooms normally have the edge of connoisseurship on those who work in departments of painting. I suspect not so many of them have looked, with real attention, at the graphic works in the original of Leonardo and his followers. I suspect most will watch the pronouncements of one or two of their most distinguished colleagues and then second their observations without really daring to consider the problem themselves.

"I would particularly listen to those who consistently make new discoveries in the field of graphic art and be much less interested in the observations of those who have never made any discoveries of any consequence. There is a tendency for all of us human beings to reject anything that is new and unfamiliar. This is fundamental to mankind and helps in self-preservation."

A close friend of mine, Richard Herner, formerly a director of the prestigious gallery Colaghi on Bond Street in London and a dealer in Old Masters for more than forty years, cautioned me to be careful about criticizing the museum directors. "They are our clients, and we need their goodwill to sell

our goods," he said. He also had a thought-provoking viewpoint on the proper role of museums.

"In principle, it's not the prime job of a museum to make discoveries," he noted. "If certain curators succeed in doing so from time to time, so much the better. Their real purpose is to preserve for future generations the wealth of physical art objects, which have survived through time, and to add to the stock of their artistic heritage with the best means at their disposal. They are not primarily in the business of putting their money on hunches. That is one of the tasks of a dealer in Old Masters but not the only one.

"Nor is there a universal system of finance covering all museums. Many haven't the means to take any financial risks, and those funded by the state are constrained by issues of security and accountability. So I don't think it's really fair to attack them for being averse to speculation. I would be wary of conflating the need to prove the authenticity of the Leonardo by the accumulation of favorable views and the resistance to criticism from some quarters with a general attack on the culture and scholarship of museum management. It wouldn't do you any good, even if you won the argument with them. For if they are all so ignorant and averse to risk, why would any of them be willing to perhaps one day purchase the painting by Leonardo? It's not as if it were their discovery!"

I appreciated his point, and perhaps I was not being as congenial and politically correct as I might be. But I felt I had to stand my ground. "I have nothing against the good ones who do their jobs," I told him. "Only against those who make reckless statements that potentially hurt *La Bella Principessa* and their own reputations."

13

What Constitutes Proof?

> There are three classes of people: those
> who see, those who see when they are
> shown, those who do not see.
>
> —*Leonardo da Vinci*

The question "How can you be sure?" was raised over and over. People found it hard to accept that differences of opinion could exist, that there wasn't an absolute stamp of proof. In asking what constitutes proof, Martin skillfully reinforced his position this way:

No single piece of evidence *proves* conclusively that the portrait of a woman in profile in colored chalks on vellum was executed by Leonardo da Vinci in the mid-1490s, or that the sitter is Bianca Sforza. Similarly, no single piece of evidence *proves* that the *Mona*

Lisa in the Louvre is a portrait by Leonardo of Lisa Gherardini (wife of Francesco del Giocondo), which was commenced in 1503 and finished a good deal later. Indeed, at least one other candidate has been promoted as the original *Mona Lisa*, and there have been many theories about the sitter's identity. The now secure position of the portrait of *Mona Lisa del Giocondo* in Leonardo's body of autograph paintings depends on an accumulation of interlocking reasons, and, not least, on the way that the painting participates actively in how we see Leonardo as a whole. Any important new work, to establish itself, must significantly affect the totality of Leonardo's surviving legacy over the longer term. With respect to the accumulation of interlocking reasons, we have gathered enough evidence to confirm that *La Bella Principessa* is indeed by Leonardo. The criteria of style and medium, coupled with the technical examinations, indicate that we are dealing with a work that looks and feels like a Leonardo.[1]

Martin and others make a convincing case, but do their premises—no matter how educated they might be—amount to proof in the way we understand the notion? Let's step back and look at some of the most pointed criticisms.

The Fine Arts Registry (FAR) launched one of the most thorough critiques of *La Bella Principessa* and concluded that it could not support the attribution, based on several flaws. Most notably, it lingered on the absence of provenance, the unreliability of carbon testing, and the forensic fingerprint question—all legitimate points but hardly at the heart of connoisseurship.

Let's review FAR's primary critiques. First, the absence of provenance:

The fact that provenance documentation is almost absent supporting the DaVinci call leaves the work suspect in terms of who had it, where it came from, and when it was made.[2]

Naturally, we always seek provenance and value it highly, but it is common to find gaps—even huge ones—in very old works. In the next chapter, we reveal an astounding discovery that puts the question to rest. In general, though, the argument about the importance of provenance is that forgers use confusion about provenance to their advantage, as van Meegeren certainly did with his phony Vermeers (see chapter 4). But many great attributed works in museums have sketchy provenance—including *Lady with an Ermine*, whose whereabouts before the late eighteenth century are unknown.

Claudio Strinati correctly observed, "Although much about *La Bella Principessa* is affirmed, not all questions can be answered, including where she lay hidden for centuries. This comes as no surprise. Many aspects of the study of Leonardo seem destined to remain unsolved, precisely because scholarship is hampered by the element of mystery that is so typical of great masters. (Indeed, it is that same mysterious dimension that can give rise to such fanciful popular creations as *The Da Vinci Code!*)"[3]

Second, FAR's critique of the unreliability of carbon testing:

Using carbon–14 analysis for a piece only 500–600 years old produces less accurate and more unreliable results, and as such cannot predict a particular age or small range of age within the period.

Carbon–14 analysis, which gives a range of about two hundred years, might not prove that the portrait was drawn in

the 1490s—although it doesn't disprove it, either. However, it does eliminate the possibility that it is a nineteenth-century work, which is how it was catalogued by Christie's. Once it has been acknowledged that the auction house and its experts got it wrong, the question of authorship begs to be investigated.

Third, FAR's critique of the forensic fingerprint question:

Matching the fingerprint of the present work with a comparable one is problematic since the exemplar used has no chain of custody. It is not even clear if the new print was taken correctly.

The fingerprint evidence has been the most widely discussed and argued—perhaps because it best captures the public imagination. But to speak of "chain of custody" demonstrates the problem with much of the criticism of the fingerprint evidence: This is not *CSI*. There are no dead bodies. And no one is at risk of being put to death on the basis of this evidence.

Fingerprint investigation of art is a fully legitimate pursuit because so many artists do leave prints embedded in their works. It is one more potential piece of a very complex puzzle. As for the controversy surrounding Biro, which was brought to light in the *New Yorker* article (see chapter 12), it has absolutely nothing to do with *La Bella Principessa*, because Biro did not discover the print or have possession of the original. His expert opinion was solicited, and he offered a convincing reading.

Martin echoed this point, saying to me, "I have always placed qualified reliance on the fingerprint within the total spectrum of evidence. It never was the killer evidence, whatever the press wanted to say. The criteria to be applied to analysis of prints—in all works of art, including this one—are

not established adequately at this point, and any conclusions are necessarily tentative. Paul [Biro] worked within very clear parameters for us, and there was no financial gain to be made by him through overclaiming."

FAR completes its evaluation with this vague and unsatisfying statement: "The above analysis draws the conclusion that the approaches, methods, and standards used to confirm authenticity of the new Da Vinci did not support an authenticity conclusion. This does not mean that the work is in authentic, only that until more research takes place following acceptable standards, methods, and approaches, present assertions of authenticity are questionable."

It occurs to me that it doesn't take much courage or insight to say, basically, "Maybe it is, or maybe it isn't." However, I don't mind in the least that these questions get raised; it's a critical part of the process of investigating a work. Even Nicholas Turner acknowledged when he first investigated *La Bella*, "Based on its style and left-handed shading, it can only be one of two things—an original work by Leonardo da Vinci or a copy, pastiche, or fake made to look like an autograph portrait by Leonardo."[4] Turner came down in favor of a Leonardo attribution.

In his review of the evidence, Strinati stated, "The scientific investigations confirm the date of the portrait and situate its origin in a fairly precise context. The conclusions are supported by the artistic quality of the portrait itself, which is exceptionally high: the tone of the facial expression, the incisive but subtle contours, and the delicate handling are all highly Leonardesque. One senses in the sitter a mixture of melancholy and strength. And, as Kemp fully demonstrates, her beauty transcends the best efforts of the Sforza court poets."[5]

One claim I find inexplicable is the assertion in FAR's critique that "most if not all of the evidence provided to

establish the authenticity of the new 'Da Vinci' has emerged from news reporting agencies quoting alleged art experts and the basis for their conclusions." Although the world-wide media jumped on the story once we made the evidence public, those reports were not in themselves evidence. Unfortunately, this canard—that the whole affair is a media creation—has been repeated in other circles. All I can say in defense of *La Bella Principessa* is that it did hard time in the laboratory before a single word was breathed to the press. And by the way, the drawing's status as a media sensation is well deserved.

In another Fine Arts Registry article, "Getting to the Truth of Authentication," Theresa Franks wrote, "Visual art is an enigma with no intrinsic value, but tucked within the layers of the mystery that visual art presents is 'true authentication,' stripped of all manufacture and pretentiousness, where connoisseurship factors in heavily. It is appreciation, discernment, perceptiveness, taste, and the pure love of fine art objects that the tools of science and forensics, though useful, can never substitute or replicate."[6]

That prim view is all well and good, but it leaves many questions unanswered when connoisseurs disagree. Consider the debate concerning two versions of the painting *Virgin and Child* by the sixteenth-century Flemish artist Jan Gossaert. Until 1994, there was a consensus that the original was the one in Vienna's Kunsthistorisches Museum, and a second work was a copy. But after cleaning the second work and removing varnish and overpainting, the National Gallery in London declared it the original. The Metropolitan Museum of Art in New York disputed the finding and still considered the Vienna work to be the original and the other to be "a copy after Gossaert."

In a 2010 exhibition, the Met showed both works side by side so viewers could make their own judgment. However, a

National Gallery exhibition in 2011 will show only the work that the Met judged to be a copy.[7] Each museum is defending its own version as being the original, and even with the help of science and technology this one will come down basically to expert opinion and connoisseurship.

So who is right? Perhaps there is another answer: that Gossaert himself did two versions because he was commissioned by a buyer to do so. I remember in the 1970s and 1980s there was a debate about two versions of a picture by Caravaggio, *Boy Bitten by a Lizard*. Which was real? My thought at the time was that both versions were by Caravaggio, and I was put down by most of the scholars I talked to. Finally, about ten years ago, experts reached agreement that they were both authentic when they were displayed side by side at the National Gallery. Today one is housed at the National Gallery and the other is at the Longhi Institute in Florence. Since that time, other "second versions" of paintings by Caravaggio have been admitted into the canon, albeit amid great debate.

I often wonder what the great connoisseurs of previous eras would have to say about the methods of evaluation employed today, particularly by museum curators. The father of an influential style of art criticism was Giovanni Morelli, a nineteenth-century art critic who devised the Morelli Method, a technique for identifying the hand of a painter by studying tiny details that reveal the artist's typical manner of portraying certain aspects, such as ears.

Morelli explained, "As most men who speak or write have verbal habits and use their favorite words and phrases involuntarily and sometimes even most inappropriately, so almost any painter has his own peculiarities which escape from him without him being aware of them. . . . Anyone, therefore, who wants to study a painter closely must know how to discover

these material trifles and attend to them with care: a student of calligraphy would call them flourishes."[8] One could fruitfully mine Morelli's ideas to study *La Bella Principessa*, because as Martin and others revealed, there are many, many signifying details in the drawing.

Those who followed Morelli adapted his concepts in their studies. For example, Walter Pater, who lived from 1839 to 1894 and was considered one of the great art critics of all time, believed that the viewer must immerse himself or herself in the work and truly see it, without allowing internal reflections to muddy the view.

Pater wrote that the purpose of the connoisseur is "to define beauty, not in the most abstract but in the most concrete terms possible. . . . In aesthetic criticism the first step towards seeing one's object as it really is, is to know one's own impression as it really is, to discriminate it, to realize it distinctly." He begged the connoisseur to ask, "What effect does it really produce on me? And he who experiences these impressions strongly has no need to trouble himself with the abstract question of what beauty is in itself or what its exact relation to truth or experiences—metaphysical questions, as unprofitable as metaphysical questions elsewhere."[9]

The art connoisseur Bernard Berenson, who spent a long lifetime in the business and was involved in some of the more intriguing capers of the last century (see chapter 4), was a follower of both Morelli's and Pater's, and he strove to view art with a populist heart:

Many see pictures without knowing what to look at. They are asked to admire works of pretended art and they do not know enough to say, like the child in [Hans Christian] Andersen's tale, "Look, the Emperor has nothing on." Vaguely the public feels that it is not being fed, perhaps [being] taken in, possibly made fun of. It is

as if suddenly they were cut off from familiar food and told to eat dishes utterly unknown, with queer tastes, foreboding perhaps that they were poisonous.

In a long experience humanity has learnt what beasts of the field, what fowl of the air, what creeping things, what fishes, what vegetables and fruits it can feed on. In the course of thousands of years it has learnt how to cook them so as to appeal to smell, palate and teeth, to be toothsome. In the same way some few of us have learnt in the course of ages what works of art, what paintings, what sculpture, what architecture feed the spirit. Not many feel as convinced of what they are seeing as of what they are eating. Just as all of us have learnt what is best as food, some of us think we have learnt what is best as art.[10]

Although Berenson pointed out that art lacks the urgency of food, he set out to educate the artistic taste buds of generations of art lovers. Berenson's idea of connoisseurship was pure, and I have often wondered what he might think of the advanced technological measures we have at our disposal today. I suspect he would have been intrigued by the opportunity to investigate art in such a bold new fashion. He was known to have said, "Between truth and the search for it, I choose the second."

Berenson pretended to have an egalitarian view of art: that the masses should consume it as they do good food (although you wouldn't find the masses dining at a fancy French restaurant). Thomas Hoving likewise took a shot at a populist approach when he wrote a treatise, "Becoming an Art Connoisseur," for Dummies.com.[11] Art connoisseurship for dummies is surely a stretch, but Hoving gave it a try. His basic, rather weak, point was that one must saturate oneself in works of art in order to appreciate and understand them. That's a fine

ambition for anyone, but a firm distinction must be drawn between one who loves art and one who holds in his or her hands the responsibility of authenticating it. (By the way, there are also Art Connoisseur Cruises sponsored by Princess Cruise Lines and a Facebook group called Contemporary Art Connoisseurs Weekly Exhibitions.)

We live in an age when the common "everybody" can aspire to be a writer, a singer, an artist, a chef, or an art critic. There are appealing aspects to this trend, but in reality the art connoisseur, like the scientist or the brain surgeon, holds an expertise that is beyond the ability of the untrained amateur. It is not a job for "dummies," although I'm sure there have been some accusations that some of the practitioners *are* dummies.

The responsibility of the modern connoisseur is greater, it seems to me, than that of the Morellis and the Berensons. They had only to trust their own skills and interior judgments and follow the trail of their "sixth sense," as Berenson put it. Today, a connoisseur must embrace technology as well and become learned in its ways. Resistance is futile, just as a writer who resists the computer will get left behind.

The sad truth is that even the most cautious museum curators can be blinded by the tempting dangle of a well-timed donation. I can't help being amused by the saga of a man named Augustus Landis, a prolific American forger and pretender, whose thirty-year spree has challenged the entire concept of the connoisseur's eye. Landis's particular genius has never been the high quality of his work, but that in every case he donated the art for free—in the name of his diseased parents—thus dazzling museum curators who could not turn away, or stand to question, what they regarded as a marvelous gift. Upping the psychological ante, Landis often appeared at the museum gate disguised as a priest.

He has become the bane of museums, but what is his motivation, if not cash? Perhaps it is a deep-seated resentment

toward the elitism of the art community. Or perhaps he is a frustrated artist who could find an audience for his work only when it was signed by someone famous. Some argue that he might be mentally ill.

He told John Gapper, a *Financial Times* reporter who wrote a piece about him, "I was awful upset when dad passed away. When mother went—I don't know if I'll ever get over that. I'd like to have had a museum named after dad or mother but I'm not a billionaire. Lots of people have pictures in museums in loved ones' memories, don't they? I mean everybody's got a tombstone, that doesn't mean anything, but a picture in a museum, that really means something."[12]

In Gapper's treatment, Landis comes across as a man with no malicious intent, but the art world certainly disagrees. To its members he is a menace and a waster of resources—although so far he has escaped the attention of the law, since he never asks for money. Still, in poking the elite museum world in its eye, he has created his own brand of graffiti; it's just another way of recognizing art as beauty.

But the real question we must contemplate is why the curators were fooled. It's not so much that the value was enhanced in their eyes because the paintings were free; it's that they were so comfortable with the aura of snobbery— the pretense Landis created that he was from a wealthy family, the kind of high-toned people who donate to museums. The religious garb made it all the more convincing: a priest from an elite family walks into a museum, seeking to perform an act of charity in honor of his beloved parents. Gotcha! Perhaps if the curators had had the means and the willingness to perform simple tests before they were tricked, they could have shown Landis the door more quickly. But every curator, even in small museums, wants to think that he or she has that sixth sense—the ability to instantly recognize great art.

I can imagine a time not far in the future when every respectable museum and auction house will have versions of the multispectral imaging camera and other technologies to immediately eliminate the frauds. It is chilling to contemplate how many misattributions might come to light were the pictures subjected to the revealing scope of Pascal's camera today. For this reason, I imagine the museums aren't in a big rush to install the technology. It's not that they don't want the assurance that they hold the real things. But human nature being what it is, even the best minds can be a bit squeamish about proof.

What this whole debate around the Leonardo boils down to, basically, is this: Whose eye should one trust? I would not dream of asking the world to trust my eye, because I am, academically speaking, a nobody. But I can say the following in my defense. In the past thirty years I have had to "put my money where my mouth is," as they say back in Brooklyn, where I spent tough years as an immigrant kid. "Put up or shut up" was the game we played, and I learned my lessons. From auction rooms, dealers, antique shops, and other venues, I have had to buy works of art with my own money, using my knowledge and experience. If I made a mistake, I had to assume the consequences. It was the school of hard knocks, but I willingly accepted the challenge because I knew that the rewards were potentially very high—especially in the field of Old Masters, be it sculpture, drawing, or painting.

Today's auction houses, unlike those in the past, seldom hire the top people; they can't or won't pay the salaries required. So they keep on turning over the staff, bringing in new employees with less and less experience. Consider how many fakes or wrongly attributed paintings clutter museum cellars. There are several instances in which museums such as

the Met have sold donated paintings that later turned out to be major works. For example, a picture donated to the Met and sold immediately, without further study, was later found to be a Raphael, and it was exhibited in Gothenburg.

Although it is not the job of academics and museum curators to take risks and immerse themselves in marketplace concerns, museums do cultivate relationships with dealers from whom they hope to make purchases for their museums—inevitably at a premium over the price paid, but only after the dealer has bought the work with his or her own funds and has given it an imprimatur as being worthy. If museum people make a mistake, they do not suffer the consequences of the market. Public funds support their errors, so they aren't personally paying out of pocket. I say none of this out of resentment, but only from a desire for us all to put our cards on the table.

For myself, I'm glad to be out there putting my money on the table, taking the risk and hopefully reaping the reward, be it a material one or just the satisfaction of spotting something others missed.

I have been asked by many people what it feels like to have made such a discovery and how it has changed our lives. It would be an obvious understatement to say that little has changed for us since the news broke. I have been inundated at times by the press and TV stations worldwide. And this has undeniably been great fun and exciting—my proverbial fifteen minutes of fame. More satisfying, however, has been the knowledge that my name will, if only in some small way, be forever linked with that of one of the greatest intellectual heroes of all times.

In August 2010, I got a call from Milton Esterow, the revered editor of *ARTNews*, with whom I had become friendly.

He and his publication had followed the story of *La Bella Principessa* closely, and he was preparing another article. I think Milton expected to find me stressed and anxious after all the controversy.

As it happened, however, his call to my cell phone caught me as I was walking through fields of flowers in the Bagatelle Park in Paris on a mild, sunny afternoon. The experience was pure bliss, and nothing could take away from that, so I let Milton ask his sharp and serious questions, and I was forthcoming and quite cheerful in my replies. Over the line, I could hear the clattering of Milton's ancient typewriter as he took down my answers. I teased him, saying, "Milton, you should get into the twenty-first century and buy a computer. You're a medieval relic!"

We continued talking, and Milton finally asked me what I thought of all the controversy. I said quite truthfully, "I'm having the time of my life." My response was not what he expected, and he asked how I could be so cavalier.

I wasn't entirely sure myself. Perhaps it was the beautiful day and the field of flowers. Perhaps it was something deeper. My thoughts traveled back to my youth in Brooklyn as a poor child of immigrants. I had enough inherent confidence to know that I'd do well in life, but I didn't really expect to score big. I chose a career in art collecting for love, not money— and certainly not for notoriety. The immigrant boy still living inside me was at first incredulous to be in possession of a Leonardo, but little by little I started to believe.

From the outset, I thought that even if the work didn't turn out to be a Leonardo, the process of investigating it would still have been a marvelous adventure. I was open to whatever might be revealed. And then, when the evidence of the portrait's authenticity began to mount, I was humbled and grateful to be living in such a historical moment.

Milton and I had lunch a couple of months after our conversation. We talked about the story and the critics and all the insanity out there. But we also talked about his origins and mine. Both of our families had come from what is now Poland and had immigrated around the same time to the United States, fleeing persecution and pogroms. I remember my dad telling me stories when I was a child of the Cossacks entering villages and slaughtering every man, woman, and child. My dad had a scar on one cheek from an attack that occurred when he was only two and in his mother's arms. Milton had similar horror stories of his own to recount.

Finally, our toasted bagels arrived, and as we loaded them with cream cheese and lox, I said, "Milton, you asked how I could not take all the negative crap to heart and be wounded by it. How could I laugh in the face of such adversity? Well, here you have it. Look at the real adversity our parents and grandparents went through—the life-and-death choices and experiences. That was serious stuff! We are so fortunate to be where we are and in good health. Everything else seems extraneous. So, yes, I feel thankful and happy, and I am indeed having the time of my life."

Milton smiled at me, nodding. "You are absolutely right," he replied. "Mazel tov, my friend."

I meant what I said. How else would I have had the privilege of meeting so many remarkable people and engaging in such a thrilling mystery hunt? I felt deeply blessed.

I might have left it at that. But just when I thought no more manna would fall from heaven and no more revelations were left to be uncovered, a miracle occurred in the most unlikely of places, the land of my ancestors: Warsaw, Poland.

14

Miracle in Warsaw

Beyond a doubt truth bears the same
relation to falsehood as light to darkness.

—*Leonardo da Vinci*

By the fall of 2010, the controversies had died down, and we were in something of a holding pattern. The Gothenburg showing had been a phenomenal success, and we were discussing future opportunities. One day in late September I received a call from Martin. He told me he had a hunch he wanted to discuss with me. It was a long shot, he warned, but it might be the final stamp of proof we needed.

I sat up a little straighter in my chair and urged him to go on. Martin and Pascal had always contended that *La Bella Principessa* had been cut out of a bound book—some kind of wedding commemorative or other memorial, which was common to the court. On the left edge of the portrait, where

it was jagged, there were signs of three stitching holes and a double vertical incision within the lower margin that appeared to be the result of a knife's slipping when the sheet was being cut. Martin thought that the portrait had been excised from the bound book at some point and laid down on a panel.

Now Martin told me he had recently learned through D. R. Edward Wright, emeritus professor of art history at the University of South Florida in Tampa, that the portrait might have come from one of the four surviving versions of the *Sforziada*, a eulogistic biography of Francesco Sforza, which were printed on vellum. Each contained a full-page illumination by the court artist Birago celebrating various glorious moments of the family's history. One of these versions is now in the Uffizi Gallery in Florence. Another is in the Bibliothèque Nationale in Paris. A third—the only one to retain its original binding—is in the British Library in London.

Of particular interest to Wright was a fourth version that was housed in the archives of the National Library in Warsaw, Poland. The Warsaw copy had once belonged to Galeazzo Sanseverino, the duke's trusted general and the husband of Bianca Sforza, the young woman we believe to be the subject of *La Bella Principessa*. The book was signed by the miniaturist Giovanni Pietro Birago, and the Birago miniature contained within it celebrates the wedding of Galeazzo and Bianca in allegorical form. The inscriptions refer to the divine sacrament of marriage and to the young bride's fertility.

Now Martin told me—mentioning again that it was an extremely long shot—there was a chance that *La Bella Principessa* might have been cut out of the Warsaw book since it contained the full-page illuminated miniature with an apparent depiction of Bianca and the duke, among others at the court, in allegorical form. This highly prized and elaborate vellum page was commissioned specifically for Galeazzo and Bianca's wedding in 1496 and had clearly been added to the book.

"So," Martin asked teasingly, "might not a second page on vellum—the portrait of Bianca—also have been added to the manuscript at that date?" Martin suggested that it would be interesting to use the evidence of the nature and placement of these needle holes to look for other surviving quires (pages) from the same codex, which, with other physical clues, might shed further light on the provenance and original commission.

He had me hooked. This was exciting news, indeed. I knew that I must see the manuscript, although to set off for nearly arctic Warsaw, Poland, in mid-December was not exactly a thought I relished. On the other hand, how could I resist? Kathy agreed. So we decided to proceed as we always had: to combine the business aspect with a pleasurable trip.

Martin had put us in touch with Kasia Wozniak, a Polish researcher, who was just finishing her art history doctorate in Berlin. He spoke highly of her, and she was fully informed of our Leonardo saga. She was invited to join us and help arrange our appointments with the various library and museum directors. We allotted ourselves three days for Warsaw—plenty of time to explore the city and overcome any possible bureaucratic hurdles to viewing the *Sforziada*. The Poles were understandably very protective of their few treasures, which had miraculously survived Warsaw's many calamities.

Before we had even packed for the trip, there was a potential setback. Kasia informed Martin that the National Library was strongly suggesting that a viewing of the microfilm of the book would be more than sufficient for our purposes. They were squeamish about bringing the heavily guarded original to the light of examination. That was understandable, since these old books are extremely fragile, but Martin was adamant. Our research was possible only if we could see the original and study the binding. He shot off a reply on December 4:

Dear Sirs and Madam,

I understand from my research assistant Kasia Wosniak that you have refused access to the *Sforziada*, suggesting that she and Peter Silverman look instead at a microfilm. This simply will not take forward the research at all, since it involves detailed codicological investigations that are simply not possible with any reproduction, even one of facsimile standard. The investigations involve: studying the physical composition of the MS, its binding, how its pages go in sequence, whether there are signs of removed pages; looking to see the means by which this copy has specifically been tailored for Galeazzo Sanseverino and any indications that it was created for his marriage to Bianca Sforza; and other observations of its composition that might be relevant to understanding its production in relation to the preceding versions of the *Sforziada*.

After 40 years research into historic manuscripts, including those by Leonardo, I of course am fully aware of the strains put on major historical holdings, but I am also aware of when consultation of the original is the only way to answer vital research questions. Thank you for your kind attention.

Martin Kemp

Martin's letter seemed to have its desired effect. There were no guarantees, but it looked very likely that we would be allowed to view the original book if we made the trip to Warsaw. We had nothing to lose—and so very much to gain.

Christmas was approaching, and the lights and festivities in eastern Europe are particularly alluring. I had a bit of business to attend to in Vienna, so I booked us a Paris–Vienna–

Prague-Warsaw-Paris ticket—a one-week trip to the heart of old Europe. We had our usual room at the Bristol in Vienna and attended the wonderful new opera *Il Postino*, which first premiered in Los Angeles with Placido Domingo. It was wonderful—a "triumph," according to one Austrian paper. We also visited two spectacular expos going on concurrently at the Albertina museum. One was on Picasso and his political engagement during World War II, which was a revelation. The second was an extensive, once-in-a-lifetime show of Michelangelo's drawings. The trip was already a success, in our eyes.

Two days later we were in Prague, halfway to Warsaw. We hadn't been to Prague for five years, and we were captivated, as always. Prague, arguably the most beautiful city in old Europe, was resplendent with Christmas lights and spirit— a pure picture postcard of what the season should be—and under a lovely new dusting of snow. An old friend, Oliver von Dohnányi, an acclaimed conductor, had just been nominated director of the magnificent neo-rococo opera house, where we attended a fine production of Georges Bizet's *Carmen* and dined with Oliver afterward. The following morning we set off for Warsaw.

We knew well the history of Warsaw: two hundred years of war, deprivation, communism, and nearly total destruction; the death of 800,000 of its inhabitants during World War II, including the total annihilation of its Jewish population of 350,000 by Hitler's goons; the valiant fight the Jews waged from their ghetto exile, holding off their Nazi murderers for weeks before being mercilessly slaughtered. My former business partner, now an Israeli, was one of the handful to survive.

After the war, the people of Warsaw made a supreme effort to reconstruct their once splendid city, often using as their guide the views of paintings of the city by the eighteenth-century Italian court artist Bernardo Bellotto, which were in

Poland's state collections. A modern visitor would have no inkling of the horrors that transpired there just sixty to seventy years ago.

As a pleasant bonus, we were surprised to discover that Leonardo's *Lady with an Ermine* was currently on exhibit at the Royal Castle Museum. We had last seen it in its permanent home in Kraków ten years earlier and were delighted with the opportunity to view it again. It was a good omen, and another reason to consider our trip a success.

On December 15, Kasia announced that she had arranged a viewing of the manuscript for the morning of December 17. That afternoon we received a phone call from Washington, D.C. It was David Murdock, producer of the forthcoming *National Geographic–Nova* documentary on the discovery. He told us that he would be willing to fly out that very evening if he was assured authorization to film at the moment we viewed the manuscript. By some brilliant tour de force, Kasia not only got approval from the National Library officials but also secured David's entry to film the Leonardo exhibition in the museum as well. Within four hours of his call, David, dynamic, dedicated, and all of thirty-seven years old, was on a flight to Warsaw, where the temperature had dropped to -15 degrees Celsius (5 degrees Fahrenheit).

On December 16, we were all very kindly received at the Royal Castle Museum after closing hours. Armed guards stood by as David filmed *Lady with an Ermine*, the Leonardo on loan from Kraków. That evening Kathy and I attended a fine production of *The Marriage of Figaro* (in Italian with Polish subtitles) in the magnificent reconstructed opera house.

The following day, with Mozart's sublime music still ringing in our ears, we set off, accompanied by Kasia and David, for the big make-or-break moment. Would we find a vital clue about our treasure?

When we arrived at the National Library, we were cheerfully greeted by a lovely young woman whose appearance made us gape in disbelief. To our amazement, she had her hair braided in the same fashion as the woman in *La Bella Principessa*: a *coazzone* more than two feet long. It was very hard not to stare. Kathy and I shared a smile, both thinking this might be a lucky portent.

We were greeted next by Anna Zawisza, the head of manuscripts, who accompanied us into a room with an armed guard standing regally to one side. On a table at the center was a metal armored case in which the *Sforziada* was kept. Donning white gloves, Zawisza slowly and carefully removed the book and set it down. I showed her the life-size reproduction of *La Bella Principessa* I had brought with me and explained our reason for wanting to consult the manuscript. "We want to know if this Leonardo portrait was once bound into this book," I said.

Zawisza's eyes widened, and she became flustered. A Leonardo in her manuscript?

We began by measuring the page size to see if it corresponded to *La Bella Principessa* and were gratified to see that it did, within a millimeter or two (a minute fraction of an inch). Zawisza pointed out that the slight variation might be explained by the fact that the manuscript had been rebound, probably two to three hundred years ago; its edges were cut slightly and trimmed with gold at that time.

Martin had surmised that the Leonardo portrait would have been placed either at the very beginning or the very end of the book, but after careful examination we could find no trace of a cut page in either place.

"May we turn each page?" I asked. It was not a simple request. The book was nearly two hundred pages, and it would be a bit laborious for her, since utmost care had to be used so as not to damage the precious work in any way. Arriving at

page 7, we finally saw the resplendent full-page illumination painted by Birago, and we were thrilled by its quality. This was the stunning allegorical rendering. Looking at it, Martin's comment made total sense: if such a piece were produced for the wedding, perhaps Leonardo would have been commissioned to do a page as well.

It was apparent that the three pinholes where the binding had been sewed, noted earlier by Martin, which we had hoped would be a key to matching, would not be relevant, since the book had been rebound using five sutures.

My mind was awhirl in flashbacks of the past five centuries, when this very book was lovingly composed for Bianca and Galeazzo Sanseverino's marriage. How could I not have suspected sooner that there was a Polish connection to this conundrum—after all, Leonardo's *Lady with an Ermine* had been in Polish hands for two hundred years! Historical records chronicle the connections between the Sforzas and the royal house of Poland. Bona Sforza, the daughter of Bianca's cousin, married Sigismund I of Poland in 1518, taking her private possessions (and possibly this very manuscript) with her on her epic journey from Bari to Kraków.

We slowly continued to view each page, but there was no sign of a missing page. Had we come all this way for an opera and a tour of Warsaw? I had begun to abandon hope and to mentally prepare myself to return empty-handed. But then Zawisza turned page 161.

There was a momentary beat of silence, and then she and I let out muffled cries. There, before our incredulous eyes, was what seemed to be the missing link, the element we longed to find: a remnant of a cut and extracted page of vellum that was the same darkish yellow as *La Bella Principessa*. We could barely contain our emotions. We measured the undulation of the remnant, and it corresponded exactly. Kathy and Kasia came around to see for themselves, while David filmed the

historic moment. Even the armed guard was caught up in the excitement.

Zawisza, who had carefully studied the book on past occasions, murmured how unhappy she was that she'd never noticed the missing page, now so glaringly obvious from the protruding remnant. She pointed out that the page had been cut out after the manuscript had been rebound. Why and by whom we could not even begin to speculate.

I was eager to tell Martin the amazing news, and back at the hotel I placed a call. Elated, I said, "You really are a sleuth extraordinaire! Your supposition by exclusion that *La Bella Principessa* represented Bianca Sforza has been fully and rather spectacularly confirmed. I and the world of art are in your debt."

Martin, too, was elated, although he cautioned that it would be premature, indeed reckless, to reach a definitive conclusion until more research had been performed. Even so, on the flight back to Paris the next day, I could afford to smile at the thought of all the lectures I had endured from rejectionists about the importance of provenance. Why and for whom had *La Bella Principessa* been created? Where had she been all these centuries? Why was there no trace of her in Italy? How could she have escaped the notice of art historians for so long? Now, perhaps, we knew.

Sitting on the Warsaw discovery while yearning to shout it from the rooftops was a test of my legendary impatience. But the secrecy was worth it. Martin needed to see the *Sforziada*, and the scientific analysis he planned with Pascal would be painstaking and time-consuming. Martin had slated a visit to Warsaw in January, so I was hoping to read his conclusions by the spring.

But spring and summer came and went, and there was still no sign of the fruits of Martin and Pascal's research. Martin

talked about reserving his findings, out of courtesy, for the Polish National Library's biannual journal; I was never quite sure if he had the library's 2011 fall issue in mind or the spring issue in 2012. There was some discussion of releasing the information to coincide with the broadcast of David Murdock's documentary. But that wasn't planned until early 2012, either. Meanwhile, there was a big Leonardo show scheduled to open on November 9 at the National Gallery in London, and I did not want *La Bella Principessa* brushed under the media carpet in the run-up to that event.

Martin remained sanguine in the face of the gentle pressure I applied in his direction. As usual, he was busy on a host of simultaneous projects, including *Christ to Coke*, a study of popular icons, and a revised, updated edition of his authoritative book, *Leonardo*. Ultimately, it was his *Leonardo* that set things back in motion. In early September, Martin informed me that the book's publication date had been set for October 6, and that it would cite *La Bella Principessa* as an authentic Leonardo, evoking the research he and Pascal had recently undertaken in Warsaw.

I eagerly awaited the arrival of their report and was thrilled when I received it. It was a twenty-one-page document titled "La Bella Principessa and the Warsaw *Sforziada*."[1] Ever the perfectionists, Martin and Pascal included nearly thirty illustrations—charts, graphs, and photographs. Their conclusion was unequivocal: *La Bella Principessa* was once contained within the Warsaw *Sforziada*.

The report makes fascinating, if highly technical, reading. As it was obviously impossible to dismantle the Warsaw volume, they used macrophotography—a process that allows extreme close-ups of an object—to examine the volume in supersonic detail, especially to determine the sequence of the sheets in the first quire (assembly) of four sheets (that is, eight folios, or sixteen pages). Helped by comparisons with

the *Sforziadas* in London and Paris, it was demonstrated that one folio, and a complete sheet, had been removed from the Warsaw *Sforziada*: not, alas, from page 161, as I had enthusiastically surmised during our Warsaw visit in December 2010, but from the first quire. This implied that, originally, the folio adorned with *La Bella Principessa* directly preceded the Birago frontispiece.

Martin and Pascal also found that the dimensions of the folios were the same as in the Paris and London versions, and that the vellum on which *La Bella Principessa* was drawn closely matched the physical characteristics of the remaining sheets in the first quire. The thickness of the vellum used for the portrait was "entirely consistent" with that of the other folios in the Warsaw *Sforziada*. Perhaps most exciting of all, the stitch holes in the vellum of the portrait matched those in the book, even though both were unevenly spaced.

This welter of evidence left no doubt that the portrait was indeed made for the *Sforziada* destined to mark the marriage of Bianca Sforza and Galeazzo Sanseverino in 1496. Leonardo's authorship, wrote Martin and Pascal, was "powerfully supported." Claims that the work was a modern forgery, a nineteenth-century pastiche, or a copy of a lost Leonardo were "all effectively eliminated." They ended with a thundering conclusion: the portrait was now "one of the works by Leonardo about which we know most in terms of its patronage, subject, date, original location, function and innovatory technique."

There is no difficulty imagining a scenario whereby Leonardo, who had known the bride and groom intimately for many years, was commanded to produce a bridal portrait for a special wedding book. His response was, characteristically, to produce a vivid image using a method that differed from traditional illumination, by extending and transforming the *trois crayons* technique he had learned about from French

court artist Jean Perréal when the latter was in Milan with King Charles VIII in 1494.

On Martin's insistence, we issued a press embargo on the report until September 28. Simon Hewitt, who had so faithfully followed the story since the outset, was doing some of his own digging, including a fact-finding mission to Poland, which took him not just to Warsaw but also to Zamosc, the town in southeast Poland where the *Sforziada* had been kept for at least two hundred years. Once the embargo was lifted, Simon wrote a major piece for *ATG* titled, "New Evidence Strengthens Leonardo Claim for Portrait."[2] The article thoroughly described Martin and Pascal's findings and also referred to the "conspiracy theories flying around the art world," with respect to *La Bella Principessa*'s absence from the National Gallery exhibition.

The international media were wowed by the Warsaw findings, and we received some wonderful press, beginning with the *Guardian*, which published an interview with Martin about the Warsaw findings.[3] *Le Figaro*, France's leading daily, renowned for its art market coverage, devoted all of its page 2 to *La Bella Principessa*, under the sizzling headline, "The Mystery of Leonardo da Vinci's 13th Portrait Elucidated."[4] A few days later, Artinfo.com, the online version of the respected American magazine *Art and Auction*, ran a lengthy interview with Martin, dubbing him the "Da Vinci Detective" and asserting that he had "rediscovered Leonardo's tragic portrait of a Renaissance Princess."[5]

In the interview, Martin described his visit to Warsaw as "a bit of a circus" due to "all the technical equipment, photographic equipment and spectral equipment" Pascal brought with him (not to mention David Murdock's film crew), and went on to outline their minute analysis of the first few pages in the *Sforziada*—those that "have all the special material in them."

Soon after Martin and Pascal's research was published, *National Geographic* magazine announced that it would run an eight-page feature on *La Bella Principessa* in its February 2012 issue, to coincide with the publication of this book and the screening of the Murdock documentary. Meanwhile, D. R. Edward Wright was busy putting the finishing touches to his own scholarly study of the history of the four *Sforziadas*, adding yet more bricks into what was rapidly becoming a wall of provenance of Jericho proportions.

In the wake of Simon's *ATG* article, there was outcry in the media about *La Bella Principessa*'s omission from the National Gallery show on Leonardo's years in Milan. Tepid, and at times confused, explanations were circulated by National Gallery spokespeople, some insisting the show was mainly about paintings, and *La Bella Principessa* was technically a drawing; others insinuating that the gallery could not be seen to do anything that might enhance the commercial value of a work in private hands. That sort of guff went down like a lead balloon with the hundreds of thousands of art lovers who felt cheated of the chance to admire what we can now assert, without exaggeration or false modesty, to be one of the greatest art discoveries in modern history.

Thanks to the reams of scientific and historic evidence uncovered between 2008 and 2011, all doubts and questions about *La Bella Principessa*'s authenticity have been laid to rest. Only the most prejudiced skeptics can dispute the shattering conclusion brought forth by the skilled marriage of technology and connoisseurship: that *La Bella Principessa*, this subtle, moving, and hauntingly beautiful image, is the work of a supreme genius—Leonardo da Vinci.

Epilogue

Life's Fleeting Grace

Art is never finished, only abandoned.

—*Leonardo da Vinci*

In 1519, Leonardo was an old man in his sixty-seventh year, and he was gravely ill, confined to his bed in the Clos Lucé, the French manor he had lived in for three years under the grace of his dear friend King François I. Perhaps in his imaginings, which were sometimes fevered, the work of his life swirled around him: the face of an angel gazing in reverence at the Christ child, the violent passion of the Battle of Anghiari, the pain in the faces of Jesus's disciples as they learned of his betrayal by one of their own, the beautiful seductiveness of Lisa's smile, the lovely countenances of the women of Ludovico's court, the thousands of sketches made in what he now despaired were a futile attempt to pull the very souls of his subjects into view.

According to the author Giorgio Vasari, as winter turned to spring, the king often came to sit by Leonardo's bedside. He was supportive of Leonardo's late-life turn to religion. After painting some of the most iconic religious themes ever made, Leonardo felt his life ebbing away and had found God. Although he was extremely weak, he would ask François and others to help him leave his chamber so he could take the sacrament of the Holy Eucharist.

On his last day of life, his breath labored, Leonardo saw his beloved friend the king in the doorway, looking at him with great sadness. "Help me sit," he said, and the king gently lifted him into an upright position.

"I am dying," Leonardo said with a faint voice, tinged with regret. "I have failed in this life to do full justice to my gift."

"No, no," François protested. "You have honored us all with your work."

"I have offended God by not working as well as I ought to have. I pray to be forgiven."

Suddenly Leonardo shuddered and let out a gasping breath. The king raised his friend's head to ease his suffering and held him in his arms as Leonardo passed on to the next life—the last thought in his mind that he had been a poor servant of his art.

Those who mourned him would disagree. Vasari recorded in the aftermath of Leonardo's leaving the earth, "The splendor of his great beauty could calm the saddest soul, and his words could move the most obdurate mind. His great strength could restrain the most violent fury, and he could bend an iron knocker or a horseshoe as if it were lead. He was liberal to his friends, rich and poor, if they had talent and worth; and indeed as Florence had the greatest of gifts in his birth, so she suffered an infinite loss in his death."[1]

Epilogue

● ● ●

The discovery and consecration of *La Bella Principessa* has been a gratifying culmination of my nearly half a century of love and passion for art. It is perhaps every collector's swan song come to fruition. As Martin so poetically put it, "It is a star portrait of a stellar sitter. *La Bella Principessa*, as the poets would claim, testifies to Leonardo da Vinci's victory over the transitory beauties of envious nature and the ravages of corrosive time. It is, I believe, an image that is bound to bring great pleasure to successive generations of viewers."[2]

But the joy and excitement are naturally tempered by a touch of melancholy and a sweet sadness for dear time's waste—the profound realization that nothing is permanent and that the only certainty in life is uncertainty.

What could better exemplify this human reality than the fate of the beautiful girl so sensitively depicted by the great Master, Leonardo da Vinci? Bianca Sforza, on the threshhold of a sumptuous courtly life, so full of promise, was suddenly struck down at the age of fourteen. Thanks to the miraculous hand of a genius, Bianca escaped a fate of oblivion, and we are able to appreciate her beauty and cherish her existence.

It is sobering to think how close Bianca came, after five hundred hidden years, to nearly being lost to us again, perhaps this time forever. I have asked myself often where fate has taken her over the centuries, from the moment her portrait was most probably cut from the family album, no longer serving either a political or sentimental purpose. Was it first passed around by former friends or her husband, framed and hung in a family chapel, or hidden in a somber room, a faint remembrance? And with the vagaries of time and through the years of plague, warfare, political dislocations and turmoil, what happened to her? Our fantasies can run wild imagining where she lay hidden all those centuries until

Giannino Marchig, an expert restorer and fine painter in his own right, found her, we know not where, prized her without knowing her origins or author, and lovingly restored her, for his own pleasure and the simple joy of bringing her back to life. And then, with some serious misappraisals, misjudgments and a quirk of fate, she fell into my almost unworthy hands—unworthy because I did not immediately understand or recognize her extraordinary qualities or importance. Fortunately, it seems my whole life as a passionate collector focalized and culminated on this one object, and through my experience and many contacts in the field of art, I was able to advance at an astonishing pace for a discovery of this magnitude. I hope this book pays adequate homage to those who made this an amazing success. It has been a truly rewarding adventure, and I am thankful for having played my part.

Yet, at the back of my mind there will forever be a sigh and a thought for Bianca and Leonardo, as a sonnet by Shakespeare echoes in my mind:

> Then can I drown an eye, unused to flow
> For precious friends hid in death's dateless night
> And weep afresh love's long since cancelled woe
> And moan th'expense of many a vanished sight.

La Bella Principessa, as the poets would claim, testifies to Leonardo da Vinci's victory over the transitory beauties of envious nature and the ravages of corrosive time. It is, I believe, an image that is bound to bring great pleasure to successive generations of viewers.

A century from now, when all who read these pages are but distant memories, Leonardo will, I pray, still be present in the world: a paradigm of perfection, an example to be emulated, a model for the geniuses of the future.

Appendix

Nicholas Turner's Report on *Portrait of a Young Woman in Profile*

After studying La Bella Principessa (*then known as* Portrait of a Young Woman in Profile) *at my request, Nicholas Turner agreed to write his analysis, which appeared on Lumiere Technology's website. He gave me permission to reprint it in full here. Turner's careful study is a model of art critique, and his conclusion, that the portrait is a signature work by Leonardo da Vinci, carries the weight of his impressive experience, judgment, and intellect.*

Statement by Nicholas Turner Concerning the Portrait on Vellum by Leonardo

Leonardo da Vinci (1452–1519), *Portrait of a Young Woman in Profile*: Pen and brown ink and body color, over red, black, and white chalk, on vellum (laid down on panel); 330 × 239 mm.

Technique and Style

This finished, colored drawing on vellum shows a young woman in profile to the left, her hair descending in a single plait from beneath an elaborate headdress or caul, wearing late fifteenth-century Italian costume. Based on its style and left-handed shading, it can only be one of two things—an original work by Leonardo da Vinci or a copy, pastiche, or fake made to look like an autograph portrait by Leonardo.

The extremely high quality of this mixed-media portrait and the evidence of scientific tests undertaken so far point resoundingly in favor of the first conclusion. According to carbon-14 tests, carried out by the Swiss Federal Institute of Technology, Zurich, the parchment support may be dated between 1440 and 1650 (dating with this technology is always given within a two hundred–year period). In the interests of preserving the integrity of the work, physical samples of the materials used in the drawing have not yet been taken, and an exact analysis of the materials and the relative order in which they were applied require further clarification.

Beyond firsthand examination of the *Portrait of a Young Woman*, an important starting point for any serious consideration of its quality is the sequence of high-resolution digital scans made early in 2008 by Lumiere Technology, a Paris-based company specializing in multispectral digital technology, which has had extensive experience of Leonardo's work, having carried out detailed studies of the *Mona Lisa* and the *Portrait of Cecilia Gallerani (Lady with an Ermine)*. The scans of

the new *Portrait of a Young Woman*, one of the most exciting discoveries in the field of Leonardo studies of recent years, may be consulted on Lumiere's website (www.lumiere-technology .com). The digital "slideshow" also includes UV, infrared, false color, and raking light reflectographs, as well as an X-ray.

Introducing this formidable array of technological support is a remarkable color scan of the whole portrait, which may be enlarged several times life-size, giving the viewer an opportunity to understand—better than with the naked eye—the exceptional quality of the drawing's execution. Among the more noteworthy elements revealed in this way is the extent of the left-handed shading—the "signature feature" and most visible testimony of Leonardo's authorship—especially in the face and neck and in the left background along the sitter's profile.

These areas of parallel hatching in pen in the background, behind the sitter's face, are blocked in to give a contrast to the highlights of her flesh. Similar dense crosshatching is to be found throughout the artist's drawings. Especially good examples of the type, also in pen, are found among Leonardo's studies of anatomical subjects, for example, the series of studies of the human skull in the Royal Library at Windsor Castle (inv. nos. 19058r & v, 19057r & v, and 19059r; Zöllner, 2007, nos. 257–61, all repr.).

The hatching strokes in the new portrait taper from lower right to upper left, just like the strokes defining the *left* background in the skull studies. Carlo Pedretti's observation (abstract of introduction to the monograph *Leonardo infinito* by Alessandro Vezzosi, published in July 2008 [available as a PDF on the Lumiere Technology website]) that Leonardo's strokes normally went from upper right to lower left applies to the shading on the *right* side of the skulls, not to the strokes to the left of the skulls. In other words, Leonardo wisely moved the pen from the object's contour outward into the background, avoiding any possible stray overlapping back into the

finished object. It is thus not surprising that he would have directed the pen away from the sitter's face and neck toward the upper left in the new portrait. Had there been background shading on the right side of the new portrait, one would have expected the lines to move from upper left to lower right. However, there was no need for any shading on the right side to set off the dark hair against the neutral light background.

In fact, all aspects of the shading of this portrait provide visual testimony of Leonardo's theories of illumination, as expounded in his *Treatise on Painting*, a posthumous and somewhat random selection from his writings. The areas of midtone indicated by the crosshatching in the left background of the *Portrait*, which are seen at the woman's profile and, to a lesser degree, at her neck and breast, are not cast shadows but local adjustments to the background to increase slightly its darkness. In his treatise (Dover reprint, Precept no. 200), Leonardo talks specifically about the need for the background to make the subject stand out or detach itself sufficiently, contrasting light with dark and dark with light. Without the visual foil of a midtone darker than the rest of the background, the lights of the woman's forehead, nose, mouth, and chin would not appear in such impressive relief as they do. The flesh of her neck immediately under her chin and her lower chest, being a darker tone than that of her face, has less of this misty shading in the adjacent background to act as contrast. Since her bodice is appreciably darker than the background, the area in front of it (like the whole right side behind her hair) has no such crosshatching.

Another feature of the portrait that is demonstrated in the Lumiere Technology scan is the presence of several pentiments, especially in the profile of the face and where the line of the hair meets the background at the top of the woman's head. Much attention was paid to the exact line of the nose,

another key point in Leonardo's theoretical discussion of ideal beauty in his treatise.

The first of the enlargeable scans also highlights the artist's intense concentration on detail—from the minutiae of the facial features and the pattern of the woman's dress to each knot of her caul. Such an obsessive quest to record even-handedly the appearance of everything within the artist's view, seemingly down to the last particle, is a characteristic of Leonardo's creativity.

Among the more readily observed passages of pen-and-ink drawing, even with the naked eye, are the slender contours defining the young woman's profile, her shoulders and costume. Such a delicate, subtly modulated outline is encountered in other examples of Leonardo's head studies, for example, as Prof. Alessandro Vezzosi first observed, the metalpoint *Head and Shoulders of a Woman* (ca. 1488–1492) in the Royal Library, Windsor Castle, where the sitter is similarly viewed in profile, but this time with her head facing right (inv. no. 12505r; Zöllner, 2007, no. 187, repr.). Another close stylistic parallel, though later and probably a pricked cartoon for a painted portrait, is the black and red chalk *Portrait of Isabella d'Este* (ca. 1499–1500) in the Louvre (inv. no. 753; Zöllner, 2007, no. XXI, repr.). All of these examples, but especially the present work, since it is technically the most akin to a painting, satisfy Precept no. 194 ("Of the Beauty of Faces") from Leonardo's *Treatise on Painting*, which states that "you must not mark any muscles with hardness of line, but let the soft light glide upon them, and terminate imperceptibly in delightful shadows; from this will arise grace and beauty to the face."

Drawn with an even finer line are the areas of dense parallel hatching that model the sitter's face and neck. These passages of penwork are readily apparent in the Lumiere Technology scan, but they are mostly covered by the delicate cream, light

pink, and white passages of body color of her face, which create a smoky gray *sfumato* effect that is typical of Leonardo.

The drawing of the woman's hair is among the most beautiful and spontaneous of all the details in the *Portrait*, as well as the most complex in its coloration. Here Leonardo was not ashamed to mix his media in what for him seems to have been the most unusual combination of brown ink and brown-red wash over black, red, and white chalk. Nevertheless, the range of textures and colors suggested by the different media enabled him to convey the velvety sheen of hair and to distinguish subtly between those parts that are relatively loose and in the light, at the top of the head, and others in shadow, at the back, with some of the hair held in place by the mesh of the caul and the rest bound tightly together in the plait.

The pen lines flow in rivulets down her head. Together with the darker, even more broadly indicated strokes of the brush and wash, they represent the descending strands of hair that are brought together into the single thick braid that hangs down the middle of her back and is cut off by the bottom of the composition. Both the underdrawing in chalk and the lines in both pen and wash are spaced farther apart at the top of the woman's head, allowing the parchment ground to show through. This creates a highlight in the hair that establishes the crown of her head, the form of which continues beautifully the curve of her brow. At the side of her head the tresses of hair are parted even more subtly to indicate the shape of the ear beneath.

There are few surviving drawn portraits with which to make technical comparisons, and it is not easy to find parallels for the more intuitive drawing in mixed media of the hair in other works by Leonardo. In *Study of a Winged Figure; Allegory with Fortune* (ca. 1480–1481), in the British Museum, London (inv. no. 1895–9–15–482; Zöllner, 2007, no. 387, repr.), the freedom of both the penwork and its accompanying brown

wash do, however, approximate to its rhythmical movement and show the same indifference to neatness. Moreover, the use of pen and brown wash in combination with body color does occur in one category of Leonardo's drawn oeuvre, those of maps and plans, of which several have survived, although these are without exception done on paper.

Support

Also apparently unprecedented is the use of vellum or parchment as a support for the new portrait. Being so far in advance of his time as a painter, draughtsman and thinker, it is not surprising that Leonardo was also a technical innovator. For the making of drapery studies, he pioneered drawing with the brush and body color on linen, showing that he was prepared to experiment when it came to finding the right support for different types of representation. Although no other work by him exists on vellum, this alone does not exclude his authorship. Professor Alessandro Vezzosi has pointed out that Leonardo, in his *Treatise on Painting*, recommended the use of vellum as a support for drawing: "take some skin of a goat, soft and well prepared, and then dry it; and when it is ready, use it for drawing, and then you can use a sponge to cancel what you first drew and make a second attempt" (quoted from Vezzosi, not apparently in Dover edition of the *Treatise*). The artist has successfully exploited the pitted texture of the material in his rendering of the figure's flesh and clothes. It would be interesting to establish whether the vellum used as the support for the *Portrait* is indeed from goat.

Dating

The *Portrait* has been dated around 1481–1482, that is, in the time shortly after Leonardo's transfer to Milan from Florence. (This probably took place during the course of 1482, sometime after the last recorded payment in Florence in September

1481.) There are two strong points in favor of such a dating—the drawing's style and the sitter's dress. From the point of view of the style, the legacy of Florence is clearly to be seen in her facial type, with its echoes of heads by Andrea del Verrocchio, Lorenzo di Credi (who trained together with Leonardo in Verrocchio's workshop), and others. The purity of the woman's silhouette set against the light background, suggestive of a paper cutout, recalls the equally uncompromising but more complex outline of the *Warrior with Helmet and Breastplate* (ca. 1472), in the British Museum (inv. no. 1895–9–15–474; Zöllner, 2007, p. 11, repr., and p. 365, no. 191, repr.). Although the *Portrait* is dissimilar in actual detail from the *Warrior* in almost every respect, it is interesting to note that the structure of the warrior's eye and eyelids are close to those of the woman in the *Portrait*. The British Museum drawing has been interpreted by some critics as a copy, or adaptation, of a work by Verrocchio, *Darius*.

It seems to have been during his first Florentine period (1472–ca. 1482) that Leonardo was in the habit of experimenting in the drawing of different human profiles, mostly the contrasting types of the stern warrior and a handsome, amenable youth. This activity seems to reflect ideas then in vogue in Verrocchio's workshop. Most of these profiles are rapidly drawn sketches on paper, while others, such as the British Museum drawing just mentioned, are more deliberate in their execution. Whatever its date, the present *Portrait* depends heavily in mood and appearance on these preoccupations and Leonardo's early Florentine experience.

Costume and Iconography

The convention of young women wearing their hair in a robust, single plait is a late fifteenth-century Lombard fashion, as is also that of encircling the head with a narrow band worn at, or just above, the forehead. Both of these features

appear in Leonardo's *Portrait of Cecilia Gallerani (Lady with an Ermine)* (1489–1490), in the Muzeum Narodowe, Czartoryski Collection, Cracow (inv. no. 134; Zöllner, 2007, no. XIII, repr.). She was the mistress of LudovicoII Moro. The same type of headdress is also found in Ambrogio de Predis's *Portrait of a Young Woman in Profile* (ca. 1490[?]), in the Ambrosiana, Milan (inv. no. 100; Zöllner, 2007, p. 98, repr.), where the ornamental border of the sitter's sleeveless jacket is decorated at the shoulder in a similar way to the border around the cutout opening at the top of the sleeve. So specific is the connection between this Milanese fashion for a particularly laborious but nonetheless extremely elegant hairdo that it seems more likely that the work was carried out in Milan. It is also within the realms of possibility that the sitter may have been either from Milan or Lombardy.

In his recent book, Alessandro Vezzosi identified this type of portrait as a *ritratto nuziale* ("marriage portrait"). He postulated that it may represent the young Bianca Maria Sforza (1472–1510), the daughter of the Duke of Milan, before her marriage in 1494 to the emperor Maximilian I (1459–1519). Her husband later praised her beauty rather than her character. The sitter's facial features conform to what Leonardo describes in his *Treatise* as the "perfectly illumined visage," showing grace, since the shadows do not appear "cutting, hard or dry" (Dover reprint, Precept no. 196). Such a function—a portrait sent for approval to a prospective groom—would explain the drawing's unusual media, support, and high degree of finish.

Condition

In my view, most of the drawing defining the features of the figure and the decoration of the woman's costume is in pen and was drawn by Leonardo; it is handled with such finesse that it is quite simply beyond the competence of a later

retoucher. A few later additions do nevertheless occur, but they are mostly in the pigmented areas and were made to replace losses in the coloring, mainly in the face and hair (see Lumiere Technology, UV reflectograph, false color reflectographs, and pigments and restoration study).

Attributional History

Since its reemergence in 1998, this work has carried only two attributions. When sold in that year by Christie's, New York (sale, January 30, 1998, lot 402, as the property of a lady), it was catalogued as nineteenth-century German school, and the sitter was described as being clothed in "Renaissance Dress." The second attribution, to Leonardo, was proposed by myself and others in 2008 and has received varying degrees of support. Among those fully in favor are Professore Alessandro Vezzosi, Mina Gregori, Carlo Pedretti, and Cristina Geddo.

As has been pointed out by Dr. Cristina Geddo, who has worked extensively on the *leonardisti milanesi*, the rejection of Leonardo's authorship in favor of an attribution to one of his many Milanese followers—for example, Giovanni Antonio Boltraffio, Ambrogio de Predis, Francesco Melzi, Bernardino Luini—would be unfounded, since none of these artists was left-handed or skilled enough to produce such a subtle portrait.

Provenance

The provenance of the work before 1998 remains a complete mystery. The appearance of what seem to be early twentieth-century French customs stamps on the back of its wooden panel implies that, at the very least, it made a passage through France. Whether it was exiting or entering remains to be established. Perhaps it was hidden for generations in some French château, although this is pure guesswork. The only hint discovered so far of its possible earlier existence is to be found in two

references, both brought to attention by Professor Alessandro Vezzosi. He has noted that in an inventory taken in the early 1480s of Leonardo's effects, there are two works that might correspond to the newly discovered *Portrait*, "*Una testa in profilo con bella cappellatura*" ("A head in profile with beautiful hair") and "*Una testa di putta con trezie rannodate*" ("A head of a young lady with plaited locks"). It could, in theory, be either of these.

Conclusion

Not only does this remarkable drawing by Leonardo fit stylistically into his oeuvre as a painter and draughtsman, it also conforms to his theories of figurative representation, as set out in his *Treatise*. This report is based on research commissioned from me by the owner's agent at my standard daily freelance rate; I have no commercial interest in this work.

Nicholas Turner, M.A., formerly deputy keeper in the Department of Prints and Drawings, British Museum, London (1974–1994), and curator of drawings at J. Paul Getty Museum, Los Angeles (1994–1998), September 2008

211

Notes

1. Found!

1. Christie's catalog, New York, January 30, 1998, lot 402.
2. There has been relatively little written about the Nazarenes, but an excellent essay, which includes illustrations of their works, is Lionel Williams, "Unwilling Moderns: The Nazarene Painters of the Nineteenth Century," *Nineteenth Century Art Worldwide*, Autumn 2003.

2. Who Is She?

1. Caroline Corrigan, restoration report, August 1, 2007:

> Condition Report: For an early XVIth century drawing on vellum laid down on a panel, "Profile of a young woman." Size: about 30 cm × 40 cm. Observations: Techniques—brown ink, probably iron gall ink; tempera, light retouch of a transparent pink on the forehead and cheeks; the surface is varnished. Support—vellum, laid down on an oak panel (the original panel must have been changed during the 19th century, as a few repaired insect holes can be seen; small accidents are noticeable on the ridges. State: This drawing is in a very good state, vellum and techniques; the 19th century restoration is rather well done. Conservation Conclusion: Under good conservation conditions, this drawing should

preserve its exceptional aspect. There is no need of other restoration; it should not be treated in any way. It is too rare and precious to risk anything.

2. Mina Gregori, "A Note on Leonardo," *Paragone*, 2009, anno LXI, no. 723, no. 91, 3–4.

3. Leonardo's World

1. da Vinci, "Of the Life of a Painter in His Studio," in *Leonardo's Notebooks*, 492.
2. Vasari, *The Lives of the Artists*, 284–287.
3. Ibid.
4. The unfinished *Adoration of the Magi* has been in the Uffizi Gallery in Florence since 1670.
5. da Vinci, "Letter to the Duke," in Vasari, *The Lives of the Artists*.
6. Christopher Hare and Baldassarre Castiglione, *Courts and Camps of the Italian Renaissance* (New York: Harper, 1908), 23.
7. da Vinci, "That Painting Surpasses All Human Works by the Subtle Considerations Belonging to It," in *Leonardo's Notebooks*, 653.
8. As Vasari recounted in *The Lives of the Artists*, p. 289,

He proposed to the Duke that he should make a bronze equestrian statue of marvelous size to perpetuate the memory of the Duke (Francesco Sforza). He began it, but made the model of such a size that it could never be completed. There are some who say that Leonardo began it so large because he did not mean to finish it, as with many of his other things. But in truth his mind, being so surpassingly great, was often brought to a stand because it was too adventuresome, and the cause of his leaving so many things imperfect was his search for excellence after excellence, and perfection after perfection. And those who saw the clay model that Leonardo made said they had never seen anything more beautiful or more superb, and this was in existence until the French came to Milan with Louis,

King of France, when they broke it to pieces. There was also a small model in wax, which is lost, which was considered perfect, and a book of the anatomy of the horse which he made in his studies.

4. Real or Fake?

1. Hoving, *False Impressions*, 17, 163.
2. Ibid., 163.
3. Two books have been published detailing the *Mona Lisa* theft and its implications: Scotti, *Vanished Smile*, and Hoobler and Hoobler, *The Crimes of Paris*.
4. Simon Kuper, "Who Stole the Mona Lisa?" *FT Magazine*, August 5, 2011.
5. Peter Landesman, "A Crisis of Fakes: The Getty Forgeries," *New York Times Magazine*, March 18, 2001. Other efforts of Turner's to expose fakes at the J. Paul Getty Museum are also detailed in this article.
6. Hebborn, *The Art Forger's Handbook*.
7. Brewer, *The American Leonardo*, 296.
8. Hahn and Benton, *The Rape of La Belle*, 3.
9. Ibid.
10. Ibid., 41.
11. Ibid., 42.
12. Ibid., 32.
13. "Duveen on da Vinci," *Time*, February 25, 1929.
14. Hahn and Benton, *The Rape of La Belle*, 5.
15. "Lapis Lazuli and Kermes Berry," *Time*, June 26, 1933.
16. Hahn and Benton, *The Rape of La Belle*, xviii.
17. Ibid., 17.
18. Ibid., 21.
19. Since Sotheby's preferred to auction the "copy," there were some who still wondered whether it might be the real thing. Peter Duveen [no relation to Sir Joseph], "Did Leonardo da Vinci Paint *La Belle Ferronnière*? If So, Which One?" *OpEd News*, January 25, 2010.
20. Brewer, *The American Leonardo*, 296.

5. The Magic Box

1. Daniel Kunitz, "Inside Leonardo's Mind," *New York Sun*, December 1, 2004.

2. Thomas Regnier, "Leonardo's Mystery: An Interview with Umberto Eco," *Queen's Quarterly*, June 22, 2006.

3. As an interesting side note, Lumière is also the name of two French brothers, Auguste and Louis Lumière, who were distinguished as the earliest filmmakers in the nineteenth century.

4. *Mona Lisa Revealed: Secrets of the Painting*, produced by Caroline Cocciardi (Miami, FL: JC Productions, 2009), DVD.

5. Descriptions of the history and technology may be found at the company's website, www.lumiere-technology.com. Examples of Lumiere Technology's digitization from public and private collections might include the works of Chagall, Fragonard, Audubon, Latour, and Renoir, as well as Picasso's *La Vie*, van Gogh's *The Roadmenders* (digitized at the Cleveland Museum of Art), the two masterpieces *Les Vieilles* and *Les Jeunes* by Goya (from the Palais des Beaux Arts de Lille), *The Escape in Egypt* by Poussin, and the two versions of *The Bedroom of Arles* by van Gogh (one at the Art Institute of Chicago and the other at the Van Gogh Museum of Amsterdam). On the website, one can view a fascinating demonstration of its advanced technology, based on the world's most renowned masterpiece, da Vinci's *Mona Lisa*, at the Louvre in Paris, and *Lady with an Ermine*, at the Czartoryski Museum in Kraków. See also P. Cotte and D. Dupraz, "Spectral Imaging of Leonardo da Vinci's *Mona Lisa*: An Authentic Smile at 1523 dpi with Additional Infrared Data," *Proceedings of IS&T Archiving '06 Conference: Ottawa*, 2006, 228–235.

6. *Mona Lisa Revealed*, DVD.

7. Ibid.

8. Vasari, *The Lives of the Artists*, 294.

9. Ibid., 284.

10. *Mona Lisa Revealed*, DVD.

11. Lumiere Technology's website, www.lumiere-technology.com.

12. Ibid.

13. Papers by Raymond N. Rogers can be viewed at www.shroud .com. They include Raymond N. Rogers and Anna Arnoldi, "The Shroud of Turin: An Amino-Carbonyl Reaction (Maillard Reaction) May Explain the Image Formation," in *Melanoidins*, ed. J. M. Ames (Luxembourg: Office for Official Publications of the European Communities, 2003), 4:106–113. This paper demonstrates that a complex but well-documented naturally occurring chemical reaction may explain all of the known image chemistry of the Shroud of Turin and provide us with an important clue in determining the actual image-formation mechanism.

14. Kemp and Cotte, *La Bella Principessa*, 107. Cotte's examination of *La Bella Principessa* was also discussed in numerous conversations with the author.

15. Ibid., 115.

16. Ibid., 177.

17. Ibid., 129

18. Ibid., 132.

19. Ibid.

20. Ibid., 135.

21. Ibid.

6. A Scholar's View

1. da Vinci, *Codex Atlanticus*, folio 1058.

2. In fact, most of Leonardo's inventions did not work, a fact that Umberto Eco deems to be part of the creative process. Calling Leonardo a genius and a tinkerer, he observed, "History is constantly illustrating the productive power of mistakes. The productivity of mistakes is what the English call 'serendipity.' Serendipity is precisely the capacity to make happy and unforeseen discoveries by accident. There is serendipity in looking for one thing and, having made an error, finding something else." Thomas Regnier, "Leonardo's Mystery: An Interview with Umberto Eco," *Queen's Quarterly*, June 22, 2006.

3. "Obituaries: Adrian Nicholas," *Daily Telegraph*, September 25, 2011.

4. Kemp and Cotte, *La Bella Principessa*, 32.

5. Martin Kemp, "La Bella Principessa: A Leonardo Discovered," University of Oxford podcast, August 16, 2010.

6. Ibid.

7. da Vinci, "Ligny Memorandum," 1499, folio 669r.

8. da Vinci, "Proportions of the Head and Face," in *Leonardo's Notebooks*, 310.

7. Leonardo's Principles

1. da Vinci, "Of the Beauty of Faces," in *Leonardo's Notebooks*, 587.

2. da Vinci, precept 200, in *Leonardo's Notebooks*, 593.

3. Dr. Sherwin Nuland, interview by Neal Conan, *Talk of the Nation*, NPR, April 14, 2009.

4. Cristina Geddo, "A 'Pastel' by Leonardo da Vinci: His Newly Discovered Portrait of a Young Woman in Profile," *Artes*, 2008–2009, 63–87. After the first paragraph, which I have quoted in full in the text, the rest of the article reads as follows:

This portrait is far from straightforward to explain, a state of affairs that results above all from the ambiguity of the work itself, a hybrid creation wavering between drawing and painting, whose original appearance, with its outlines applied '*a secco*', has to be separated in the mind's eye from subsequent retouches with the brush in liquid colour. For this reason, it is not surprising that it was mistaken for a nineteenth-century work of the Renaissance revival, associated with the Nazarenes, and sold by Christie's, New York, ten years ago, with an attribution to the early XIXth-Century German School.[1]

Only now has the *Portrait of a Young Woman in Profile* been recognized—firstly by Nicholas Turner, and then by a group of Leonardo specialists, still quite restricted in number, among them the present writer[2]—as an astounding, unpublished work by Leonardo, lost to sight for five centuries, and a significant addition to the small corpus of

portraits that are given to the artist today. And only now has the historical and critical study of the piece been initiated, in conjunction with its physical examination entrusted to Lumière [sic] Technology, a Paris-based diagnostic laboratory that specializes in new techniques of non-invasive, multi-spectral digital photography.

The aim of this preliminary contribution to the subject, which is still fraught with unanswered questions, is not completeness but to put forward a strong proposition—already expressed in the title—which is based on the convergence between the technique employed in the execution of the portrait and what Leonardo himself maintained on the use of such media. It is a thesis that ought to be judged in the light of the technical and scientific analyses that are at the moment underway in order to complete the "clinical record" of the work.

The portrait is carried out almost to life size on a piece of vellum cut into a rectangle, measuring 328 × 238 mm, laid down with copious amounts of glue on to an old oak panel; this vellum support was presumably attached to this backing at some time in the second half of the nineteenth century, perhaps at the same time as the restorations to the work itself. Two old customs' stamps of Central Customs, Paris, are imprinted on the other side of the panel (DOUANE CENTRALE/ EXPORTATION/PARIS), telling us that the work was kept in France for a time at some point before the Second World War, before travelling to the United States.

In spite of the insertion of 'butterfly keys' to minimize the bowing of the panel, the poor adherence of the skin to the wooden backing has resulted in considerable lifting of the vellum in the upper centre, increasing the losses of pigment in the face and neck. This problem has been exacerbated by the apparent crudeness in the preparation of the parchment and by its mediocre state of preservation, covered by horizontal furrows, with three poorly mended tears

along the edges and a fourth on the chin, as is shown in the photograph in raking light (fig. 5).

The edges seem untrimmed, with the exception of that to the left, which has been cut crudely: an important clue, on the basis of which one can presume that the leaf was originally contained in a hand-stitched volume and so had been detached from a parchment codex.

Besides the presence of the follicles, the rough unworked surface of the hide and its darkened, somewhat yellowish colour show that the portrait was made on the outer surface of the skin (formerly fur-covered) and not on the inner one covering the flesh, which was aesthetically the superior of the two and commonly used as a support for written documents. This observation opens up the possibility that the verso of the parchment may have writing on it, a point that could be verified were it to be lifted from its present backing in some future (and much hoped for) restoration.

The choice of the skin side was dictated in all probability for technical and stylistic reasons: the porosity and permeability that characterize it would have, in fact, guaranteed a better adhesion to the surface of the 'dry' colours, while the yellowish tint of the ground would have provided a more inviting base for the colours of the drawing, reinforcing the lights, in just the same way as a tinted paper does. In any case, one is here dealing with a parchment or part of a recycled codex: one can deduce this from the superimposed numbers visible through the parchment above the central decoration of the costume, which should be decipherable, like others written in pen, such as very pale inscription visible along the upper border of the sheet and the little winged dragon—at least this is what it seems—in the lower left corner. This feature, too, counts in favour of an attribution to Leonardo, who, even though he has never to our knowledge used a parchment support in his work, was in the habit of re-using the paper on which he wrote or drew.

As far as the *media* used and the subsequent restoration are concerned, the recommendation must be that all the necessary technical investigations are completed to identify the pigments and their binders, so that the materials used in the execution of the work may be clarified once and for all, together with an irrefutable scientific report as to the author of the work, as well as to its restorer. But already the direct examination of the work, extraordinarily strengthened by the multi-spectral, exceptionally high-resolution scanning of Lumière [*sic*] Technology—visible on the computer screen in macro-photographic detail, with the possibility of successive enlargements—and the comparison made by Pascal Cotte, who is already investigating these materials and perfecting his fundamental mapping of the different pigments and restorations, furnish sufficient information to back up our proposition.

Indeed, this multi-spectral analysis confirms that, as originally sketched in, the *Portrait of a Young Woman in Profile* was drawn in black chalk, red chalk and white chalk (*pierre noire*, *sanguine* and *craie blanche*), and then finally picked out with the most obviously appropriate graphic medium for the purpose—pen and brown ink.[3]

Many experimental outlines, *pentimenti* and corrections bear witness to the drawing's complex process of elaboration as well as to the artist's *modus operandi*.[4] This is unquestionably a strong indication that one is here dealing with an original work, created from scratch (*ex novo*), and not with a copy derived from a pre-existing model that cannot be traced.

The outlines drawn in lightly on the parchment had to make way eventually for the definitive solution of the head, occupying the same relative position on the sheet and having essentially the same proportions, as is suggested by the contour, partly covered by shading, that runs just outside and parallel to the line of the sitter's forehead, nose and neck, and the same applies to the preparatory contour within the

neck itself, which is notably smoother and more sponta-
neous than the final outline, as well as to the preliminary
lines around the nape of the neck that were eventually can-
celled. The artist then redrew the contour of the face with
black chalk, reinforcing it eventually with a delicate line of
brown ink, which does not always follow the underlying
contour in chalk drawn beneath. Along the lean, but differ-
ently modulated line of the profile one can detect numer-
ous "pentiments"—which are more legible in the infra-red
reflectographs (fig. 6)—corresponding in position to the
forehead, the rounded point of the nose, the lower lip, the
throat, the neck and the curve of the breast.

The artist has gone over his entire preliminary drawing
in pen and brown ink, the strokes of which are touched in
with incomparable delicacy, their springiness suggesting the
flexibility of line of an engraving.[5] The superlative qual-
ity of this draughtsmanship may be observed in the detail
of the eye shaded by the long eyelashes, in the worn pen-
work showing the interlacing of her garment—in part,
poorly retouched with the point of the brush in black ink,
an intervention that is contemporaneous with similar resto-
rations found in other areas of the drawing—as in her hair-
do, beautifully modelled through the use of the parchment
colour as a mid-tone (in a technique referred to in Italian as
'a risparmio'), and then finally in the complex, mixed graphic
effects of the hair itself, the reading of which has, however,
been disturbed by the restorer's numerous retouches with
the point of the brush.

The silhouette of the head detaches itself from its neutral
background as if it were a bas-relief set on a slab of traver-
tine, thanks to the fine external hatching in pen and ink that
reinforces the underlying shading in black chalk: this shad-
ing is unequivocally leftwards slanting in direction—from
the lower right towards the upper left, or vice-versa, instead
of from the lower left towards the upper right—as is found
in some other areas of the drawing. The artist responsible for

the execution of the portrait was, therefore, left-handed, and this fact alone rates as incontrovertible proof of Leonardo's authorship, since he did not share this very personal peculiarity with any of his major pupils.

As far as the colouring of the portrait is concerned, the variations in the naturalistic polychromy are essentially suggested by the mixing of the three different coloured "chalks" with the surface of the ground—the yellowish, slightly transparent, skin side of the parchment support. In spite of the modifications to its surface caused by subsequent restorations—which Cotte is in the process of demonstrating—the undisturbed: transparency of this ground remains fundamentally intact.

The yellow of the young woman's undergarment, the red-brown colour of her leather sleeve, seen at her shoulder showing through the cut in the garment above, and the grey-green of her bodice, originally covered by light passages of shading in red and black chalk, are in fact the result of glazes of watercolour. The coppery-gold colour of the hair is strengthened in hue by the underlying red and black chalk, as well as by the interaction of these materials with the yellow ground, the untouched passages of which function as the highlight that strikes the top of the head and gives it convexity, while the lifelikeness of the flesh tints, also indicated in red and white chalk, is enhanced because these same materials gain in resonance as rendering human complexion by being are drawn on this same yellowish ground. In both the original drawing of the young woman's hair and face, the delicate opaque colouring, applied '*a secco*', is subtly changed and intensified as a result of the watercolour retouching in several areas at the time of its restoration, bringing, as it were, a covering of lavish *fin de siècle* cosmetics to the purity of a Renaissance face. These additions can be observed even with the naked eye in the flesh-colour, where the initial, diaphanous tonality can be distinguished from the mawkish rose tint that light up the heavy brush-

work in the cheek, in the forehead and in some small areas of the neck, not to mention the touch of 'lipstick' on the lips (where the incoherent modelling of the brushstrokes is clearly visible . . .).

Close examination of the portrait's surface reveals it is extensively drawn with fine, left-handed shading (slanting from top left to bottom right), which may be seen both with the naked eye and, far more effectively, in the digital scans made under infra-red light. With parallel strokes of red and black chalk the artist has modelled chromatic harmonies of the flesh across a predominantly cool setting that ranges between pallid rose and violet to the intensity of the shaded areas, reinforced in some passages with pen and brown ink. With abundant use of white chalk the artist has then brightened the flesh and picked out those parts that catch the light. And with precise, masterly strokes, he has picked out the more sharply structured highlights, such as on the outer surface of the eye, the cornea and on the eyelids, details that are well seen in the ultra-violet reflectographs.

The areas of the young woman's flesh have suffered damages that are generally consistent with the original media. Abrasions and losses—confusingly and only partially integrated by the restorer, whose additions, as has been already pointed out, have strayed into some undamaged areas—are to be found in the uneven parts of the upper eyelid and orbital cavity, on the cheek, the jaw, the chin, the upper lip, and, again, on the neck, the shoulder and the *décolleté*, as is well demonstrated in the false colour infra-red reflectographs (i.e. the yellow areas against a blue background) and in those for inverse false colour (i.e. the blue areas against a red background). The degradation of the media and the interventions of the restorer, which not even the cleverest faker would have known how to achieve, *ex novo*, ought to be considered, in my opinion, as decisive arguments in favour of the authenticity of the work.

In conclusion, the *Portrait of a Young Woman in Profile* is the product of an experiment in mixed techniques, that bring together into partnership the new method '*a secco*' of three chalks with the traditional, liquid medium of ink,[6] and for this union of the two the artist made use of an unusual support of parchment, which, for drawing and some other media, had already been substituted by paper by the end of the fifteenth century, with the notable exception of the niche production of *deluxe* illuminated manuscripts. Thanks to this singular *mélange* of materials and techniques, the artist succeeded in combining the pictorial values of softness and colour with linear decisiveness and a sense of the volume of figurative form.

With this new work, we are therefore at the opposite extreme to what is generally understood as Leonardo's draughtsmanship, namely a practice that was tied either to the creation of a specific work in another medium or to engage with some cognitive undertaking or research. The portrait that we have before us now, coloured and finished with extreme accuracy in every detail, belongs to another category of drawing: it is autonomous, having been made as a work in its own right, or better still, an exceptionally refined hybrid between drawing, miniature and painting, conceived as a finished work of art in order to decorate some precious manuscript to be placed among the rarities of a private study.

The close physical analysis of the work has reduced, if not completely eliminated, the main doubts that originally weighed down the *Profile of a Young Woman*, including the claims that it was a period copy, or a fake from the late nineteenth or early twentieth century. Overcoming such deceits now opens the way to the recognition of Leonardo's paternity of the work, which may be backed up on the basis of four fundamental arguments: the style and female typology of the sitter; the overall quality of

the work; the left-handed execution; and the self-same experimental technique with which the portrait has been realized.

5. Martin Kemp, interview with Ana Finel Honigman, *Universal Leonard ArtNet*, January 19, 2005.

6. Alessandro Vezzosi, "Nuptial Portrait of a Young Woman," in *Leonardo Infinito* (Bologna, Italy: Scripta Mancant Edizioni, 2010). After the first paragraph, which I have quoted in full in the text, the rest of the monograph reads as follows:

Above all else, the left-handed handling is unequivocal and impressive in its fluidity, certainty and precision. The line serves to give form to the profile and texture to the garments portrayed, suggesting the classicism of a polychromed sculpture, interpreted in a dynamic interplay of light and shadow. This accentuates the purity of the lines in contrast to the suffused softness of the light, rose-tinted flesh. We will find this same trait, indeed, in the most accurate of the studies from the Madrid Codex and in the anatomical sketches in Windsor from the early Milanese period. Nicholas Turner, who was the first to suggest Leonardo's name for this profile portrait, has emphasized that the handling of the parallel penstrokes, both incisive and concise, is clearly attributable to a left-handed artist and not an imitator. The technique is masterly, Tuscan in style, but undoubtedly the work was finished in a Milanese context. Mina Gregori attributed it to Leonardo himself, noting not only its very high quality and left-handed execution, but also the reflection of its Florentine character and the style of Leonardo's first years of activity in Lombardy.

The use of parchment was until now unknown in the work of Leonardo, but in this sense, the new work fills a previously incomprehensible gap—given the frequency of its use among his Florentine miniaturist friends and colleagues and the activities of his Milanese collaborators (in particular De Predis). Besides, in his *Treatise on Painting*, Leonardo wrote, in the precept to "learn well by heart" and "not to

make errors again": "And if you want to prepare a thing, you should not have plain glass, take some skin of a goat, soft and well prepared, and then dry it; and when it is ready, use it for drawing, and then you can use a sponge to cancel what you first drew and make a second attempt" (§72).

Moreover, the use of parchment might be more sympathetic for the creation of a lifelike and representative portrait for a long-distance marriage proposal. This genre of commission would also explain the highly finished character of this portrait, which one could, indeed, entitle a *Nuptial Portrait*, a work intended to attract interest and to represent beauty, without being licentious or overly ornamental.

The origins of this genre of female portraiture (in parallel with that of the male portrait tradition, known as "di Salai," which would be used by Leonardo for decades), can perhaps be traced, on a small scale, to a sheet in the British Museum, predating the present work by some years: here the *Madonna del Fiore* dominates but there is also an instrument that resembles a perspective device used to translate reality, and for this device one needed a transparent support—for which parchment was ideally suited.

In the inventory of Leonardo's effects, datable to the early 1480s, one finds "*Una testa in profile con bella cappellatura*" ("A head in profile with beautiful hair") and "*Una testa di putta con trezie rannodate*" ("A head of a girl with plaited locks"). The line of the face is of absolute purity and, though describing the physiognomy of the young woman, also succeeds on an idealized level. With a completely different effect and a profile in the opposite direction, it recollects a drawing in Windsor (inv. no. 12505). Notwithstanding the differences that stem from the noble effigy on the one hand and the popular type on the other, and between a finished work and a study in progress, the proportions coincide exactly.

The present *Profile* is the culmination of an extraordinary sequence that, in the story of Renaissance art, began

with Piero della Francesca (with the *Portrait of Battista Sforza*, wife of Federico da Montefeltro, c. 1465, preserved in the Uffizi) and the presumed portrait of the wife of Giovanni de' Bardi, attributed to Piero del Pollaiolo (c. 1470, Museo Poldi Pezzoli, Milano), as well as Piero di Cosimo's *Cleopatra* (or *Simonetta Vespucci*, c. 1483, Musée Condé, Chantilly), and Domenico Ghirlandaio's *Portrait of Giovanna Tornabuoni* (1488, Thyssen-Bornemisza Collection, Madrid).

The composition is enlivened by a balance of elements vigorously interpreted, in a composed harmony of refined intensity and nobility. In the hair, the strokes run vibrantly in waves, interpreted in their natural visual flow with a dialogue with the natural lightness of the parchment.

The "Leonardesque knot" on the shoulder is obviously a paradigm of the artist and not only a decorative feature. It constitutes here an original assemblage, in a unique arabesque, in the form of geometrical matrices with two knots, alluding to symbols of infinity, like those drawn at the end of 1473 and which can be seen elaborated in the clothing of the both *Lady with an Ermine* and the *Mona Lisa*.

The border reinforces it, also with simplified knots, which run around the edge of the sleeve in a reticulated pattern, which is, in its turn, created by the most refined interlacing. The hairdo, called in Milan a "coazone" is also characteristic of the period and was fashionable at the Sforza court.

Limpid is the detail of the eye that interprets Leonardo's concept of the Window of the Soul and expresses in its unconventional gaze the interior grace and strength of character of the sitter. The rhythms of the contours and borders, and the lines and profiles that intersect and vary in their course animate the subject. Equally as harmonious are the different proportions of the facial elements that correspond to an anthropometric ideal.

One is tempted to think that this actual portrait may have inspired other Lombard portraits, including the *Dama con la*

reticella di perle in the Ambrosiana and perhaps the lost and this still mysterious painting attributed to Leonardo by Adolfo Venturi in 1941: "Leonardo executed the portrait of Beatrice d'Este, beloved of Ludovico il Moro, who he called his *puttina*. One sees this, unfortunately totally ruined, almost destroyed, at Kraków, in the Museo Czartoryski, the young little bride."

Even Cristina Geddo excludes the possibility that one is dealing here with the work of a follower, and, in effect, the comparison with paintings attributed to Ambrogio de Predis or to Bernardino de' Conti ultimately confirms the assignment to Leonardo. A hypothesis for the identification of the sitter might also be suggested in passing: she could be a member of the Sforza or a similar noble family, for example Bianca Maria Sforza as a young woman. In 1494 Bianca Maria, the second-born daughter of Galeazzo Maria, Duke of Milan, and Bona di Savoy, kinswoman of the king of France, married the Emperor Maximilian I, who would praise her beauty rather than her character. The wedding ceremony and the marriage procession, at which it is sometimes said that Leonardo himself may have participated, were memorable. The comparison with the presumed portraits of Bianca Maria, attributed to Ambrogio (National Gallery of Art, Washington) or to Bernardino (Louvre), is eloquent: they reveal not insurmountable distances.

This *Profile Portrait*, so diaphanous and sculptural, elegant in its unadorned simplicity (without jewellery), is masterful in every detail, as has also been demonstrated by the scientific examinations and the in-depth analyses of the Lumière Technology.

7. Carlo Pedretti, introduction to Vezzosi, "Nuptial Portrait of a Young Woman." Here is most of Pedretti's introduction to the monograph:

After overcoming an initial moment of stunned surprise upon opening this imposing and spectacular book, the

reader who is not totally ignorant of the present state of Leonardo studies cannot fail to feel a sense of *déjà vu*—not simply because of the splendid reproductions of the works of art (not only by Leonardo) that it features, but also for the very original and attractive, yet scientifically impeccable way in which they are presented. This approach is, moreover, the same as that applied to the exhibition programmes of the Museo Ideale in the center of Vinci, founded in 1993 by its current director, Alessandro Vezzosi. . . .

This and other new findings allow the reader to make discoveries for himself, without the help of systematic indices or listings, and I actually think that it is better not to mention too many of these new findings—in order not to deprive the reader of the excitement that these will arouse.

Other notable critics and art historians before me have seen and examined it—none of whom wish to be mentioned by name. The exception is Nicholas Turner, who has issued a declaration in which he limits himself to describing and commenting on what he has seen of the original, with particular attention paid to the left-handed execution. According to him, the strokes in the background beyond the sitter's profile move from lower right to upper left: since he did have access to a technical examination, this process needs to be checked, since it can be demonstrated that the direction of the strokes in Leonardo's celebrated drawings of skulls of 1489 in the Royal Library at Windsor is the opposite. I must confess that an exception, however, must be made for one new previously unpublished item—too important to be skimmed over lightly. I refer to the large drawing on parchment of a *Young Woman Seen in Profile to the Left*, dressed in a lavish Renaissance outfit without jewellery, and presented as a presumed portrait of a "betrothed bride," the sort of portrait that one could imagine being sent to a distant prospective groom—as was the case of Emperor

Maximilian, who lived a long distance from Bianca Maria Sforza, the niece of Ludovico il Moro.

This fascinating story, which concluded with the lavish marriage festivities in 1494, and other similar stories in the political manoeuvres on the part of her astute uncle, not to mention the various aspects of the portrait's complex attributional problems, are told by Vezzosi with the same restrained eloquence with which he has tackled every other theme or problem. I owe to him my knowledge of this extraordinary work of art, in the first instance from a digital image and then firsthand in the original. My first impression, perhaps influenced by the wooden panel to which the parchment has been attached, on the back of which one sees two old customs stamps, was that this is the sort of wooden support applied to boxes of chocolates in the middle of the nineteenth century. It is also curious that on the only occasion that the work has been described in print, when it was sold at Christie's, New York, in January 1998, it was attributed to a nineteenth-century German artist and estimated at between $12,000 and $16,000. It was, in fact, sold for $21,850—a surprising result for a work attributed to an anonymous nineteenth-century German hand.

Another reason to be perplexed is the costume, where one would expect to see a detachable sleeve held in place by laces. Here instead one has a triangular opening (but not large enough to squeeze an arm through) with elegant, embroidered Leonardo-style knots along the sides. Impeccable, however, is the typical Lombard hairstyle, with the hair gathered in a "coazzone" which falls along the back of the sitter and is held in place at various points with ribbons—all drawn without a single perspectival error.

There were also curious aspects to the story of the reattribution of that painting, which are brought to light in my essay on it as a political allegory, published in 1990 in the volumes of miscellaneous studies in honor of Luigi Firpo. In his sober and

essential account of the new study on vellum, Vezzosi dwells on the naturalistic elements of the image, including the head-and-shoulders portrait format, as an attribute of movement or timely decorum, which gives it its extraordinary and unexpected power: "Looking at the compositional schema, the curvilinear system is of such extreme purity that it has always made me think of an innovation on the scale of that of *Mademoiselle Pogany* by the twentieth-century sculptor Brancusi."

8. Nicholas Turner, "Statement by Nicholas Turner Concerning the Portrait on Vellum by Leonardo," Lumiere Technology website, www.lumiere-technology.com, September 2008. For the full report, see the appendix.

9. Timothy Clifford, "How I Know the New Portrait Is by Leonardo," *Times* (London), October 14, 2009.

10. Ibid.

8. Beloved Daughter

1. An account derived from Vasari's *The Lives of the Artists* and Kemp's *Leonardo*. Also according to Vasari, in *The Last Supper* Leonardo finished Judas's head, "which is a true portrait of treachery and cruelty," but the head of Christ he left imperfect. The art scholar D. R. David Wright also weighed in on the surface Leonardo used, writing, "Given the vellum ground I would guess (only a guess) that he would have worked on a wooden tabletop, or a wooden board held in the hand." Wright references a copy of a painting by Baccio Bandinelli in the Gardner Museum in Boston in which the artist holds a 3-by-3-foot board with a drawing attached (edges curling to reveal the board) as typical of the era.

2. Vasari, *The Lives of the Artists*, 289–290.

3. Ibid., 290.

4. Ibid.

5. Kemp and Cotte, *La Bella Principessa*, 24.

6. Martin Kemp, "Leonardo and the Ladies," *Art Quarterly and Review*, Spring 2010.

7. Vasari, *The Lives of the Artists*, 290.

8. Kemp and Cotte, *La Bella Principessa*, 80.

9. Martin Kemp, "Leonardo daVinci: Science and Poetic Impulse," *Journal of the Royal Society of Arts*, 133 (1985), 196–214; see also A. Giulini, "Bianca Sanseverino Sforzafigliadi Lodovico il Moro," *Archivio storico lombardo*, 39 (1912), 233–252.

10. Kemp and Cotte, *La Bella Principessa*, 81.

11. Ibid., 82.

12. Elisabetta Gnignera to Martin Kemp, e-mail, April 11, 2010. Details of hair and clothing may be found in Gnignera, *I Soperchi Ornamenti*. Ad nexus caps are mentioned in the wedding trousseau of Bianca Maria Sforza (1472–1510), who married Holy Roman Emperor Maximilian I in 1494, and Gnignera notes "almost total similarities" between the ad nexus caps in *La Bella Principessa* and in *La Dama con la Reticella* (attributed to Ambrogio de Predis), thought to portray Anna Sforza, Ludovico's niece, who married Alfonso d' Este in 1491 and died during childbirth in 1497 at the age of twenty-one.

But whereas the cap in *La Dama con la Reticella* is a sumptuous affair made of silk ribbons and lined with pearls, the one in *La Bella Principessa* appears to be made of linen. This, says Gnignera, suggests everyday use, but it could also tie in with Martin Kemp's suggestion that *La Bella Principessa*'s plain costume and absence of jewelery suggests it to have been a memorial portrait. Gnignera concludes that the hairstyle in *La Bella Principessa* was in use at the Sforza Court in Milan for less than a decade (between 1491 and 1499), when the braided Spanish style gave way to the freer, braidless French style. Gnignera believes that the subject must have been "a lady very close to [Duchess] Beatrice d'Este."

See also E. Welch, "Art of the Edge: Hair, Hats, and Hands in Renaissance Italy," *Renaissance Studies* 195, no. 22 (2008), 1–29.

13. Kemp and Cotte, *La Bella Principessa*, 71.

14. Vezzosi, "Nuptial Portrait of a Young Woman."

15. Geddo, "A 'Pastel' by Leonardo daVinci."

16. Kemp and Cotte, *La Bella Principessa*, 84.

9. The Art of Fingerprints

1. Biro's biographical details are from his own story at www .peterpaulbiro.com and conversations with the author.
2. Kemp and Cotte, *La Bella Principessa*, 161.
3. Ibid.
4. Ibid., 44.

10. The World Reacts

1. "Art: Every Line Will Be Alive," *Time*, September 12, 1960.
2. Elisabetta Povoledo, "Dealer Who Sold Portrait Joins Leonardo Debate," *New York Times*, August 29, 2008.
3. Richard Day, *Artful Tales: The Unlikely and Implausible Journal of an Art Dealer* (London, privately published, 2009).
4. Gene Weingarten, "Pearls before Breakfast," *Washington Post*, April 8, 2007.
5. According to various sources, the ten most expensive paintings ever sold are: (1) Jackson Pollock, *No. 5, 1948*, for $140 million (2006; alleged, for the records are in some dispute); (2) Gustav Klimt, *Portrait of Adele Bloch-Bauer*, for $135 million (2006); (3) Pablo Picasso, *Nude, Green Leaves and Bust*, for $106.5 million (2010); (4) Pablo Picasso, *Garçon à la Pipe*, for $104 million (2004); (5) Pablo Picasso, *Dora Maar with Cat*, for $95.2 million (2006); (6) Vincent van Gogh, *Portrait of Dr. Gachet*, for $82.5 million (1990; one of two versions); (7) Claude Monet, *Le Bassin aux Nymphéas*, for $80,451,178 (2008); (8) Pierre-Auguste Renoir, *Bal au Moulin de la Galette*, for $78 million (1990); (9) Peter Paul Rubens, *Massacre of the Innocents*, for $76.7 million (2002); and (10) Vincent van Gogh, *Portrait de l'Artiste sans Barbe*, for $71.5 million (1998).
6. Vasari, *The Lives of the Artists,* pp. 295–296, provides some details of Leonardo's work on *The Battle of Anghiari*:

By the excellence of the works of this most divine of artists his fame was grown so great that all who delighted in art, and in fact the whole city, desired to have some memorial of it. And the Gonfalonier and the chief citizens agreed that, the Great

Hall of the Council having been rebuilt, Leonardo should be charged to paint some great work there. Therefore, accepting the work, Leonardo began a cartoon [a preliminary sketch in the size of the work] representing the story of Nicolo Piccinino, captain of the Duke Filippo of Milan, in which he drew a group of cavalry fighting for a standard, representing vividly the rage and fury both of the men and the horses, two of which, with their forefeet entangled, are making war no less fiercely with their teeth than those who ride them. We cannot describe the variety of the soldiers' garments, with their crests and other ornaments, and the masterly power he showed in the forms of the horses, whose muscular strength and beauty of grace he knew better than any other man. It is said that for drawing this cartoon he erected an ingenious scaffolding that could be raised and lowered. And desiring to paint the wall in oil, he made a composition to cover the wall; but when he began to paint upon it, it proved so unsuccessful that he shortly abandoned it altogether.

There is a story that having gone to the bank for the sum which he was accustomed to receive from the Gonfalonier Piero Soderini every month, the cashier wanted to give him some packets of farthings, but he refused to take them, saying, "'I am no farthing painter." As some accused him of having cheated Soderini in not finishing the picture, there arose murmurs against him, upon which Leonardo, by the help of his friends, collected the money and restored it to him, but Piero would not accept it. [This last bit is typical Leonardo; his career was fraught with money issues!]

7. Mark Irving, "On the Trail of a Lost Leonardo," *Times* (London), May 16, 2006.

11. The $100 Million Blunder?

1. The details of this story were provided to me by Jeanne Marchig in a personal interview in February 2010 and an interview with her lawyer, Richard Altman, in January 2011.

2. Ernest Samuels (*Bernard Berenson: The Making of a Legend*) wrote that a number of portraits owned by Berenson were deposited with Giannino Marchig in 1944. Berenson, who was sequestered in Tuscany during the war, also wrote a diary of the period, *Rumour and Reflection, 1941–1944*, which was published by Simon and Schuster in 1952.
3. Meryle Secrest, *Being Bernard Berenson: A Biography* (Littlehampton, UK: Littlehampton Book Services, 1980).
4. *Marchig et al. v. Christie's Inc.*, 10 Civ. 3624 (S.D.N.Y. Aug. 13, 2010).
5. Judith Bresler, "*Bella Principessa* and the Hazard of Expert Opinion," *Art Law*, September 2010. Bresler is also the coauthor, with Ralph Lerner, of *Art Law: The Guide for Collectors, Investors, Dealers and Artists* (New York: Practising Law Institute, 2009).
6. *Marchig et al. v. Christie's Inc.*, 10 Civ. 3624 (S.D.N.Y. Jan. 31, 2011).
7. Simon Hewitt, "Marchig Vows to Fight On in 'Leonardo Case.'" *Antiques Trade Gazette*, March 7, 2011.

12. The Art World Strikes Back

1. Richard Dorment, "*La Bella Principessa*: A £100m Leonardo or a Copy?" *Daily Telegraph* (London), April 12, 2010.
2. David Grann, "The Making of a Masterpiece," *New Yorker*, July 12, 2010.
3. Press release, www.peterpaulbiro.com.
4. *Peter Paul Biro v. Conde Nast, a division of Advance Magazine Publishers Inc., David Grann, et al.* Filed June 29, 2011, U.S. District Court, Southern District of New York.

13. What Constitutes Proof?

1. Kemp and Cotte, *La Bella Principessa*, 187.
2. Theresa Franks, "Getting to the Truth of Authentication," Fine Arts Registry, December 17, 2006. The Fine Arts Registry (www.fineartsregistry.com) is a registration system for art, purporting to ensure authenticity.
3. Kemp and Cotte, *La Bella Principessa*, 9.
4. Turner, "Statement by Nicholas Turner Concerning the Portrait on Vellum by Leonardo."

5. Kemp and Cotte, *La Bella Principessa*, 8.

6. Theresa Franks, "Getting to the Truth of Authentication."

7. "Man, Myth and Sensual Pleasures," exhibition at the Metropolitan Museum of Art, New York, October 5, 2010–January 17, 2011, and at the National Gallery, London, February 23–May 30, 2011.

8. Giovanni Morelli, *Italian Painters: Critical Studies of Their Works* (London: John Murray, 1900).

9. Walter Pater, *Studies in the History of the Renaissance* (Charleston: Bibliolife, 2011; orig. 1873), viii.

10. Bernard Berenson, *The Italian Painters of the Renaissance* (London: Phaidon, 1953), ix.

11. Thomas Hoving, "Becoming an Art Connoisseur," Art Appreciation, Dummies.com, www.dummies.com/how-to/content/becoming-an-art-connoisseur.html.

12. John Gapper, "The Forger's Story," *Financial Times*, January 21, 2011.

14. Miracle in Warsaw

1. Pascal Cotte and Martin Kemp, "La Bella Principessa and the Warsaw Sforziad," September 28, 2011. The full report is available at www.lumiere-technology.com.

2. Simon Hewitt, "New Evidence Strengthens Leonardo Claim for Portrait," *ATG*, October 3, 2010.

3. Dalya Alberge, "Is This Portrait a Lost Leonardo?" *Guardian*, September 27, 2011.

4. "The Mystery of Leonardo da Vinci's 13th Portrait Elucidated," *Le Figaro*, September 30, 2011.

5. "Martin Kemp on Lost Leonardos," Artinfo.com, October 14, 2011.

Epilogue: Life's Fleeting Grace

1. Vasari, *The Lives of the Artists*, 297–298.

2. Kemp and Cotte, *La Bella Principessa*, 190.

Bibliography

Books

Arasse, Daniel. *Leonardo da Vinci*. Old Saybrook, CT: William S. Konecky Associates, 1998.

Bayer, Andrea, and Mina Gregori. *Painters of Reality: The Legacy of Leonardo and Caravaggio in Lombard*. New York: Metropolitan Museum of Art, 2004.

Bresler, Judith, and Ralph Lerner. *Art Law: The Guide for Collectors, Investors, Dealers and Artists*. London: Practising Law Institute, 2009.

Brewer, John. *The American Leonardo: A Tale of Obsession, Art and Money*. Cambridge: Oxford University Press, 2009.

Brown, David Alan. *Leonardo da Vinci: Origins of a Genius*. Hartford, CT: Yale University Press, 1998.

Buss, Chiara. *Silk, Gold and Crimson: Opulence in the Workshops of the Courts of the Viscotti and the Sforza*. Milan: Silvana, 2009.

Cadogan, Jean K. *Domenico Ghirlandaio: Artist and Artisan*. New Haven, CT: Yale University Press, 2001.

Charney, Noah. *Stealing the Mystic Lamb: The True Story of the World's Most Coveted Masterpiece*. New York: Public Affairs, 2010.

Clark, Kenneth, and Martin Kemp. *Leonardo da Vinci*. Rev. ed. New York: Penguin, 1989.

Folin, Marco. *Courts and Courtly Arts in Renaissance Italy: Arts and Politics in the Early Modern Age.* London: ACC Editions, 2010.

Gnignera, Elisabetta. *I Soperchi Ornamenti: Copricapi e Acconciature Femminili nell'Italia del Quattrocento* [Hairdressing in Fifteenth-Century Italy]. Siena, Italy: Protagon Editori, 2010.

Hahn, Harry, and Thomas Hart Benton. *The Rape of La Belle.* Kansas City, MO: Frank Glenn, 1946.

Hebborn, Eric. *The Art Forger's Handbook.* New York: Overlook, 2004.

Hoobler, Dorothy, and Thomas Hoobler. *The Crimes of Paris: A True Story of Murder, Theft and Detection.* New York: Little, Brown, 2009.

Hoving, Thomas. *False Impressions: The Hunt for Big-Time Art Fakes.* New York: Simon and Schuster, 1996.

Kemp, Martin. *Leonardo.* Cambridge: Oxford University Press, 2004.

———. *Leonardo da Vinci: The Marvelous Works of Nature and Man.* Cambridge: Oxford University Press, 2006.

Kemp, Martin J., and Pascal Cotte. *La Bella Principessa: The Story of the New Masterpiece by Leonardo.* London: Hodder and Stoughton, 2010.

Marani, Pietro C., and Edoardo Villata. *Leonardo da Vinci: The Complete Paintings.* New York: Harry N. Abrams, 2000.

Mohen, Jean Pierre, Michael Menu, and Bruno Mottin. *Mona Lisa: Inside the Painting.* Harry N. Abrams, 2006.

Mould, Philip. *The Art Detectives: Fakes, Frauds and Finds and the Search for Lost Treasures.* New York: Viking Press, 2010.

Richter, Irma A., Martin Kemp, and Thereza Wells. *Leonardo da Vinci Notebooks.* London: Oxford World Classics, 2008.

Salisbury, Laney, and Aly Sujo. *Provenance: How a Con Man and a Forger Rewrote the History of Modern Art.* New York: Penguin Press, 2009.

Samuels, Ernest. *Bernard Berenson: The Making of a Legend.* Cambridge, MA: Harvard University Press, 1987.

———. *Rumour and Reflection, 1941–1944.* New York: Simon and Schuster, 1952.

Bibliography

Scotti, R. A. *Vanished Smile: The Mysterious Theft of Mona Lisa*. New York: Alfred A. Knopf, 2009.

Secrest, Meryle. *Being Bernard Berenson: A Biography*. Littlehampton, UK: Littlehampton Book Services, 1980.

———. *Duveen: A Life in Art*. New York: Alfred A. Knopf, 2004.

Thornton, Sarah. *Seven Days in the Art World*. New York: W. W. Norton, 2008.

Tinagli, P. *Women in Italian Renaissance Art: Gender, Representation, Identity*. Manchester, UK: Manchester University Press, 1997.

Unger, Miles. *Magnifico: The Brilliant Life and Violent Times of Lorenzo de' Medici*. New York: Simon and Schuster, 2008.

Vasari, Giorgio. *The Lives of the Artists*. Translated by Julia Bondanella and Peter Bondanella. Cambridge: Oxford University Press, 2008.

Vezzosi, Alessandro. *Discoveries: Leonardo da Vinci*. New York: Harry N. Abrams, 1997.

Vinci, Leonardo da. *Leonardo's Notebooks*. Edited by Anna Suh. London: Black Dog and Leventhal, 2009.

Wittman, Robert K., with John Shiffman. *Priceless: How I Went Undercover to Rescue the World's Stolen Treasures*. New York: Crown, 2010.

Zollner, Frank, and Nathan Johannes. *Leonardo da Vinci, 1452–1519: The Complete Paintings and Drawings*. 25th ed. London: Taschen, 2007.

Websites

Art Law Blog: www.theartlawblogspot.com

Peter Paul Biro: www.paulbiro.net

Christie's: www.christies.com

Martin Kemp: www.martinjkemp.com

La Bella Principessa: www.labellaprincipessa.com

Leonardo da Vinci Museum: www.museoleonardo.com

Lumiere Technology: www.lumiere-technology.com

Sotheby's: www.sotheby's.com

Index

acconciatura alla spagnuola, 101

Adoration of the Magi (Leonardo da Vinci), 28

age, of portrait, 207–208. *See also* carbon dating

Altman, Richard, 135, 138, 139

American Leonardo, The (Brewer), 50

Ames-Lewis, Francis, 159

anatomical drawings (Leonardo da Vinci)
 authentic representation in, 80–82
 Kemp on, 78
 mathematical precision of, 64

Annesley, Noël, 133, 135

Antico, 12

Antiques Trade Gazette (ATG), 120–123, 131–132, 137, 194, 195

Armand Hammer Foundation, 86, 127

Art and Auction, 194

art authentication
 Biro on, 106–108, 112, 113–116
 Clifford on, 89–90, 121, 126–127, 164

Geddo on, 82–83, 102–103

Gregori on, 15–16, 20–22

Kemp on, 167–168, 170–171
 (*See also* Kemp, Martin)

museum curators and, 141–142, 165–166, 176–177

Pedretti on, 86, 152, 203

Strinati on, 147, 169, 171

Turner on, 18–20, 87–89, 201–211

Vezzosi on, 86, 203 (*See also* Vezzosi, Alessandro)

See also carbon dating; connoisseurship; fingerprint authentication; multispectral digital imaging; provenance

art collecting, about, 11–13

Artes (University of Pavia), 82

Art Forger's Handbook, The (Hebborn), 42–43

art forgery
 by Hebborn, 42–43
 by Landis, 176–177
 Mona Lisa, 38–40

243

Index

art forgery *(Continued)*
 *Portrait of a Woman Called La Bella
 Ferronnière,* 43–50
 problem of, 35–36
 Turner on, 40–43
 by van Meegeren, 36–38
*Artful Tales: The Unlikely and
 Implausible Journal of an Art
 Dealer* (Day), 119
Art Law (Bresler), 139–140
ArtNet, 85
ARTNews, 122, 179–181
auction houses, staffing of, 178. *See
 also* Christie's; Sotheby's

Bambach, Carmen C., 148
Baptism of Christ, The (Verrocchio), 25
Bartolommeo, Fra, 40
Battle of Anghiari, The (Leonardo da
 Vinci), 127–128
beauty
 Leonardo da Vinci on, 79–80
 perception and, 124–125
"Becoming an Art Connoisseur"
 (Hoving), 175–176
Being Bernard Berenson (Secrest), 131
Bell, Joshua, 124–125
Bella Principessa, La (Leonardo da
 Vinci)
 age of, 16, 60–61, 169–170,
 207–208
 costume and iconography, 22,
 31–32, 100, 209
 dimensions of, 86, 189
 financial value of, 123–127
 hairstyle features of, 16, 22,
 88–89, 94, 100–103, 206,
 208–209
 identity of subject, 90, 91–104

media used for, 63, 66–67, 77,
 109–110, 113, 132
multispectral digital imaging
 examination, 59–60, 61–69
 (See also Lumiere Technology)
naming of, 75
needle holes in, 68, 184, 190
provenance of, 129–132, 183–195
publicity about, 117–128
"Report on *Portrait of a Young
 Woman in Profile*" (Turner),
 201–211
sale of, in 1998, 3–7, 118–120,
 132–133, 164
sale of, in 2007, 1–3, 7–13, 18
security for, 68
technique, 58, 63, 87, 102, 193–
 194, 202–207
vellum canvas of, 21, 60–61, 63,
 76–78, 89
See also art authentication;
 Leonardo da Vinci
*Bella Principessa: The Story of the
 New Masterpiece by Leonardo, La*
 (Kemp, Cotte), 147, 159–160
Belle Ferronnière, La (Leonardo da
 Vinci)
 hairstyle of subject, 103
 Leonardo attribution of, 131
 *Portrait of a Woman Called La Belle
 Ferronnière* and, 44
 proportional system used for, 78
Bellincioni, Bernardo, 98–99
Bellotto, Bernardo, 187–188
Benton, Thomas Hart, 48–49
Berenson, Bernard
 on art connoisseurship, 174–175
 Hahn and, 45
 Marchigs and, 130–131

Index

Biblioteca Nazionale (Naples, Italy), 78

Bibliothèque Nationale (Paris), 184

bifurcation, 115

Birago, Giovanni Pietro, 184, 190

Birkbeck College, University of London, 159

Biro, Geza, 104–105

Biro, Joanne, 104

Biro, Laszlo, 106

Biro, Peter Paul

 biographical information, 105–106

 on Leonardo authorship, 113–116

 New Yorker article and, 153–158, 170

 on Pollock authorship, 112

 on Turner authorship, 106–108

 See also fingerprint authentication

Black, William Harman, 45–47

Boltraffio, 18–19, 210

Borne, François, 5, 132–133, 136

Boy Bitten by a Lizard (Caravaggio), 173

Bresler, Judith, 139–140

Brewer, John, 50

British Library (London), 184

British Museum (London)

 Chapman and, 155–156

 Jones and, 41–42

 Study of a Winged Figure; Allegory with Fortune, 206–207

 Turner and, 18

 Warrior with Helmet and Breastplate, 208

Brotherhood of St. Luke, 4

Brown, Dan, 73, 83–86

Brueghel, 12

Bugiardini, Giuliano, 132

Burlington, 160–163

Cappuzzo, Gianmarco

 on Lumiere Technology, 51–52, 59

 Vezzosi and, 83

Caravaggio

 Boy Bitten by a Lizard, 173

 Gregori on, 15

 Saint Matthew painting, 161

carbon dating

 carbon-14 isotope technique, 60–61

 need for, 16

 reliability of, 169–170

Carpaccio, Vittore, 12

Castello Sforzesco, 30

Castiglione, Baldassare, 30

Caterina (mother of Leonardo da Vinci), 24

Center of Interdisciplinary Science for Art, Architecture, and Anthropology, 127

chalk, 63, 77, 113

Chapman, Hugo, 155–156

Charles VIII (King of France), 77, 194

Chaudron, Yves, 40

Chichester Canal (Turner), 107

Christ and His Disciples at Emmaus (forgery), 37–38

Christie's

 Borne and, 5, 132–133, 136

 Dickenson and, 126

 January art auctions, 1

 Marchig v. Christie's, 130, 133–143

 New Yorker article and, 153

Christie's *(Continued)*
 1998 sale of *La Bella Principessa*
 (Leonardo da Vinci) sold by, in
 1998, 3–7, 118–120, 132–133,
 164
 reaction to publicity, 123
Clifford, Timothy
 on first impression of *La Bella
 Principessa* (Leonardo da Vinci),
 164
 La Bella Principessa (Leonardo da
 Vinci) examined by, 89–90
 on media publicity, 121, 126–127
CNN, 112
coazzone
 Gregori on, 16, 22
 identifying portrait subject by, 94,
 100–103
Cobden, Sandra, 135, 136, 137,
 139
Codex (Leonardo da Vinci), 6, 68
color
 colorimetric print, 62
 detected by multispectral digital
 imaging, 55–59, 61–64
 flesh tones, 64, 77, 113–114
 materials used, 47–48
 See also media (used for fine art);
 multispectral digital imaging
Condé Nast, 153
connoisseurship
 Ganz on, 118
 methodology, 20–22
 New Yorker article on, 156
 Pollock authentication and, 112
 proving authenticity and,
 173–178
 Turner on, 142
Cooper, Anderson, 112

Cooper Hewitt Museum (New
 York), 90
Corradis, Bernardina de, 97–98
Correggio, Niccolò da, 99–100
Corrigan, Caroline
 La Bella Principessa (Leonardo da
 Vinci) reviewed by, 16
 on restoration, 132, 141
Cosimo, Piero di, 132
costume, 22, 31–32, 100, 208–209
Cotte, Pascal
 biographical information,
 52–53
 Cappuzzo and, 51–52
 on identity of portrait's subject,
 93–94
 *La Bella Principessa: The Story of
 the New Masterpiece by Leonardo,*
 147, 159–160
 La Bella Principessa (Leonardo da
 Vinci) examined by, 59–60,
 61–69
 Lady with an Ermine (Leonardo
 da Vinci) examined by, 57–59,
 64, 65
 Lumiere Technology established
 by, 53–54
 Mona Lisa examined by, 54–57
 on provenance, 191–195
 publicity about *La Bella
 Principessa* (Leonardo da Vinci)
 and, 118
craquelure
 spectral digital imaging used to
 detect, 61
 van Meegeren and, 38
CRISATEL project, 54
Crivelli, Lucrezia, 44
Czartoryski, Prince (Poland), 57

Czartoryski Museum (Krakow, Poland), 57

Daily Telegraph (London), 147–153
Da Vinci Code, The (Brown)
Kemp on, 73
mock trial about, 83–86
Day, Richard, 119
Decker, Karl, 39–40
de Gaulle, Charles, 162
Department of European Paintings, 148
Desiderio da Settignano, 40–41
d'Este, Duchess Beatrice, 31, 101, 102–103
d'Este, Isabella (Marchioness of Mantua), 96
detection techniques
carbon dating, 16, 61, 169–170
chemical comparison, 47–48
DNA, 113
fingerprints, 105–116, 153–158, 170–171
multispectral digital imaging, 53–69, 110, 137, 178
X-ray fluorescence spectroscopy, 41
De Vecchi, Pierluigi, 150
Dickenson, Simon, 126
DNA, for art authentication, 113
Dohnányi, Oliver von, 187
Dorment, Richard, 147–153
"Drawings by Rembrandt and His Pupils: Telling the Difference" (J. Paul Getty Museum), 17
Dummies.com, 175–176
Dussler, Leopold, 149
Dutch Rembrandt Society, 37–38
Duveen, Joseph, 44–47

Eco, Umberto, 52–53

Ekserdjian, David, 160–163
Esterow, Milton, 179–181
"Expert Opinions and Liabilities" (New York University), 138

facial features
eyes, 64–65
Lady with an Ermine (Leonardo da Vinci), 57–59
of Mona Lisa (Leonardo da Vinci), 56
Turner on technique, 202–207
Fahy, Everett, 148
False Impressions: The Hunt for Big-Time Art Fakes (Hoving), 36
Figaro, Le (France), 194
Financial Times, 177
Fine Arts Registry (FAR), 168–173
fingerprint authentication
analysis method for, 109–110
basic types of, 109
Biro on Leonardo da Vinci authorship, 113–116
Biro's biographical information and, 105–106
mathematical analysis used for, 108
multispectral digital imaging of, 110
New Yorker article on, 153–158
Pollock example, 110–113
reliability of, 170–171
Turner example, 106–108
"Fingerprint Points to $19,000 Portrait Being Revalued as $100m Work by Leonardo da Vinci" (ATG), 120–123
flesh tones
fingerprint evidence and, 113–114
Leonardo da Vinci on, 77

Index

flesh tones *(Continued)*
 multispectral digital imaging used
 for examination, 64
Florence, fifteenth century charac-
 teristics of, 31
foggia alla Francese, 101
frames, auction house customs
 regarding, 133
Francis (François) I (King of
 France), 95, 197–198
Franks, Theresa, 172

Gallerani, Cecilia
 poem about, 99
 as subject of *Lady with an Ermine*
 (Leonardo da Vinci), 57, 65,
 94–95, 96–97, 209
 See also Lady with an Ermine
 (Leonardo da Vinci)
Ganz, Kate
 Dorment and, 148, 151
 La Bella Principessa (Leonardo
 da Vinci) purchase (1998) by,
 118–120, 164
 La Bella Principessa (Leonardo
 da Vinci) sale by (2007), 2–3,
 7–13, 18
Ganz, Sally, 8
Ganz, Victor, 8
Gapper, John, 177
Gates, Bill, 6, 68
Geddo, Cristina
 on identity of portrait's subject,
 102–103
 La Bella Principessa (Leonardo da
 Vinci) examined by, 82–83
"Getting to the Truth of
 Authentication" (Fine Arts
 Registry), 172

Getty Conservation Institute, 41
Gherardini, Lisa. *See* Giocondo,
 Lisa del
Ghirlandaio, Domenico, 17, 130,
 132
Giacommetti, 126
Ginevra de'Benci (Leonardo da Vinci),
 115, 131
Giocondo, Lisa del, 95, 168. *See also
 Mona Lisa* (Leonardo da Vinci)
Giocondo family, 56
Giovanni del Fora, Gherardo di, 78
Gnignera, Elisabetta, 101
Goering, Hermann, 37
Goguel, Catherine, 16
Gossaert, Jan, 172–173
Gothenburg exhibition, 145–146
Gould, David, 43
Grann, David, 153–158, 170
Gregori, Mina
 on *La Bella Principessa* (Leonardo
 da Vinci) authorship, 15–16,
 20–22
 on *La Bella Principessa* (Leonardo
 da Vinci) eye feature, 65
 on *La Bella Principessa* (Leonardo
 da Vinci) technique, 87
 Vezzosi and, 86
Guardian (London), 194
gum arabic, 137

Hahn, Andrée, 43, 47
Hahn, Harry, 43–50
hair features
 coazzone, 16, 22, 94, 100–103
 Turner on, 88–89, 206, 208–209
Hals, Franz, 13
Harvard Center for Renaissance
 Studies, 130

Index

hatching
 left-handedness and, 19
 media and, 63
 restoration and, 66–67
 Turner on, 203–204
Head and Shoulders of a Woman, 205
Hebborn, Eric, 42–43
Herner, Richard, 165–166
Hewitt, Simon
 initial *ATG* story by, 120–123, 137
 La Bella Principessa (Leonardo da
 Vinci) provenance and, 131–132
 "New Evidence Strengthens
 Leonardo Claim for Portrait"
 (ATG), 194, 195
Hokusai, Katsushika, 117
Holy Grail, 84
Horne Museum (Florence), 2
Horton, Teri, 111–113
Hoving, Thomas
 "Becoming an Art Connoisseur,"
 175–176
 Metropolitan Museum of Art
 (New York) and, 36
 New Yorker article and, 156
 on Pollock authentication, 111
Hug, J. Conrad, 44, 47

International Foundation for Art
 Research, 112
Isabella of Aragon, 97, 102–103

J. Paul Getty Museum
 "Drawings by Rembrandt
 and His Pupils: Telling the
 Difference," 17
 Turner and, 40–43
*Jason & Queen Hippolyte with the
 Women of Lemnos* (Cosimo), 132

Jerusalem Museum, 13
Jesus
 Adoration of the Magi (Leonardo
 da Vinci), 28
 The Baptism of Christ
 (Verrocchio), 25
 Christ and His Disciples at Emmaus
 (forgery), 37–38
 The Da Vinci Code (Brown)
 portrayal of, 83–86
 The Last Supper (Leonardo da
 Vinci), 23, 92–93, 127
 Shroud of Turin, 60–61, 73
Jones, Mark, 41–42
Judas, 92–93
Julius II, Pope, 127

Kansas City Art Institute, 44
Katz, Daniel, 150
Kemp, Martin
 on appreciation of *La Bella
 Principessa* (Leonardo da Vinci),
 199
 Berenson archives and, 131
 on fingerprint evidence, 113
 on identity of portrait's subject,
 93–94, 95–97, 100–103
 *La Bella Principessa: The Story of
 the New Masterpiece by Leonardo,*
 147, 159–160, 160
 La Bella Principessa (Leonardo da
 Vinci) examined by, 69, 71–78
 Leonardo, 71–71, 192
 Marchig v. Christie's and, 134
 at mock trial of *The Da Vinci
 Code* (Brown), 85
 National Gallery lecture (2010),
 153
 on provenance, 183–186, 191–195

Index

Kemp, Martin *(Continued)*
 on proving authenticity, 167–168,
 170–171
kermes berry, 48
Koetl, John, 142–143
Kress Foundation, 127
Kunsthistorisches Museum
 (Vienna), 172
Kurosawa, Akira, 140

Lady with an Ermine (Leonardo da
 Vinci)
 Cecillia Gallerani as subject of,
 57, 65, 94–95, 96–97
 costume and iconography, 209
 fingerprint evidence and, 114
 Leonardo attribution of, 131
 multispectral digital imaging used
 for, 57–59, 64, 65
 proportional system used for, 78
 provenance of, 169
 Royal Castle Museum (Warsaw)
 exhibition, 188
lampblack, 48
Landesman, Peter, 41–42
Landis, Augustis, 176–177
Landscape with a Rainbow (Turner),
 106–108
lapis lazuli, 48
Lardoux, Andrée (Hahn), 43, 47
Last Supper, The (Leonardo da Vinci)
 commission for, 92–93
 condition of, 127
 fame of, 23
latent fingerprints, 109
lawsuits
 Biro's suit against Grann, 158
 Marchig v. Christie's, 130, 133–143
Lefranc of Paris, 132

left-handedness
 detecting, 16, 19, 75
 restoration and, 67
 Vezzosi on left-handed shading,
 88
Leonardo da Vinci
 Adoration of the Magi, 28
 anatomical drawings by, 64, 78,
 80–82
 The Baptism of Christ (Verrocchio)
 and, 25
 The Battle of Anghiari, 127–128
 biographical information, 22,
 23–33, 197–198
 Codex, 6, 68
 forgery attempt, 38–40
 Ginevra de'Benci, 115, 131
 Hahn painting and, 43–50
 ideals of beauty, 79–80
 Lady with an Ermine, 57–59, 64,
 65, 78, 95, 96–97, 114, 131,
 169, 188, 209
 The Last Supper, 23, 92–93, 127
 left-handedness of, 16, 19, 75
 "Ligny Memorandum," 77
 The Lives of the Artists (Vasari), 56
 (*See also* Vasari, Giorgio)
 lyre created by, 28
 Mona Lisa, 22, 23, 38–40, 54–59,
 78, 93, 114, 167–168
 Musician, 95
 Notebooks, 88
 parachute design of, 72–73
 patrons of, 95
 portrayal of women by,
 95–97
 sexual orientation of, 97
 St. Jerome in the Wilderness,
 115–116

Treatise on Painting, 89, 204, 205, 207, 211
use of fingertips by, 110
Vitruvian Man, 64
See also art authentication; *Bella Principessa, La* (Leonardo da Vinci); media (used for fine art); technique
Leonardo da Vinci Society, 159
Leonardo Infinito (Vezzosi), 86, 203
Leonardo (Kemp), 71–71, 192
Leonardo Project, 127
"Ligny Memorandum" (Leonardo da Vinci), 77
Lives of the Artists, The (Vasari), 56. *See also* Vasari, Giorgio
Longhi Institute (Florence), 173
Los Alamos National Laboratory, 60–61
Louis XII (King of France), 77, 95
Louvre (Paris)
 Boltraffio work in, 18
 Mona Lisa stolen from, 38–40 (*See also Mona Lisa* (Leonardo da Vinci))
 Portrait of Isabella, 205
Lumiere Technology, 51–69
 Cappuzzo on, 51–52
 Clifford and, 90
 Cobden on, 137
 Cotte's biographical information, 52–53
 media publicity, 123
 multispectral digital imaging, defined, 53–54
 multispectral digital imaging used for *La Bella Principessa*

(Leonardo da Vinci), 59–60, 61–69
 multispectral digital imaging used for *Mona Lisa,* 54–59
 "Report on *Portrait of a Young Woman in Profile*" (Turner), 201–211
lyre, created by Leonardo da Vinci, 28

macrophotography, 192–193
Marchig, Giannino, 129–132, 200
Marchig, Jeanne
 Christie's lawsuit by, 133–143
 La Bella Principessa (Leonardo da Vinci) ownership by, 129–132
 La Bella Principessa (Leonardo da Vinci) sale by, 132–133
Marchig Animal Welfare Trust, 129, 137–138
Marchig v. Christie's, 130, 133–143
Marianeschi, Massimo
Matter, Alex, 155
media (used for fine art)
 chalk, 63, 77, 113
 Leonardo da Vinci on, 77
 multispectral digital imaging used for examination, 63
 oil paints and fingerprints, 109–110
 pastels, 132
 pen and ink, 63, 66–67
 See also color; restoration
Medici, Lorenzo de', 28–33, 78
Metropolitan Museum of Art (New York)
 Hoving and, 36, 111
 Virgin and Child (Gossaert), 172–173

Index

Michelangelo
 Albertina (Vienna) exhibition, 187
 left-handedness of, 19
 Leonardo da Vinci and, 127
 misattribution, 2, 90, 119
Milan
 Leonardo da Vinci in, 28–33
 portrait costume and iconogra-
 phy, 31–32, 87, 209
Milan, Duke of (Ludovico il Moro
 Sforza)
 Crivelli and, 44 (*See also Belle
 Ferronnière, La* (Leonardo da
 Vinci))
 fashion and, 100, 101
 Galeazzo Sanseverino and, 184
 Gallerani and, 57, 94, 95, 96, 209
 (*See also Lady with an Ermine*
 (Leonardo da Vinci))
 on *The Last Supper* (Leonardo da
 Vinci), 93
 as patron of Leonardo di Vinci,
 22, 27, 28–33
 relationship to Bianca Sforza, 92,
 93–104
Miller, S. Lawrence, 46
"Mind of Leonardo da Vinci, The"
 (Uffizi Gallery, Florence), 128
Mona Lisa
 Lisa del Giocondo as subject of,
 95–97
 multispectral digital imaging used
 for, 54–57
Mona Lisa (Leonardo da Vinci)
 authenticity of, 167–168
 fame of, 23
 fingerprint evidence and, 114
 La Bella Principessa (Leonardo da
 Vinci) compared to, 22, 93

multispectral digital imaging used
 for, 54–59
 proportional system used for, 78
 theft of/forgery attempt, 38–40
Morelli, Giovanni, 173–174
Morelli Method, 173
Moses, Harry, 111
multispectral digital imaging
 accessibility of, 178
 defined, 53–54
 fingerprint evidence and, 110
 protective material identified by,
 137
 used for *La Bella Principessa*
 (Leonardo da Vinci), 59–60,
 61–69
 used for *Lady with an Ermine*
 (Leonardo da Vinci), 64
 used for *Mona Lisa,* 54–59
 See also Lumiere Technology
Murdock, David, 188–191, 192–193
Museo Ideale Leonardo da Vinci
 (Vinci, Italy), 83
Museum Boijmans Van Beuningen
 (Rotterdam), 37
museum curators, authentic-
 ity assessed by, 141–142,
 165–166, 176–177. *See also* art
 authentication
Musician (Leonardo da Vinci), 95
"Mystery of Leonardo da Vinci's
 13th Portrait Elucidated, The"
 (Le Figaro), 194

National Gallery (London)
 Boy Bitten by a Lizard
 (Caravaggio), 173
 La Bella Principessa (Leonardo da
 Vinci) lecture (Kemp), 153

Index

Leonardo da Vinci exhibition
(2011–2012), 192, 194
museum laboratory exhibition
(2010), 141–142
Penny and, 149, 150
Virgin and Child (Gossaert),
172–173
National Gallery of Art
(Washington, D.C.), 115, 150
National Geographic (magazine),
194–195
National Geographic-Nova, 188,
192–193
National Library (Warsaw, Poland),
184–186, 188–195
Nazarenes, 4–5, 164
"New Evidence Strengthens
Leonardo Claim for Portrait"
(ATG), 194, 195
Newhouse, Sy, 153
New Yorker, 153–158, 170
New York Times
on art authentication, generally,
41–42
on *La Bella Principessa* (Leonardo
da Vinci) authenticity, 118, 122
New York University, 138
Nicholas, Adrian, 72–73
Notebooks (Leonardo da Vinci), 88
Nuland, Sherwin, 81

oil paints, 109–110
Opus Dei, 84–85
Oxford University, 71

parachute design, 72–73
Pater, Walter, 174
Pedretti, Carlo, 86, 152, 203
pen and ink

restoration of, 66–67
used by Leonardo da Vinci, 63
Penicaut, Jean
Cappuzzo and, 51–52
fingerprint evidence and, 116
on *Lady with an Ermine* (Leonardo
da Vinci), 58–59
Lumiere Technology established
by, 53–54
on media publicity, 123
Penny, Nicholas, 149–153
pentimenti, 76
Perréal, Jean, 77, 193–194
Peruggia, Vincenzo, 39–40
Pforr, Franz, 4
Picasso, Pablo
Albertina (Vienna) exhibition,
187
high price commanded by art of,
126
Mona Lisa (Leonardo da Vinci)
theft and, 39
Pinacoteca Ambrosiana (Milan), 95
plastic fingerprint impressions, 109
poems
about Bianca Sforza, 98, 99–100
about Gallerani, 99
by Shakespeare, 200
Pollock, Jackson
Biro and, 155
high price commanded by art of,
126
Horton painting and, 110–113
Porte de Clignancourt (Paris),
11–13
*Portrait of a Woman Called La Bella
Ferronnière,* 43–50
Portrait of a Young Gentleman
(Bugiardini), 132

Index

Portrait of a Young Woman in Profile to the Left. See Bella Principessa, La (Leonardo da Vinci)

Portrait of Isabella d'Este, 205

Portrait of Piero (Gherardo di Giovanni del Fora), 78

Poussin, Nicholas, 13

Priory of Sion, 84

proof. *See* art authentication

provenance
 defined, 5
 documenting, 168–169
 fingerprint evidence and, 108
 of *La Bella Principessa* (Leonardo da Vinci), 183–195
 Turner on, 210–211

publicity, 117–128
 Ames-Lewis on, 159
 Burlington article, 160–163
 Cotte and, 117–118
 Daily Telegram article, 147–153
 Ganz and, 118–120
 Gothenberg exhibition and, 145–146
 Hewitt *(ATG)* and, 120–123, 131–132, 137, 194, 195
 La Bella Principessa: The Story of the New Masterpiece by Leonardo (Kemp, Cotte), 147, 159–160, 160
 New Yorker article, 153–158, 170
 perception of art and, 163–166
 See also individual names of media outlets

Queen's College (London), 56–57

Raimondi, Marcantonio, 149

Rape of La Belle, The (Benton), 48–49

Raphael
 forgeries, 40
 high price commanded by art of, 126
 left-handedness of, 19
 misattribution, 2, 132, 149–150
 use of fingertips by, 110

Rashomon (film), 140

Rembrandt
 authorship of, 17
 Dutch Rembrandt Society, 37
 Kemp on, 104
 "Report on *Portrait of a Young Woman in Profile*" (Turner), 201–211

restoration
 Corrigan on *La Bella Principessa* (Leonardo da Vinci), 16
 by Giannino Marchig, 132
 hatching and, 66–67
 tracked by spectral digital imaging, 65–68

ritratto nuziale, 209

Rogers, Raymond N., 60–61

Royal Castle Museum (Warsaw), 188

Royal Library, Windsor Castle, 205

San Donato a Scopeto (Florence), 28

Sanseverino, Galeazzo
 marriage to Bianca Sforza, 98–100
 Sforziada owned by, 184, 186, 193

Santa Maria delle Grazie (Milan), 92

Secrest, Meryle, 131

Seracini, Maurizio, 127–128

Ser Piero (father of Leonardo da Vinci), 24–25, 26–27

Sforza, Bianca
 La Bella Principessa (Leonardo da Vinci) as legacy of, 199
 Sforziada and, 184–186, 188–195
 as subject of portrait, 97–104
 Vezzosi on, 209

Sforza, Bona, 190

Sforza, Francesco
 as Sforza family patriarch, 32, 93
 Sforziada, 184–186, 188–195
 as subject of Leonardo da Vinci monument, 93

Sforziada, 184–186, 188–195

sfumato, 58, 206

Shakespeare, William, 200

Shroud of Turin, 60–61, 73

Sigismund I (King of Poland), 190

Silverman, Kathy
 on authentication, 68, 83
 La Bella Principessa (Leonardo da Vinci) purchase, 1–3, 7–13
 on naming, 75

60 Minutes, 111

Smithsonian Institute, 127

Soderini, Piero, 127

sonnets. See poems

Sortais, Georges, 43, 47

Sotheby's
 January art auctions, 1
 Portrait of a Woman Called La Bella Ferronnière, 49–50

Spiegel, Der (German), 148

St. Jerome in the Wilderness (Leonardo da Vinci), 115–116

stamped fingerprint impressions, 109

Strinati, Claudio
 on authenticity, 169, 171
 foreword to La Bella Principessa: The Story of the New Masterpiece by Leonardo (Kemp, Cotte), 147

Study of a Winged Figure; Allegory with Fortune, 206–207

Supreme Court of New York, 45–47

Swiss Federal Institute of Technology (Zurich), 60

Tate Gallery (London), 107

technique
 "Leonardesque" knots, 102
 sfumato, 58, 206
 Turner on, 202–207 (See also hatching; left-handedness; media (used for fine art))

"Thrift Shop Jackson Pollock Masterpiece, The" (60 Minutes), 111

Time (magazine), 46

Times (London), 122, 148

titanium oxide, 41

Treatise on Painting (Leonardo da Vinci), 89, 204, 205, 207, 211

trifurcation, 115

trois crayons technique, 63, 193–194

Turcotte, Andre, 112, 154

Turner, J. M. W., 106–108

Turner, Nicholas
 on art forgery, 40–43
 on authenticity, 171
 on connoisseurship, 142
 on La Bella Principessa (Leonardo da Vinci) authorship, 18–20, 87–89
 preface to La Bella Principessa: The Story of the New Masterpiece by Leonardo (Kemp, Cotte), 147

Index

Turner, Nicholas *(Continued)*
Report on *Portrait of a Young Woman in Profile,* 201–211
Tuscany, style of *La Bella Principessa* (Leonardo da Vinci) and, 87

Uffizi Gallery (Florence)
The Baptism of Christ (Verrochio), 25
"Mind of Leonardo da Vinci, The," 128
Mona Lisa (Leonardo da Vinci) theft and, 39
Sforziada, 184
University of London, 159
University of Pavia, 82
University of South Florida, 184
USA Today, 122

Valfierno, Eduardo de, 39–40
Van Dyck, 2
van Gogh, Vincent, 6
van Meegeren, Hans, 36–38, 61
Vasari, Giorgio, 56
art of, 127
on death of Leonardo da Vinci, 198
on *The Last Supper* (Leonardo da Vinci), 92
Leonardo da Vinci biography of, 24, 26, 28
Vatican
The Da Vinci Code (Brown) portrayal of, 84
St. Jerome in the Wilderness (Leonardo da Vinci), 115–116
vellum
carbon dating of, 60–61
Kemp on, 76–78

multispectral digital imaging used for examination, 63
Turner on, 89, 207
visual age detection of, 21
Vermeer, Jan, 37–38. *See also* van Meegeren, Hans
Verrocchio, Andrea del, 130
Leonardo da Vinci as apprentice to, 17, 24–25, 130
Turner on, 208
Vezzosi, Alessandro
Gothenberg exhibition, 145–146
on "Leonardesque knot," 102
Leonardo Infinito, 86, 203
mock trial of *The Da Vinci Code* (Brown), 83–86
on provenance, 211
on Sforza, 209
on use of vellum, 207
Vinci, Italy, 83–86
Virgin and Child (Gossaert), 172–173
Vitruvian Man (Leonardo da Vinci), 64. *See also* anatomical drawings (Leonardo da Vinci)

Wallert, Ari, 41
Warrior with Helmet and Breastplate, 208
Welsh, Evelyn, 56–57
Who the #$&% Is Jackson Pollock? (documentary), 111
Wilde, Oscar, 52
Windsor Castle, 205
Wozniak, Kasia, 184–186, 188–191
Wright, D. R. Edward, 184, 195

X-ray fluorescence spectroscopy, 41

Zawisza, Anna, 189